THE CALL OF THE CORBETTS

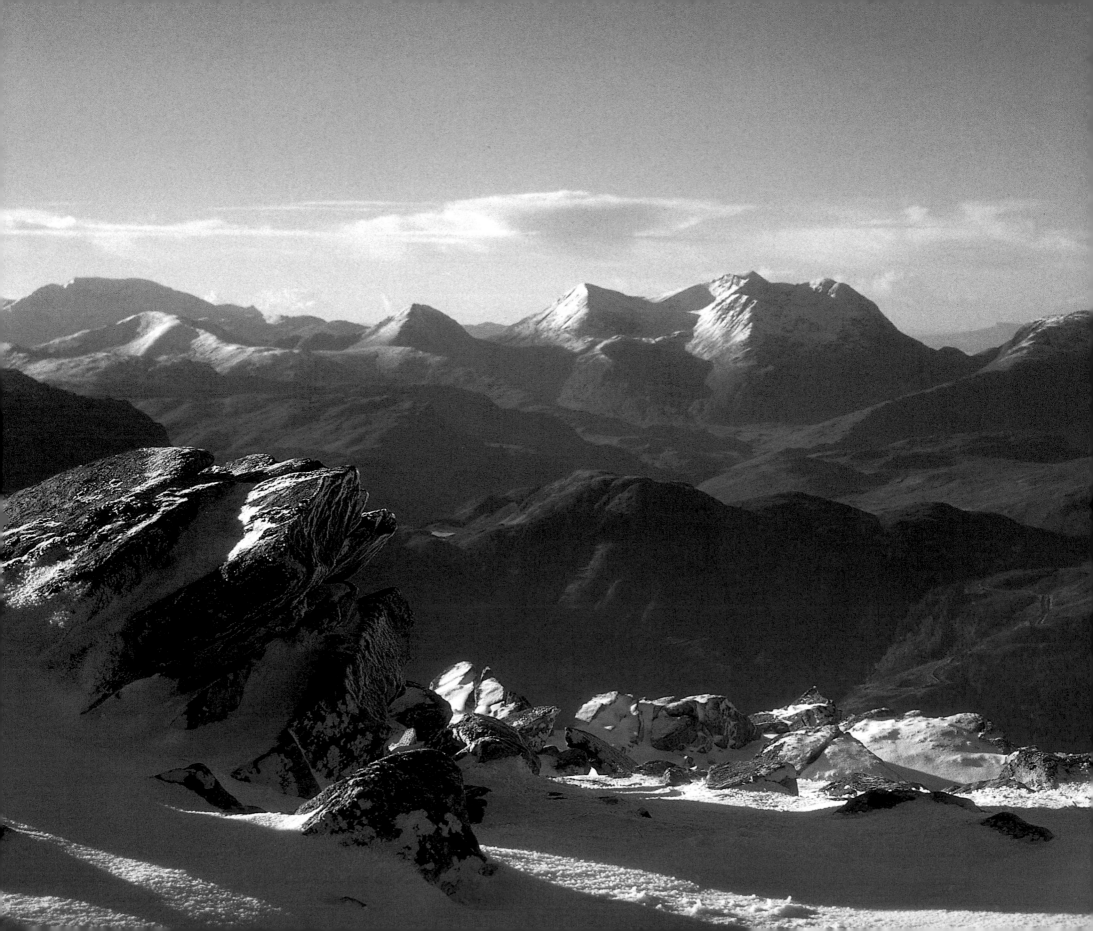

THE CALL OF THE CORBETTS

IRVINE BUTTERFIELD

David & Charles

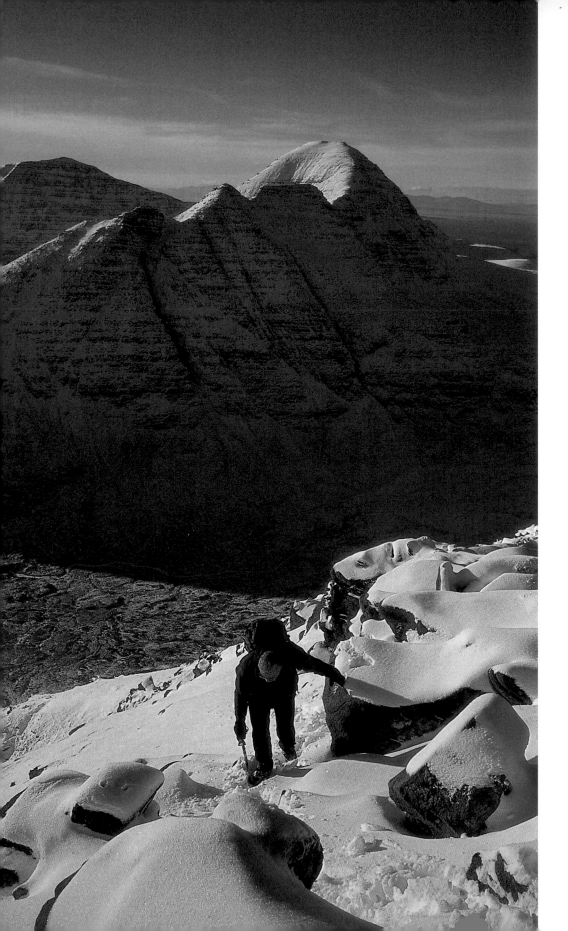

ACKNOWLEDGEMENTS

I would like to thank the many friends and acquaintances who persuaded me to put pen to paper again, and without whose help this book could not have been created. I am deeply grateful to all who have given generously of their time, and have offered encouragement. This volume is as much a credit to their own endeavours as it is to mine. I therefore acknowledge with gratitude the help and encouragement given by John Allen, Bert Barnett, Tom Binnie, David Binns, Ian Boreland, Ian Boulton, Colin Brash, Campbell Burnside, Peter Collin, Jim Convery, Paul Craven, Mike Dales, John Digney, John Donohoe, Ian Evans, Tom and Liz Forrest, Allen Fyffe, Mark Gear, Richard Gibbens, Richard Gilbert, John Gillham, Van Greaves, Don Green, Stephen Greenwood, Gordon Hadley, Roger Holme, Dane Love, Jim Maison, Ron Maguire, Eddie Martin, Dave Matthews, David May, Dave McLeod, Ian Mitchell, Martin Moar, Hugh Munro, Malcolm Nash, Lorraine Nicholson, Tom Noon, Alan O'Brien, Clarrie Pashley, John Pringle, Ruaridh Pringle, Stuart Rae, Peter Roberts, Martin Ross, Tom Rix, Iain Robertson, Derek Sime, Jon Sparks, Ralph Storer, Jim Teesdale, Ronald Turnbull, Roy Wentworth, Peter and Heather Willimot, and Richard Wood.

Page 1 Bla Bheinn, Belig and Garbh-bheinn from Applecross (*Stuart Rae*)

Page 2 Beinn Sgritheall from Sgurr an Airgid (*Mark Gear*)

Page 3 Cir Mhor and Caisteal Abhail from Goat Fell (*Derek Sime*)

A DAVID & CHARLES BOOK

First published in the UK in 2001

Text Copyright © Irvine Butterfield 2001
Paintings Copyright © Paul Craven 2001

Irvine Butterfield has asserted his right to be identified as author of this work in accordance with the Copyright, Designs and Patents Act, 1988.

A catalogue record for this book is available from the British Library.

ISBN 0 7153 1152 2

Edited by Sue Viccars
Book design by Les Dominey
and printed in Singapore
by KHL
for David & Charles
Brunel House
Newton Abbot
Devon

Left Beinn Alligin from Stuc Loch na Cabaig, Beinn Dearg (*Jim Teesdale*)

Right Ben Ledi from Dumyat (*Martin Ross*)

Page 6 Rainbow over summit of Sgorr na Diollaid (*Richard Wood*)

Page 7 The Paps of Jura from Knapdale (*Martin Ross*)

CONTENTS

INTRODUCTION

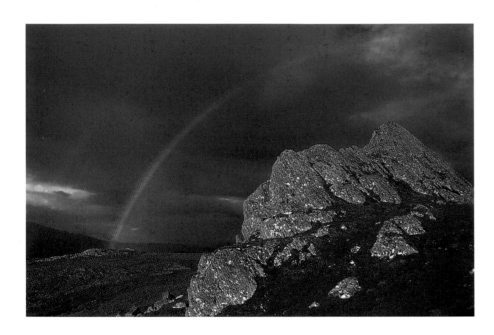

'DURING THE LAST FEW YEARS THERE HAS ARISEN AMONG some of the members of the Rucksack Club a new craze or hobby, which may be looked upon as a special form of the old passion for "peakbagging" which has long been known to mountaineers.' Thus wrote John Rooke Corbett in the *Rucksack Club Journal* of 1911. 'This hobby,' he continued, 'consists in visiting as many as possible of the English and Welsh summits which are more than 2,500ft above sea level.' Collectively these had come to be known as the 'Twenty-fives', and the list included any summit within a 50ft contour ring attaining the critical elevation.

Corbett was an indefatigable mountaineer who also turned his attentions to the Scottish peaks, becoming the fourth Munroist in 1930. He topped out on Buachaille Etive Mor completing both 'mountains' and 'tops' to become the first Englishman to complete the round. He was also busy looking at a potential list of Scottish 2,500ft peaks, choosing initially to include all tops of that height. However, realising that the list would be too exhaustive to encourage mountaineers to take up the challenge with a view to completion, he eventually listed only those mountains which were distinguished by a positive reascent on all sides. Although he did not state this clearly in his notes it became obvious upon examination of his work that he regarded a reascent in the order of 500ft as the criteria for inclusion in his list. Sadly Corbett never lived to see his list in print as a further inclusion to the publication of *Munro's Tables* of 1931.

It is this reascent of 500ft on all sides which marks out the Corbetts as most singular mountains, and it therefore comes as no surprise to find that a given peak can be but rarely linked to others by connecting ridges. It is this isolation which adds to their attraction for their summits frequently provide uninterrupted views of neighbouring peaks, be they Corbett or Munro, or belvederes for the grander panoramas of mountain, moor and loch. The lower elevations include many in areas which the Munroist never visits, several on the larger Hebridean islands. Others, though possessed of no dramatic crags, or grandeur of form, lie in parts of the Highlands whose charm relies on the remoteness of their situation. Such is their individuality and attraction, which I have chosen to think of as 'The Call of the Corbetts'.

Irvine Butterfield, Pitcairngreen, Perth

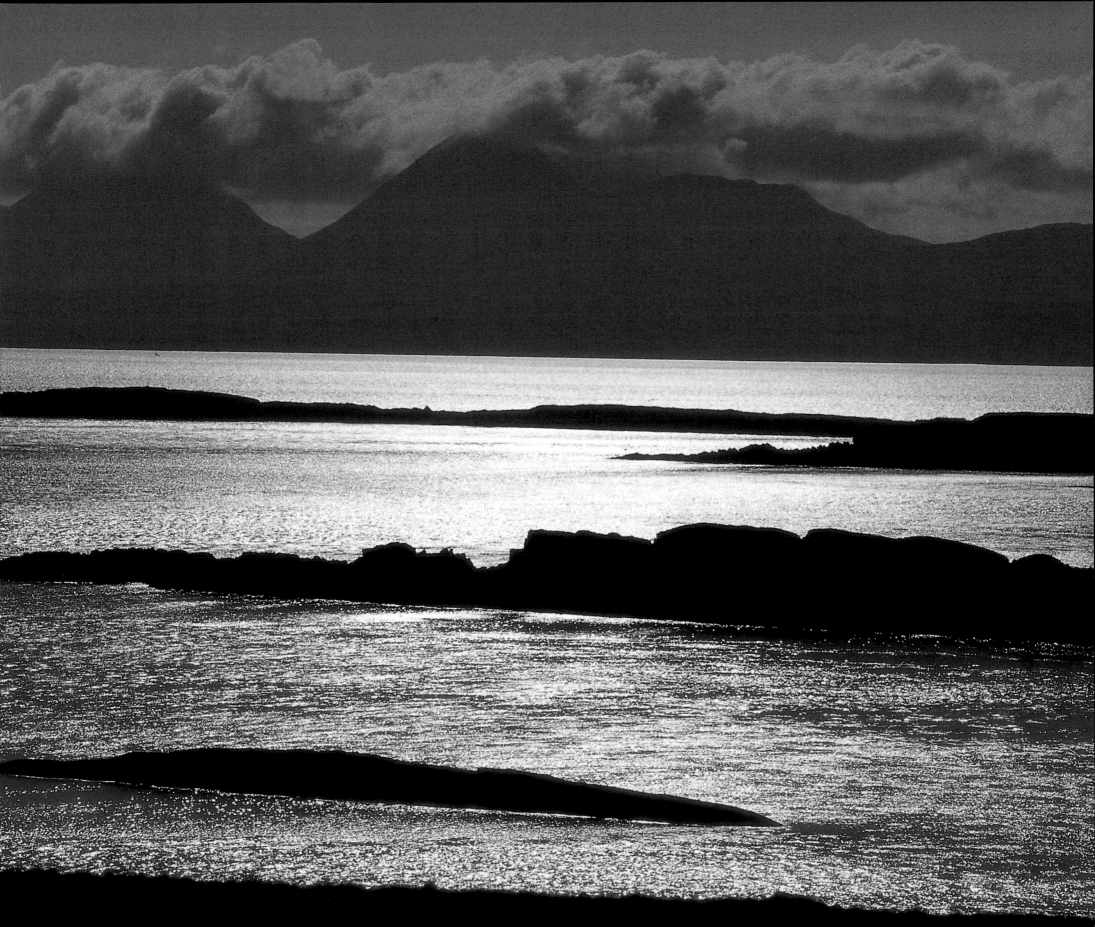

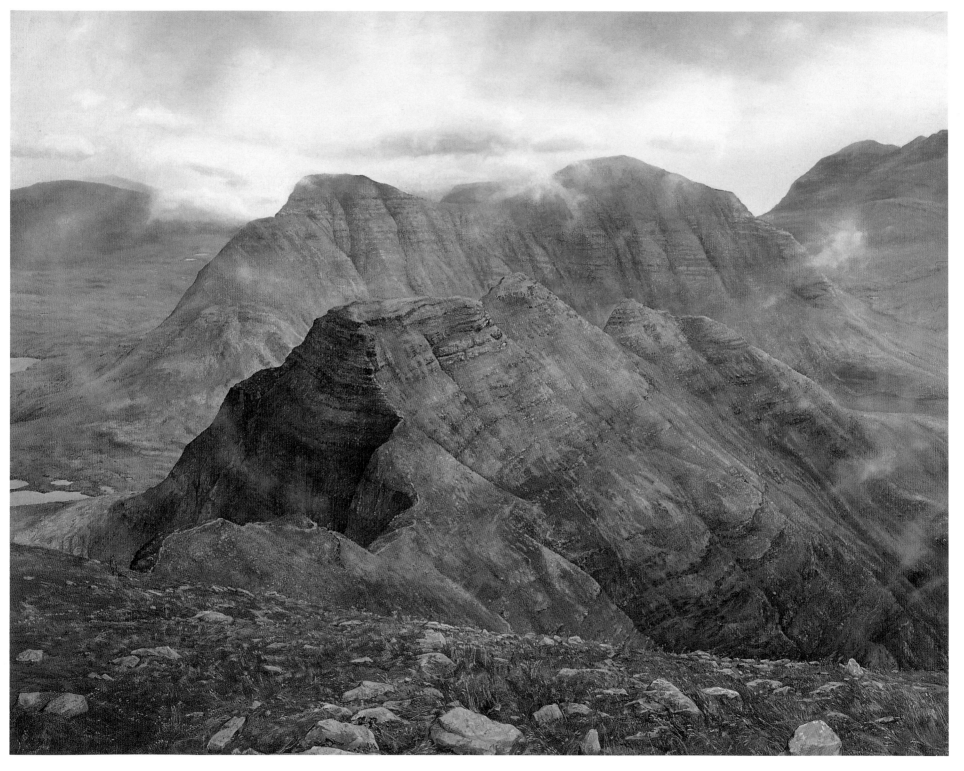

THE NORTHERN HIGHLANDS

GAUNT STACKS OF TORRIDONIAN SANDSTONE SET ON plinths of ancient gneiss stand in bold array along the western sea lochs. Distinguished by russet terraces supporting crowns of craggy coronets, their rugged grandeur is much appreciated by the hill connoiseur. In stark contrast the rounded heather hills of the interior occupy a vast solitude, reached along ancient routes probing lengthy glens where narrow roads and tracks lead to the foot of remote summits, prized for their isolation.

Left Beinn Dearg from Beinn Alligin (*Paul Craven*)

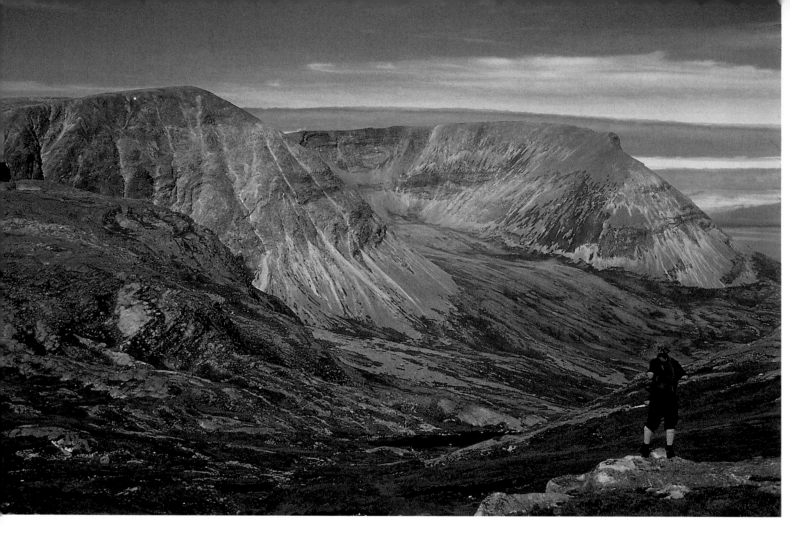

FOINAVEN

Wart mountain, or fair, or whiter, mountain

The most reliable guide as to the origin of the mountain's name is the local pronunciation as 'fionne-bheinn'. This translates as the unflattering wart mountain, supported by the observations of the Rev J.B. Johnston who noted that the mountain had 'three protuberances'.

Maps and guides appear to have misspelt the name as Foinaven to suggest 'fionn bheinn' as the original Gaelic title. Though equally descriptive, due to the abundance of white quartzite screes, the term white mountain is hardly calculated to distinguish the mountain from many others in the neighbourhood with like characteristics. A suggestion put forward by Johnson in his *Place Names of Scotland* in 1892 suggests 'fonn abhuinn', river

ARKLE

2,582ft/787m

Ark hill, the mountain of the level top, or whale rock

Lying in an area where the Gaelic and Norse names intermingle it is difficult to be specific about the origin of the mountain's name. Either the Norse 'ark-fjall', or the Gaelic–Norse 'airc-fjall', would give ark mountain, a suggestion which has the greater credibility as the silent 'fj' of fjall would render the phonetic pronunciation as 'Arkle'. The name might equally come from the Norse

'arg-fjall', hill of the shieling.

Another possibility is some form of derivation from the Norse 'orc', a whale, to be loosely interpreted as whale rock. This would not be inappropriate given the shape of the hill seen from the lower ground.

Curiously the majority of guide books tend to favour hill, or mountain, of the level top which is topographically correct given the level crown paved with great fissured slabs of quartzite.

Above Arkle from the climb to Creag Dionard (*Stephen Greenwood*)

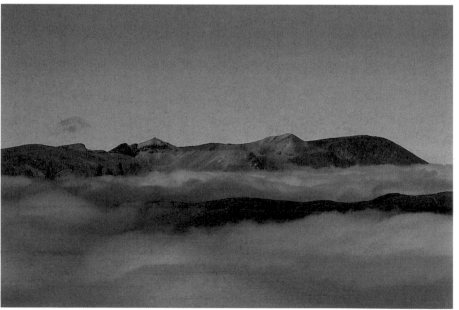

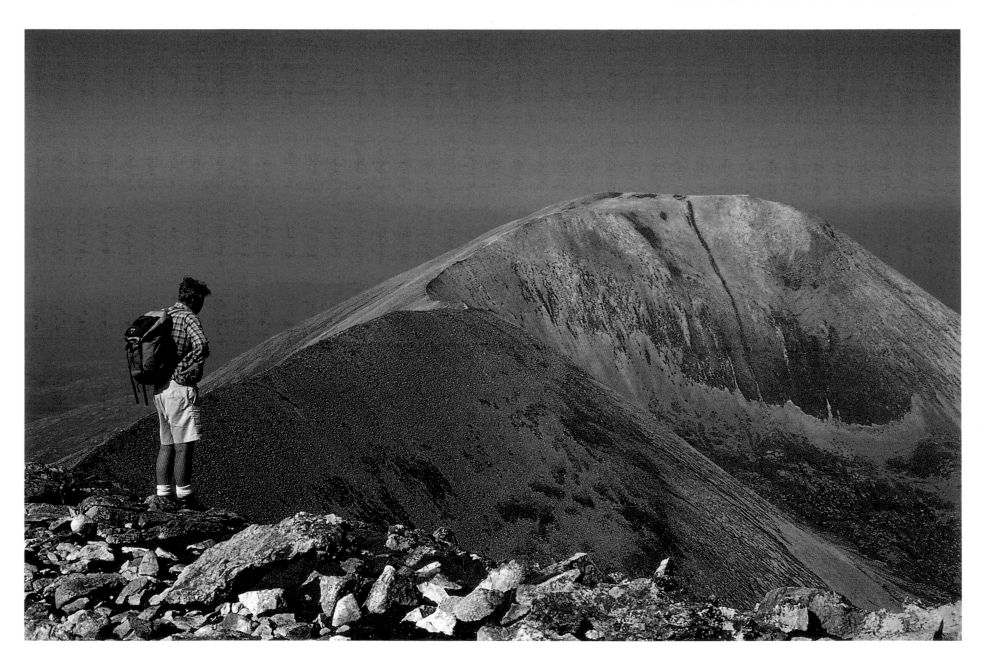

land. This seems less persuasive a theory than the others unless the maze of lochans dotting the moor round about were seen as a river, with the mountain the one sure piece of solid ground.

Left The ridge of Foinaven from the north (*Stuart Ra*e)

GANU MOR

2,999ft/914m

The great wedge, or big head

The name is a corruption of the Gaelic 'ceann mor', big head, which is an obvious reference to the great buttressed end of the mountain, which has the appearance of an inland headland.

Above Ganu Mor from Fionne Bheinn (*Tom Rix*)

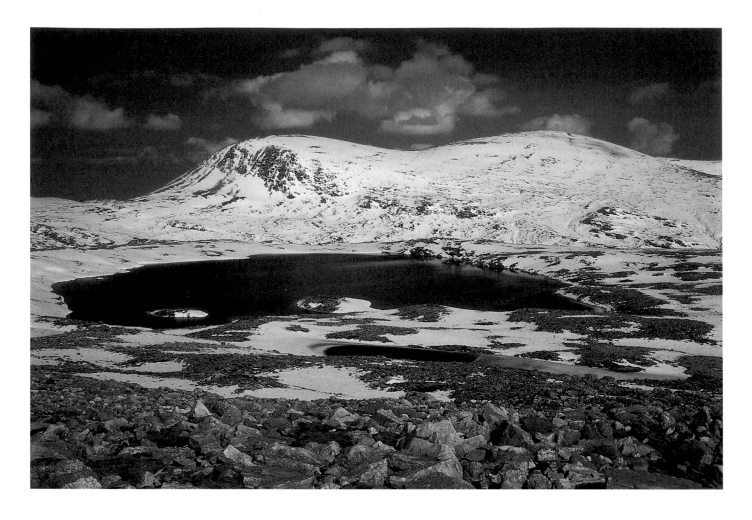

MEALL LIATH COIRE MHIC DHUGHAILL

2,628ft/801m

The grey hill of Dugald's son's (MacDougall's) corrie

This mountain has the longest name of any in the Scottish Highlands. The name MacDougall is not a local one and in all probability relates to a keeper, or visiting sportsman, who had a particular attachment to the mountain. It is difficult to visualise the mountain from the Ordnance Survey maps as it lies on the borders of three, and even on the ground the complex of ridge and spur is best appreciated from a distant height.

Right Meall Liath Coire Mhic Dhughaill from Arkle (*Tom Rix*)

MEALL HORN

2,549ft/777m

Hill of the cairn, horn, or notable bird (eagle)

Alex McBain in his *Place Names of the Highlands and Islands of Scotland* says 'horn' is simply the Norse term commonly used for hills and capes. The name 'meall' is Gaelic for a rounded hill, and here there may be a mix of Norse and Gaelic. The title could be solely Gaelic in origin were the word 'horn' a phonetic corruption of 'fhir-eoin', or 'fìor-eun', signifying that this was an area where the 'notable' or 'true' bird might be found or seen. This is the eagle, more usually represented by the Gaelic 'iolaire', of which there are many examples. The use of the word 'notable' may be significant and might perhaps refer to the sea eagle which once nested along these north-western coasts.

Even though a part of the same complex fold of mountains as Foinaven and Arkle it lacks their presence, appearing in most views as the high point of an eastern spur.

Above Meal Horn from Lochan na Faoileige (*Hugh Munro*)

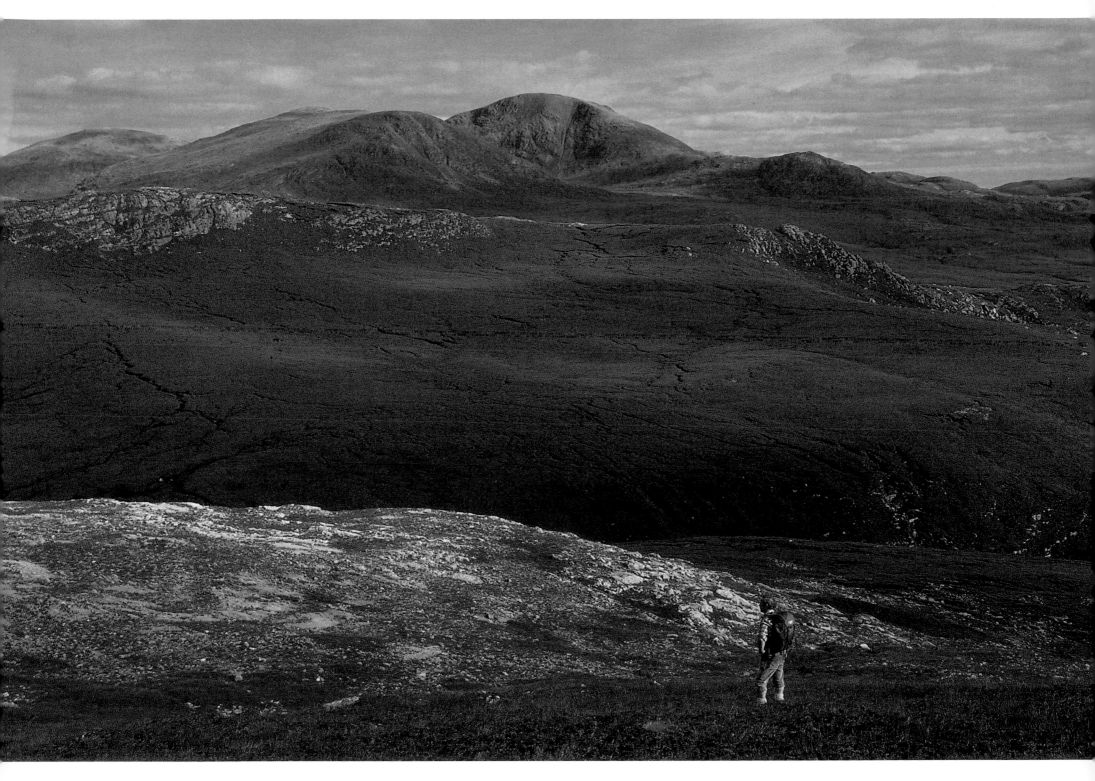

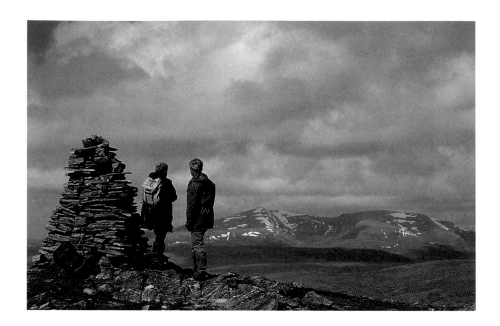

BEN HEE

2,864ft/873m

The fairies' mountain, or peaceful-looking hill

The name may stem from the Gaelic 'fiadh', a deer, though it is more probably derived from 'shith', or 'shithe', pronounced 'hee', meaning peace, or quiet, in the sense that this is a tame, peaceful-looking hill. This would be a perfect description of the mountain as seen from the road beside Loch Merkland.

Of more general currency is its link with the fairy folk. There are various spellings of the Gaelic word for fairy. 'Sithean', or 'shidh', appears in the far north, and hee is the phonetic corruption of the word. Such hills are usually conical in shape and though this mountain hardly conforms to that pattern it does provide a fine vantage looking west to the pronounced cone of Ben Stack.

Above Ben Hee from Ben Klibreck (*Stephen Greenwood*)

BEINN LEOID

2,598ft/792m

The sloping mountain, or mountain of the slope

The term slope is derived from either 'leitir' or 'leathad', a reference to the long incline to the summit from the south. The terminology used is also significant in that it is intended to convey that the slope also has breadth, as those ascending the mountain by this southern approach will be aware.

Right Beinn Leoid from Meallan a' Chuail (*Jim Teesdale*)

BEN LOYAL (BEINN LOAGHAL) – AN CAISTEAL

2,506ft/764m

Legal hill, levy hill, or leafy hill – The Castle

The shapeliness of the hill as seen from the north west had led to it being regarded with affection as the 'Queen of the Scottish mountains'.

Eminent scholars have differed as to the origins of the mountain's name. A Professor Watson argued that it was Old Norse in origin from 'laga fjall', meaning legal mountain. There was support for this in that there was a strong Norse tradition of gathering people on the hills to hear legal proclamations. Watson also used the local pronunciation of the name to substantiate his case, which might have been further supported had it been accepted that there is evidence of the Gaelic 'laghail' as a derivation of 'laga-fjall'. The Gaelic scholar Alexander McBain contested Watson's claim as he considered the name derived from 'leidh', levy, or 'lauta', leafy. The latter could be a reference to the existence of trees in the immediate area, a feature uncommon in these northern counties, but the argument lacks the confirmation of Watson's study. The spelling sometimes given is Beinn Laoghal, pronounced as loyal. This could be the Gaelic 'laogh al', meaning hind calves' rock.

There is no doubt about the title of the actual summit which is simply the castle.

Right Ben Loyal from Kyle of Tongue (*Malcolm Nash*)

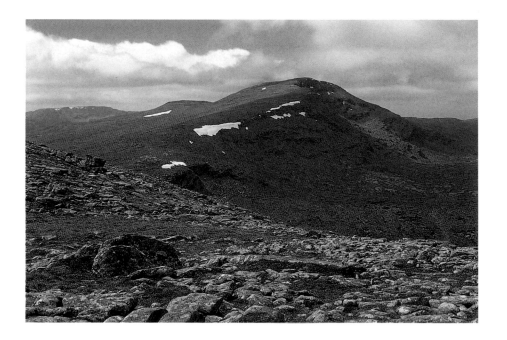

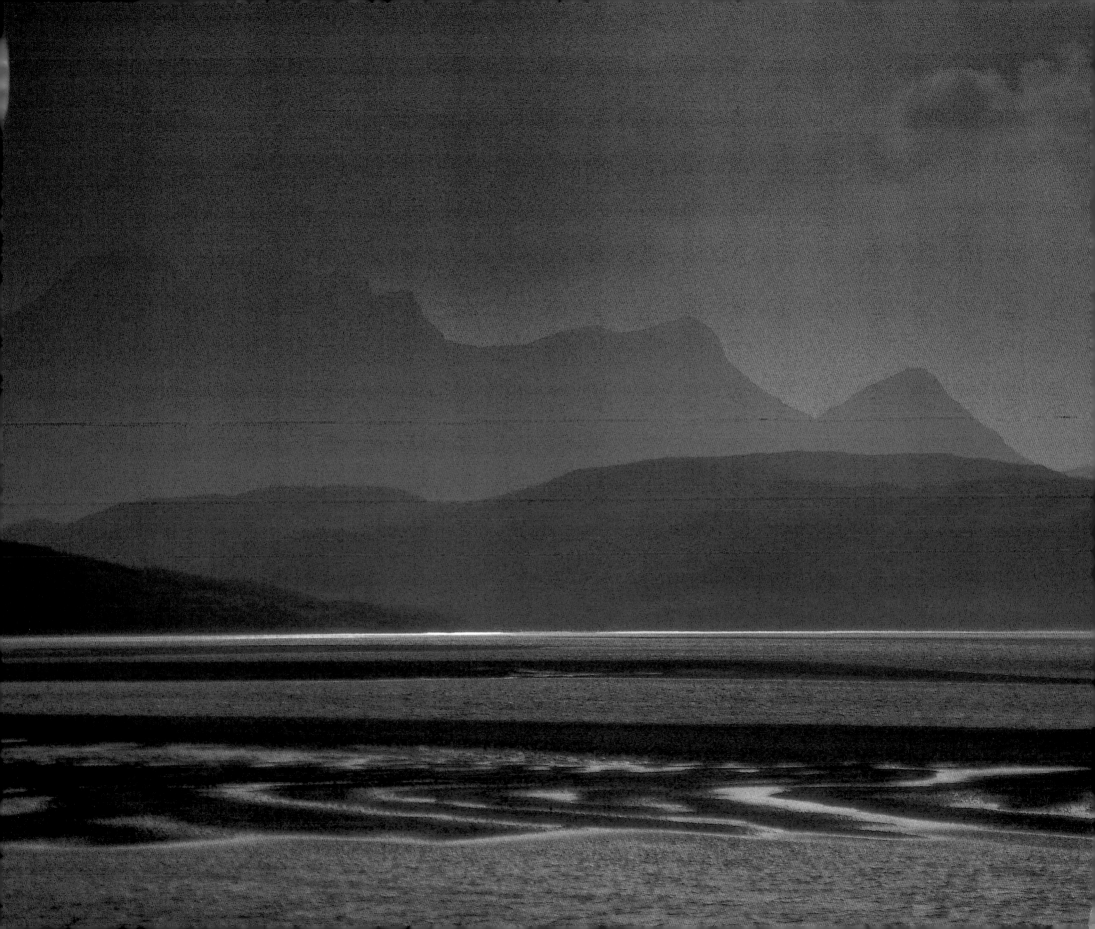

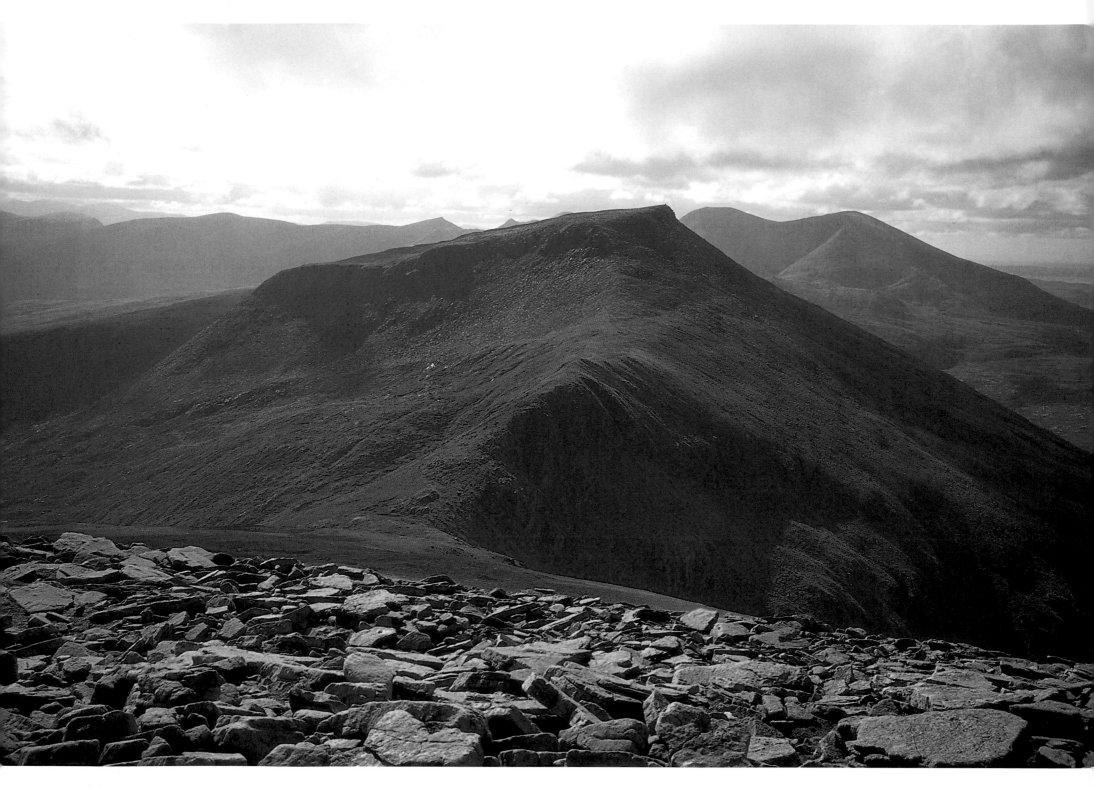

CRANSTACKIE

2,628ft/801m

Rugged hill

The latter half of the name is rooted in 'stac', or 'stacan', a steep hill or little precipice, an obvious reference to the broken cliffs on the slopes above Srath Dionard. This part of the name is descriptive. The first part 'cran' is more problematic, and could be from 'crann', a tree. In a district lacking arboreal cover, the presence and proximity of trees could be used as a means of singling out a given peak. 'Crain', pronounced cran, meaning an ugly old woman, might prove an alternative explanation if a link were established with a tale of the Cailleach Bheur of folk myth.

Left Cranstackie from Beinn Spionnaidh (*Hugh Munro*)

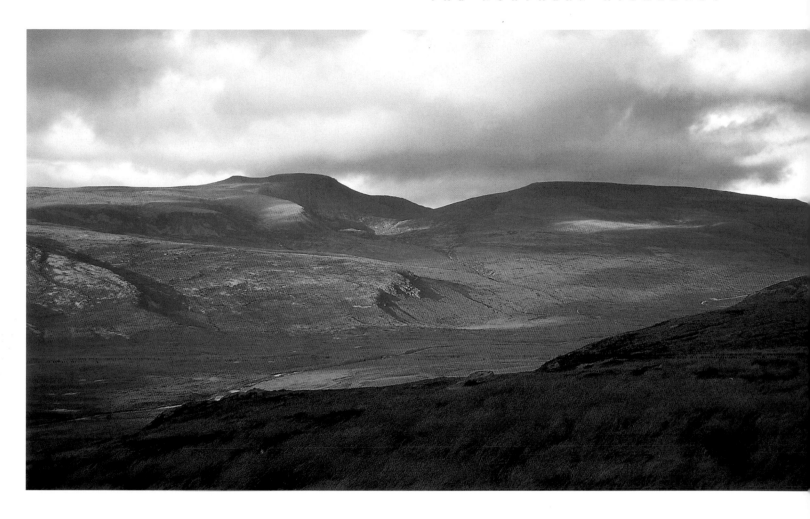

BEINN SPIONNAIDH

2,536ft/773m

The mountain of strength

The name originates in the Gaelic 'spionnadh', strength or vigour. The mountain has a strong presence as a back-cloth to the sounds of Loch Eriboll and the Kyle of Durness, and the name may have been a means of portraying this dominance.

Interestingly, the hill and neighbouring Cranstackie could be regarded as one mountain, as from eastern and western viewpoints the only visible separation is the dip at the centre of the long-backed ridge of which they both form a part. Seen from Strath Beag the sprawl of Beinn Spionnaidh's expansive slopes shows it to be pre-eminent.

Above Cranstackie and Beinn Spionnaidh from Strath Beag (*Hugh Munro*)

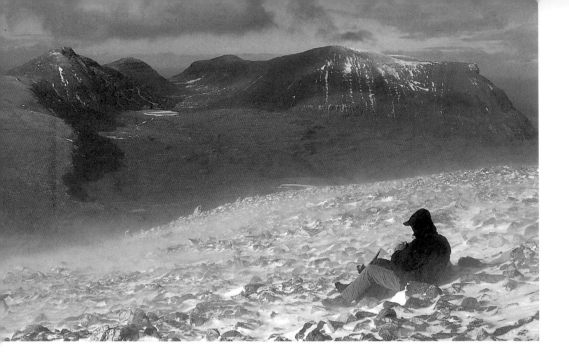

QUINAG (CUINNEAG)

The water barrel, churn, spout or bucket, or milking pail or stoup

The name either stems from its shape from which the Gaels saw it as 'cuinneag', a churn or milk pail, or from 'caoinag', a diminutive of 'caoin', meaning beautiful.
Above Quinag from Glas Bheinn (*Jim Teesdale*)

SAIL GHARBH

2,651ft/808m

The rough heel

'Sail' is a descriptive word most prevalent in the North-West Highlands and actually refers to the slopes falling away from the summit than to the summit itself. Here, the term rough may be intended to convey that, of the two terminal points of Quinag, this is the most rocky. The slopes are stonier than the twin, Sail Gorm, and with a face incised with deep gullies is rough indeed.

SAIL GORM (GHORM)

2,546ft/776m

The green, or blue, heel

Most interpretations of the name favour blue as the colour of this second rocky promontory of the mountain range. Such would indicate that this point is more readily seen from a distance, and with the flanks exposed to view from more points of the compass than its neighbour this may well explain its hue. The Gaelic 'gorm' means both green and blue, the green hue suggesting the rich grasses on which to graze cattle.
Above right Sail Gharbh and Sail Gorm from Loch Glencoul (*Hugh Munro*)
Right Looking south west from Sail Gorm – Sail Gharbh col (*David McLeod*)

SPIDEAN COINICH

2,506ft/764m

Mossy peak

It is said in an old guide book that this is the peak which gave Quinag its name as it 'stands out boldly like a water-spout'. This in Gaelic is 'cuinneag', a narrow-mouthed water bucket. As the name implies this is a shapely honed peak rich in mosses to give it a greener appearance than other summits in the range. Mossy, in Gaelic, should more correctly be spelt 'coinnich'.
Right Spidean Coinich from Sail Gharbh (*Jim Teesdale*)

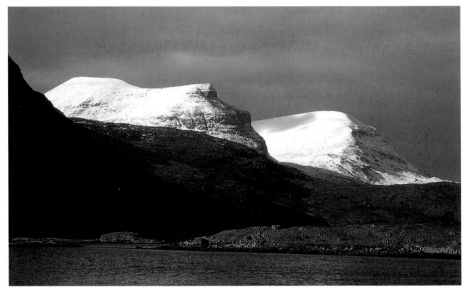

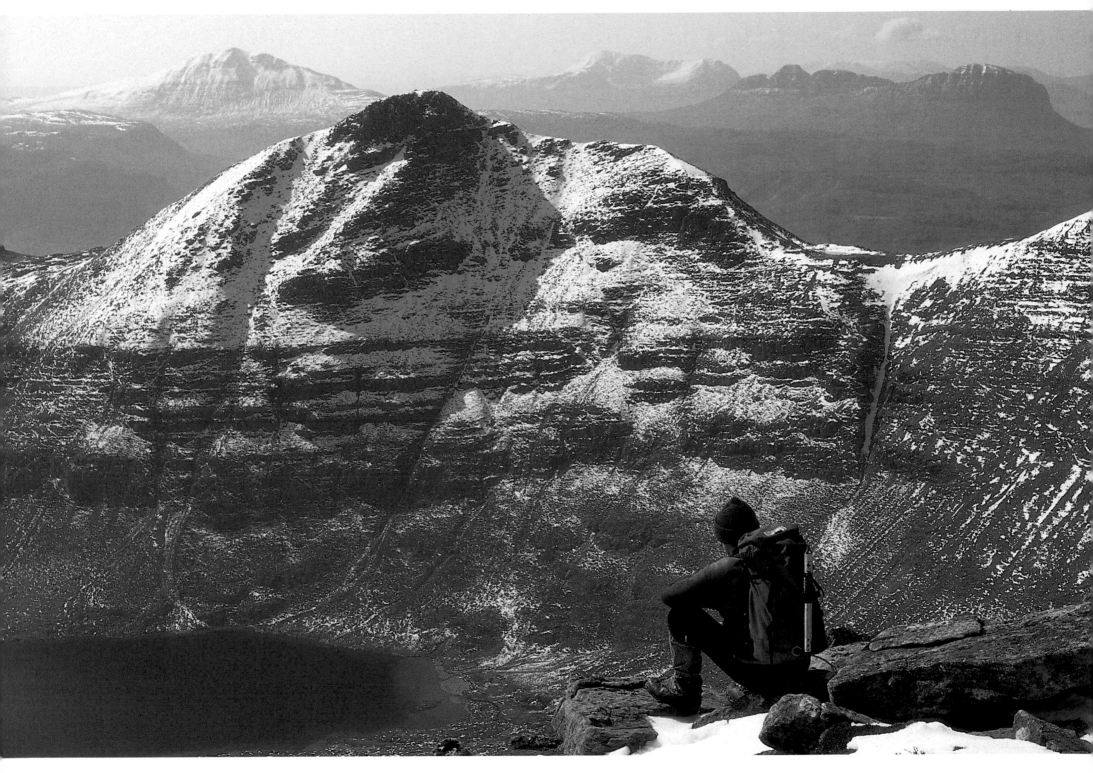

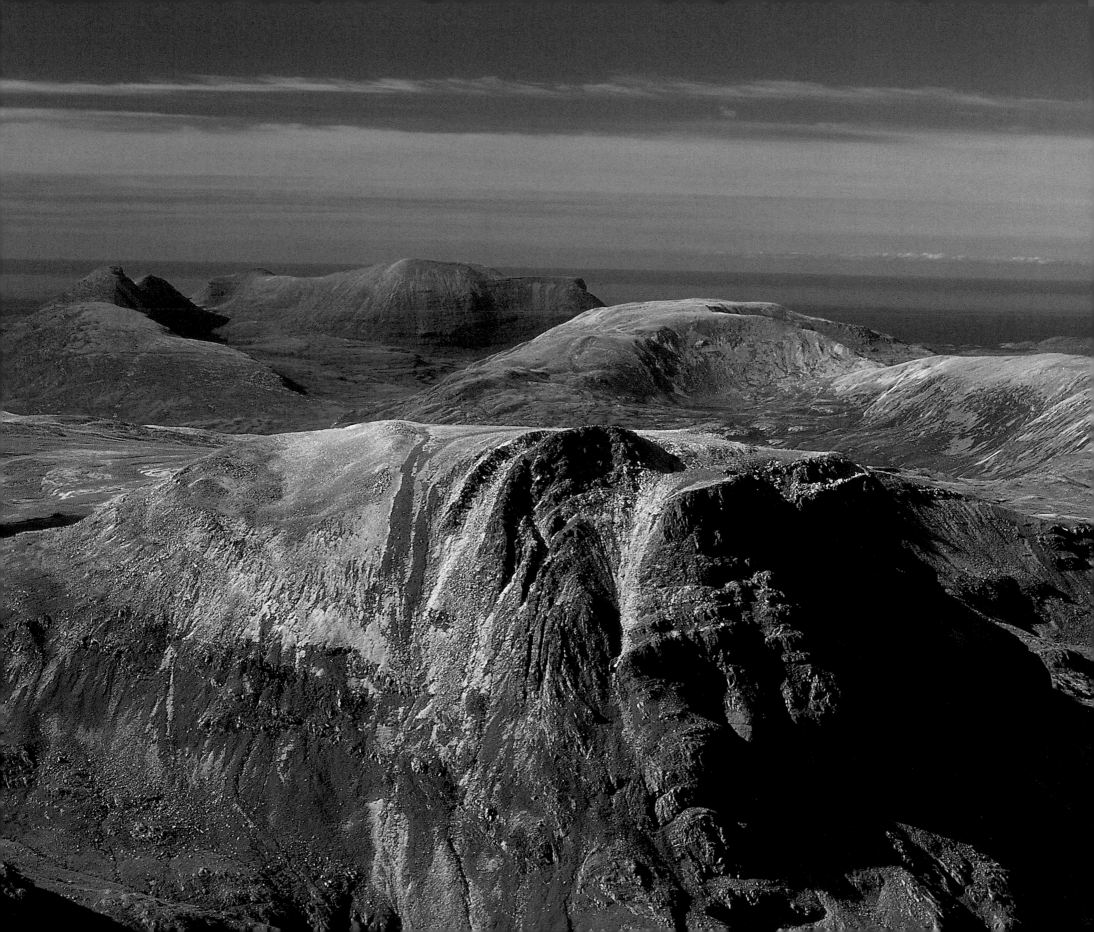

GLAS BHEINN

2,546ft/776m

The green, or grey, mountain

A mix of fine grey screes, and grass, on a western nose, with grassier slopes prevailing on a southern and eastern flank, mean that descriptive colours in the mountain's title depend upon the viewpoint from which it is seen. The green would appeal to those who wished to find the best feeding ground for their cattle and this offers the most likely explanation for the origins of the name.

The mountain's coverlet of stone suggests a structure similar to that of the higher Ben More Assynt to which it is linked by a long ridge extending across Beinn an Fhuarain. *Left* Quinag, Glas Bhein and Beinn an Fhuarain, from Ben More Assynt (*Stuart Rae*)

CANISP

2,775ft/846m

White mountain

The derivation of this mountain's name is obscure. The most probable root lies in the initial 'can', an old Gaelic word for white. This could have been a means of differentiating the peak from those close by as this is the one mountain with traces of white quartzite cliffs to be seen on its north face. It has been suggested that it could be from the Old Norse 'kenna ups' which suggests the shape of a house roof. This would be most apparent from the west along the coast near Lochinver, an area known to the Scandinavian sea raiders. Though an appropriate description, it is less convincing as place names in the district are mostly Gaelic, and the Norse were not noted for figurative descriptions. Also of note is that the hill was sometime Ben Canisp. This name is said to be derived from another old Gaelic word 'can', a lake, linked to 'easpuig', a bishop, so that the mountain could be the mountain of the bishop's lake.

Right Canisp from the east (*Van Greaves*)

BREABAG – CREAG LIATH

2,674ft/815m

Little kick, or start – Grey crag

'Breabag' is a term which when applied to a hill implies there is a cleft, which might be considered to have been caused by a sudden start. In this case the cleft appears between the northern end of the ridge, and is here separately named as Breabag Tarsuinn. This looks across the distinctive gap between the mountain and the bulkier Conival. There are several hills with names similarly spelt which have been more readily interpreted as 'braigh beag', little height. There is little doubt about the name of the summit which is a simple reference to the colour of the cliffs fringing the edge above the upper glen of the River Oykel.

Although the mountain is a part of the Ben More Assynt group of hills it can claim some affinity with the other Assynt peaks as the summit looks across to the isolated stacks of Suilven and Canisp to the south west.

Below Suilven and Canisp from Breabag (*John Donohoe*)

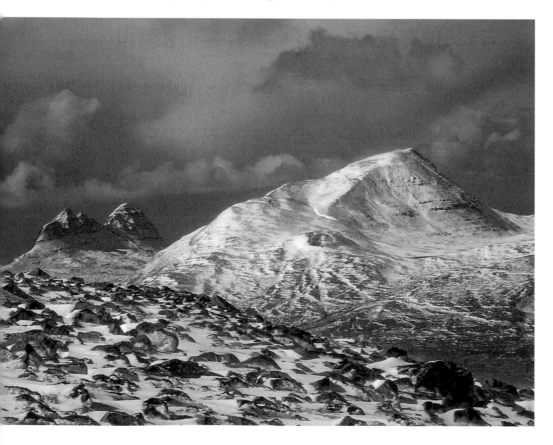

CUL MOR

2,785ft/849m

Big back

The hill name has been recorded at one time as Cuthail Mhor and its neighbour Cuthail Bheag. The latter part of the word 'cuthail' is probably the Norse 'fjall', a hill, but the first part is very obscure. Less well known, though equally significant, are two hills of like name, and proximity one to the other, which sit south of the Falls of Orrin some seven miles west of Muir of Ord.

The Norse 'kvi', a pen or fold, may provide a possible explanation of 'cul', to give pen-fell, or fold-fell.

The Gaelic 'cul' means the back of something and is the generally accepted source. This when applied to a hill denotes that it is a backdrop to either other hills, or glens. Here the mountain is a very grand backdrop to the glen around Elphin though given the proximity to the smaller Cul Beag it provides a similar foil to the lower, but equally impressive, Stac Pollaidh. The latter peak and the panoramas to north and west provide truly memorable views and the attainment of the cairn eagerly anticipated.

Right Cul Beag and Stac Pollaidh from Cul Mor (*Alan O'Brien*)

CUL BEAG

2,523ft/769m

Little back

As the smaller of two hills this mountain has, as discussed, a similar origin to its neighbour, and we are no nearer resolving what it is that this mountain is at the back of, or a backdrop to. Suffice to say that whatever it may be this peak is equal in stature and grandeur to neighbouring hills, as is well illustrated to the traveller along the road beside Lochan as Ais.

Above Cul Beag from Lochan an Ais (*Allen Fyffe*)

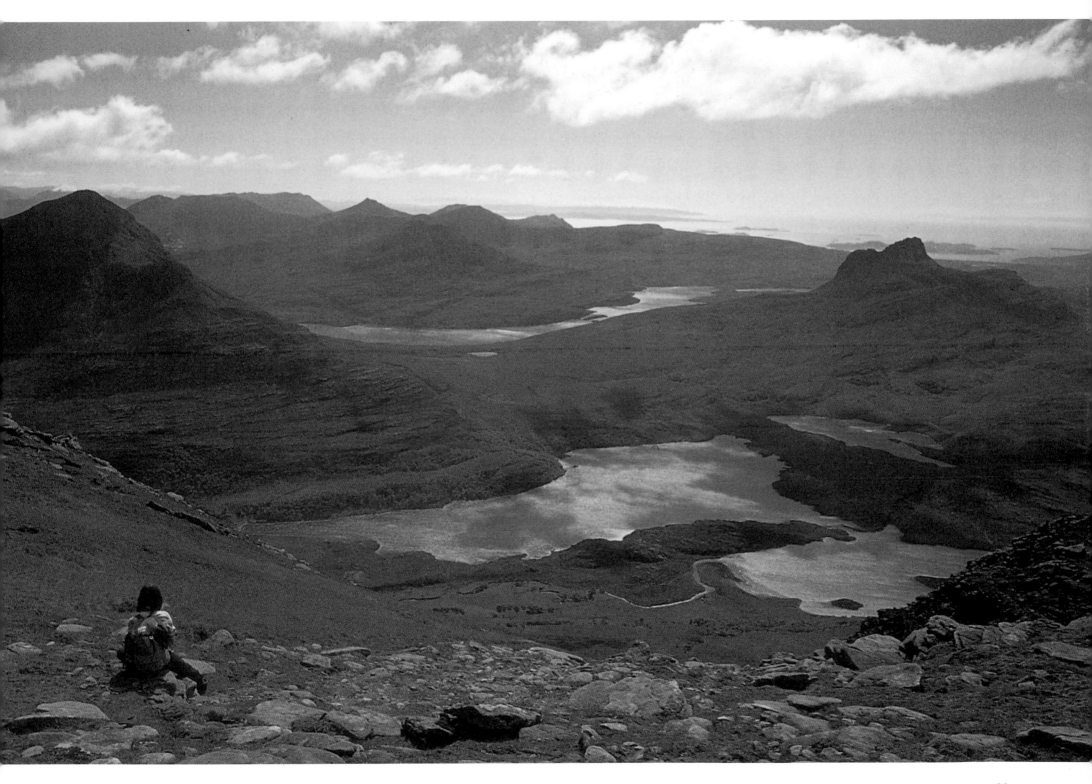

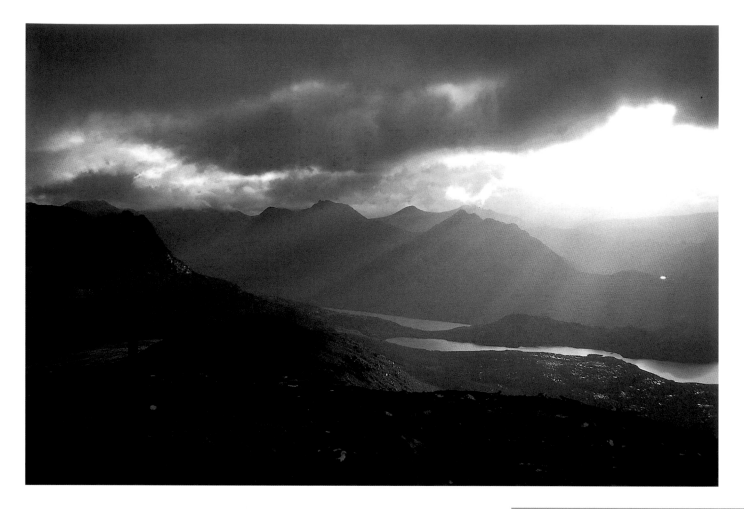

BEINN DEARG MOR

2,985ft/910m

Big red mountain

The deep blood-red of the Torridon sandstone is most in evidence on the great crags which confront those who approach from the north by way of Strath na Sealga. The mountain is big relative to its neighbour, being the larger of the two both in height and bulk. Its steep walls provide a taxing clamber to a summit cairn placed on a narrow projecting platform central to its cliff-face.

The classic approach to the mountain is from the north by way of Shenavall, its steep walls a constant invitation to the bold to seek one of the finest belvederes on any Scottish mountain.

Right Beinn Dearg Mor from Shenavall (*Alan O'Brien*)

Below The summit, Beinn Dearg Mor (*Alan O'Brien*)

SAIL MHOR

2,516ft/767m

The big heel

The name is a simple expression of the mountain's form, 'sail', a heel, used here to indicate a slope falling from a height which lies at the end of a chain of peaks. A look at the map shows that this is the terminal high point of a long ridge stretching out from the great bulk of An Teallach, an association which becomes clearer once the summit is attained.

Beyond Loch na Sealga to the south lie the Fisherfield Forest hills, which caught in the shafts of sunlight appear brooding and remote from this sentinel on the periphery of their vast domain.

Above Beinn Dearg Mor and Beinn Dearg Bheag from Sail Mhor (*Hugh Munro*)

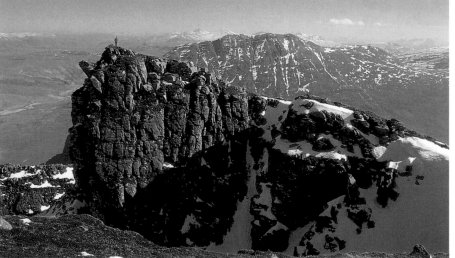

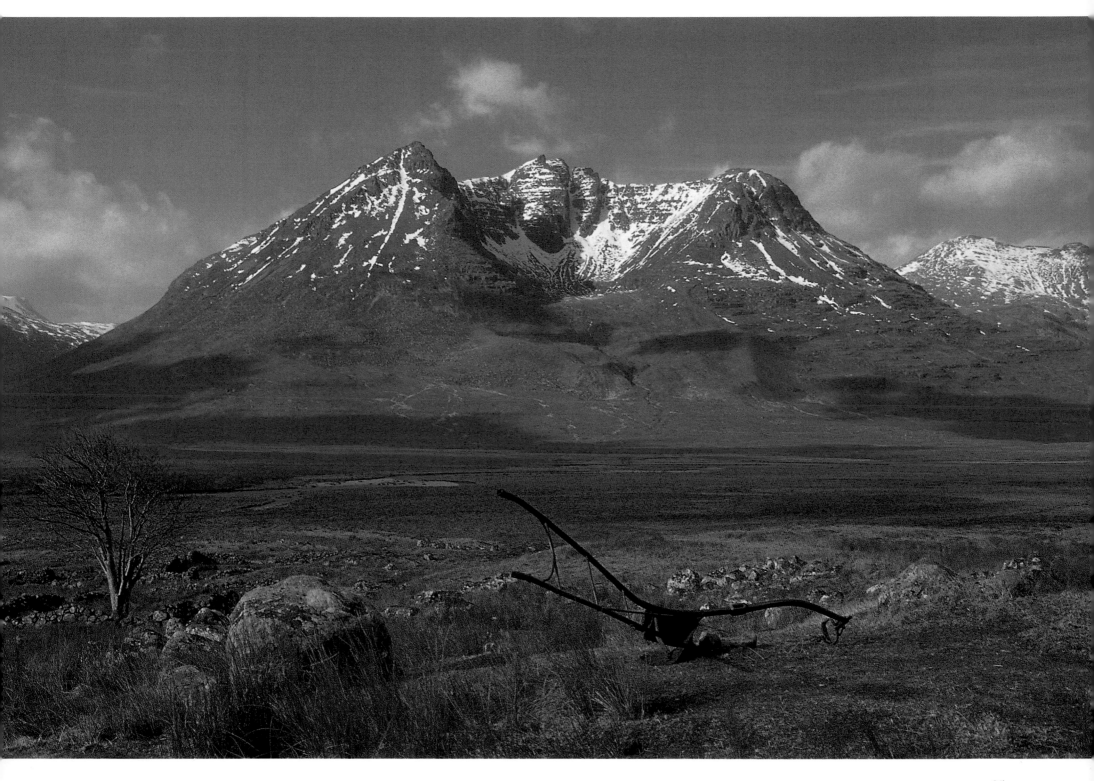

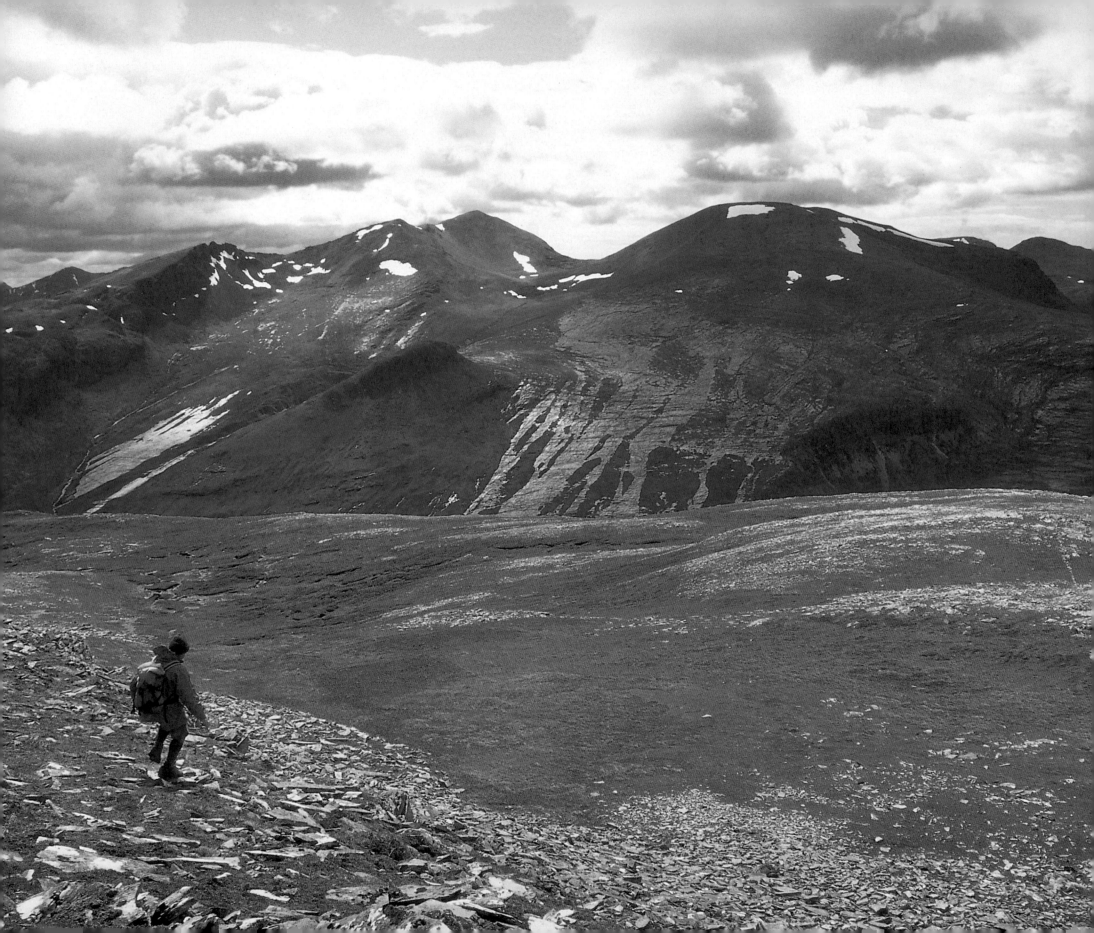

CREAG RAINICH

2,648ft/807m

Ferny (bracken) crag

The crags are to be found on the slope above Loch an Nid and its draining stream. These would be familiar to the people who once lived under this western slope of the mountain and it seems most probable that they gave the mountain its simple descriptive title. As an isolated peak its summit affords clear views along the deep fold of Abhainn Loch an Nid to the spires of An Teallach, and across the glen to the scoured white slabs of Sgurr Ban. *Left* Mullach Coire Mhic Fhearchair and Sgurr Ban from Creag Rainich (*Jim Teesdale*)

BEINN DEARG BHEAG

2,684ft/818m

Small red mountain

The smaller of the twin peaks which overlook the moating trench of Loch na Sealga, this mountain, like its higher companion, takes its name from the colour of the rock. This is much in evidence on the small castellations of the summit ridge which give an entertaining approach to the cairn.

Right above Loch Ghiubhsachain from Beinn Dearg Bheag (*Alan O'Brien*)

BEINN A' CHAISGEIN MOR

2,808ft/856m

The big hill of the tuft, or the big forbidding hill

Although the name is said to mean the big forbidding hill, books of reference, which have actually given a meaning to its name, have failed to reveal the source of the contentious word 'chaisgein'. Any interpretation put upon the spelling of the Ordnance Survey must also apply to the smaller Beinn a' Chaisgein Bheag, above the lower reaches of Fionn Loch. The root of 'chaisgein' may be 'ceasg', a tuft, in the sense that the hill is covered in rough grass, though this does little to explain a forbidding aspect. The local pronunciation, 'caarshgan', suggests that the derivation lies elsewhere. There is a ruined shepherd's cottage at the northern end of Fionn Loch which goes by the name Feith a' Chaisgein. 'Feith' is a term applied to areas of wet or boggy ground and easily explained. A possible clue lies in the word ending of 'chaisgein' which can indicate that the name used is a nickname. Here it could be that of the shepherd whose character was such that the names of the hills on his hirsel took their title from him.

Right below Beinn a' Chaisgein Mor from Beinn Lair (*Tom Rix*)

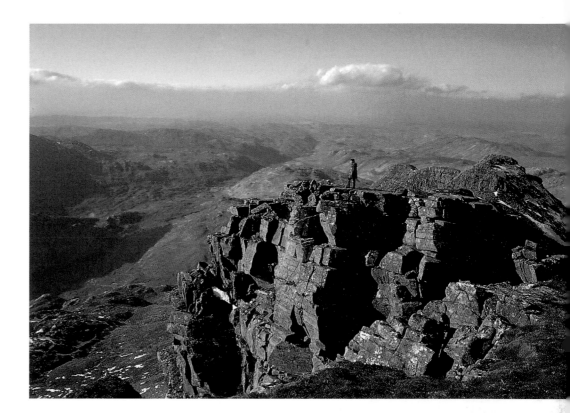

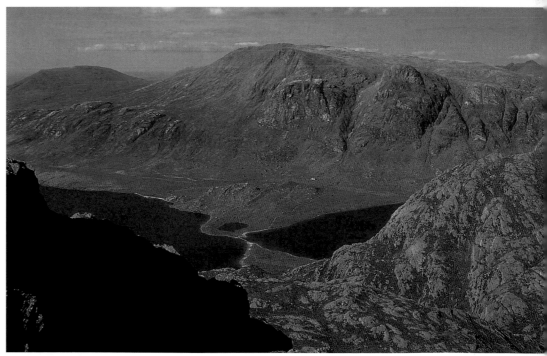

BEINN LAIR

2,818ft/859m

The mountain of the mare

This mountain should be seen in the same light as Ardlair, a promontory further to the north west which juts into Loch Maree. Off the point there are two rocks called 'An Lair', the mare, and 'An Searrach', the foal. This sets the scene for Beinn Lair as mare-hill.

The mountain is best known for the mile-long face of cliffs which buttress a northern slope above the trough of Gleann Tulacha, a sight reserved only to those who venture into the wilds of the Letterewe Forest.

Right North face of Beinn Lair and Gleann Tulacha (*Stuart Rae*)

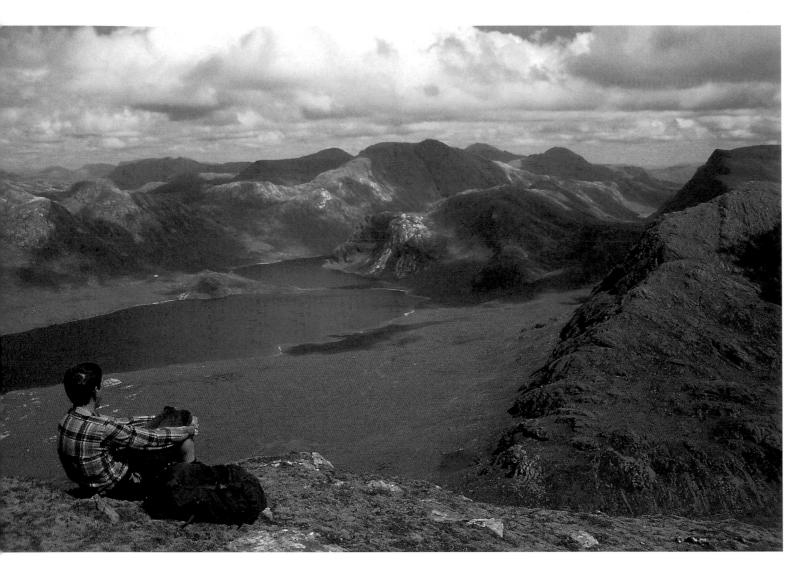

BEINN AIRIGH CHARR

2,595ft/791m

The mountain of the bogland shieling, or hill of the shieling of the projecting rock, or rock-shelf

This particular hill has strong associations with the practice of transhumance when, in summer, the young girls took the cattle to the summer pastures in the mountains. The old shielings beside Loch an Doire Crionaich are overshadowed by extensive cliffs buttressing this northern slope of the mountain. Detached from this face is Martha's Peak, which commemorates one of the young cowherds who is said to have been the first recorded person to traverse its gaunt tower. Unfortunately she dropped her crook and when attempting to retrieve it fell to her death. This story lends support to the connection with a projecting rock in the lesser known of the two titles offered.

Above A'Mhaighdean and Fionn Loch from Beinn Airigh Charr (*Don Green*)

SGURR A' MHUILINN

2,884ft/879m

The peak of the mill

Anciently spelt Scuir Vuillin, a corruption of 'sgor a' mhuilinn', rock of the mill. The presence of a settlement called Milton at the eastern foot of the mountain is significant as this provides a connection, suggesting that in times past a small mill for the grinding of corn operated in that locality, and that the water to drive the wheel was drawn from the Allt Bail a' Mhuilinn, which enters the River Meig under the name of the Allt Mor.

Though the mountain is more closely associated with Strath Conon the finest appreciation of its form is as a backdrop to the wider Strath Bran to the north. *Left* Sgurr a' Mhuilinn from Loch a' Chroisg (*Irvine Butterfield*)

MEALLAN NAN UAN

2756ft/840m

Little hill of the lambs

The introduction of sheep in great numbers did not occur until the nineteenth century when many glens were cleared of people to provide sheep runs for the Cheviots, which were not a breed suited to the wetter hills of the Highlands. This hill bears one of the few names associated with that animal and the specific mention of lambs suggests that this was a hill where the young stock tended by the native Gaels were fattened. *Below* Sgurr a' Ghlas Leathaid from Meallan nan Uan (*Richard Wood*)

BAC AN EICH

2,785ft/849m

Bank of the horse

'Bac' probably derives from the Old Norse 'bakkr', examples of which occur in isolated places in the west and the Hebrides visited, and settled, by the Scandinavian sea raiders. This example is therefore unusual in its location in the interior of the country at some distance from the nearest sea loch. Horses were of some importance to the economy of the Gaels and ran free, so that here the presence of good grass would provide suitable grazing.

Right Bac an Eich from Meall na Faochaig (*Jim Teesdale*)

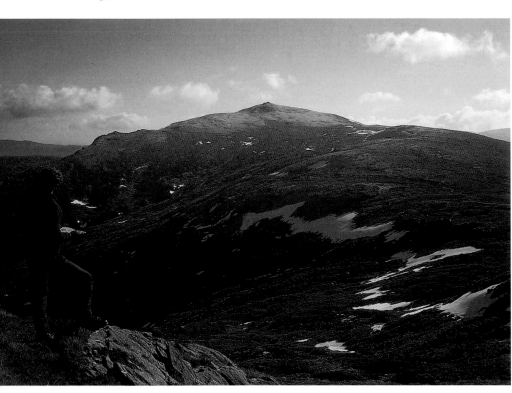

AN SIDHEAN

2,670ft/814m

Fairy hill

This is one of several mountains connected with the fairies though its particular relevance to their presence in this lonely glen is lost in the mists of time. Most of the fairy hills tend to be conical in shape, though in this particular case this may not be immediately obvious on perusal of the map. On the ground observation suggests that whoever named the hill would have most likely been resident in the glens to north or south.

Left Bac an Eich from An Sidhean (*Mark Gear*)

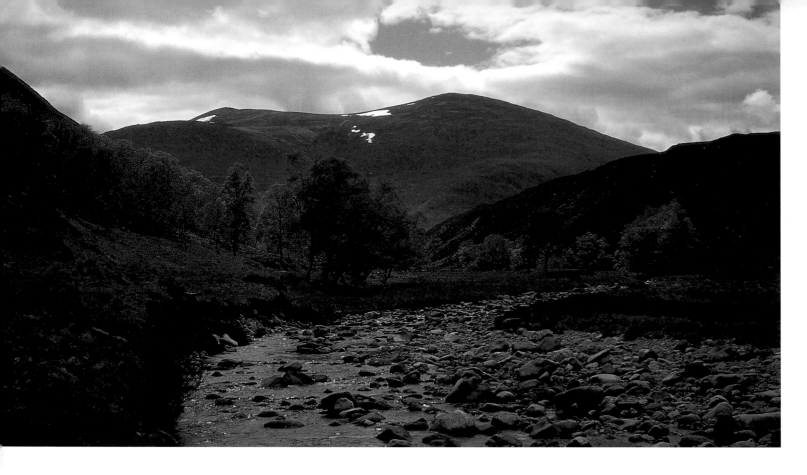

BEINN ENAIGLAIR

2,917ft/889m

The mountain of the timid or fearful birds, or brow cliff

The name usually suggested is said to come from 'eun', a bird, or 'eagal', fear or dread. Quite why the timidity of the birds on this hill merited such attention is not easily explained, and the origins of the name might be better understood by looking elsewhere. The location is close to Loch Broom, known to Norse seafarers. The Old Norse 'enni-klett', brow cliff, is an apt description as small bands of crag are to be found on the seaward face a short distance below the bouldery summit.

The mountain's situation provides an incentive to visit the cairn, a place to linger and appreciate the views.

Right Loch Broom and Ben Mor Coigach from Beinn Enaiglair (*Jim Teesdale*)

CARN CHUINNEAG

2,749ft/838m

The hill of the cairn of the churn, or buckets (milk pail)

The peak's shape, which the local inhabitants likened to an upturned pail, or churn, probably accounts for the name. It otherwise appears to the unimaginative as a rather bland rolling hill, and not unlike the many similar heathery hills above the adjoining glens. Fortunately, identification of the mountain is made easier as the entrance to its lonely sanctuary is by way of a track along Glen Calvie which leads directly to the mountain's foot.

Above Carn Chuinneag from Glen Calvie (*Peter Collin*)

CARN BAN

2,772ft/845m

The white hill, or cairn

'Ban' is the most common of the Gaelic words signifying something white, or light in colour. Here the colour might be that of the exposed schists in the mountain's rocky couloirs or from the bald pate of bleached grasses. These might seem of small account to the mountaineer preoccupied with the long approach to the cairn, for the mountain is one of the most isolated in Corbett's list. There are few other hills which enjoy so wide a view of the Coigach and Assynt hills which from this remove appear as a frieze on the distant horizon.

Below Carn Ban looking to the Assynt and Coigach hills (*Peter Collin*)

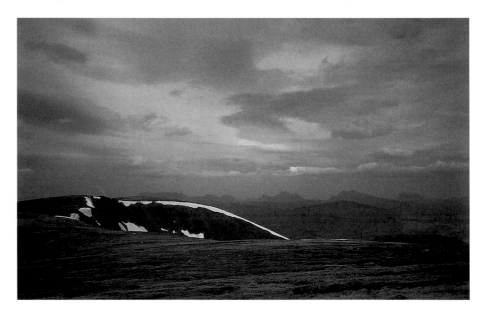

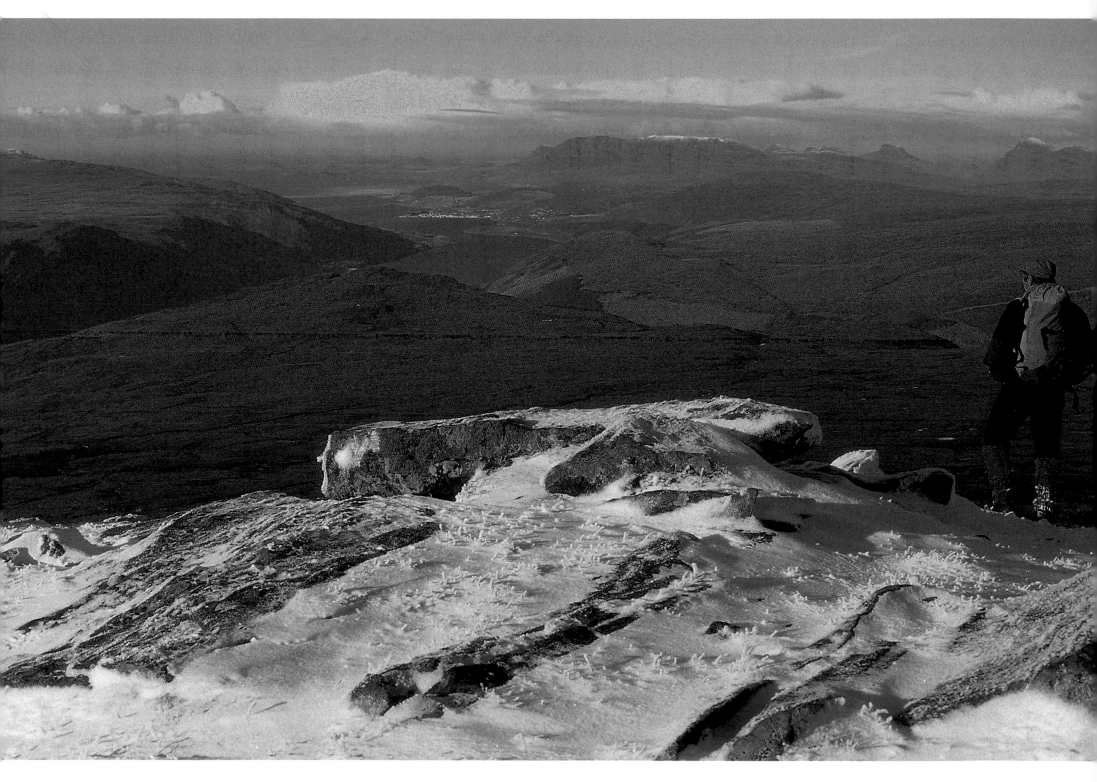

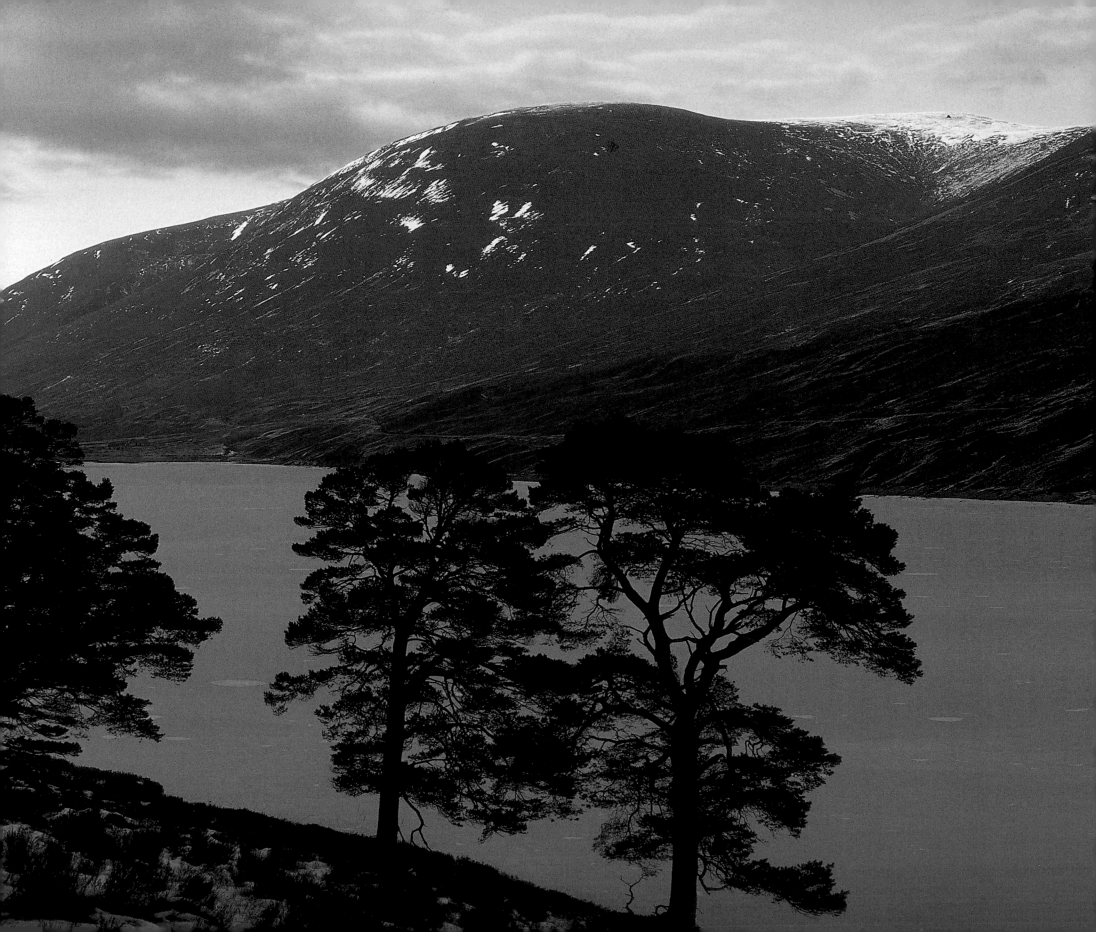

BEINN A' CHAISTEIL

2,582ft/787m

Castle mountain

One would expect there to be rocks to provide defences for a mountain thought to be castle-like but, in this, the mountain disappoints. Such fortifications as it can muster, and worthy of the name, must relate to lower ramparts of steep heather which present a bold front to Strath Vaich. As a fortress it is also defended on this side by the moat of Loch Vaich.

Left Beinn a' Chaisteil and Loch Vaich (*Jim Teesdale*)

BEINN LIATH MHOR A' GHIUBHAIS LI

2,513ft/766m

Big grey hill of the colourful pines

The broad sweep of this hill's green slope, liberally speckled with grey stone, provides the element of the big grey hill, but gone are the colourful pines for which the small regimented stands of today's plantations are a poor substitute.

Above Beinn Liath Mhor a' Ghiubhais Li from Loch Glascarnoch (*Jim Teesdale*)

LITTLE WYVIS

2,506ft/764m

Little noble mountain, or small awesome hill

The derivation is akin to that of the higher Ben Wyvis. This most probably comes from the now-obsolete Gaelic 'fhathais', a great quantity. Alternatively this could be 'beinn uais', a high hill, in that this is derived from 'uas-al', meaning high in the sense that it is noble in appearance. The smaller hill is a lesser mirror image of its mightier neighbour, and still possesses the same great flank exposed to the road along the glen to the south.

This mountain attracted little interest until it entered the lists in 1980 and it is easy to see why its bland hump bedecked with trees inspired so little interest. As with so many other hills of like appearance the best aspect is the view.

Right Little Wyvis from Ben Wyvis (*Alan O'Brien*)

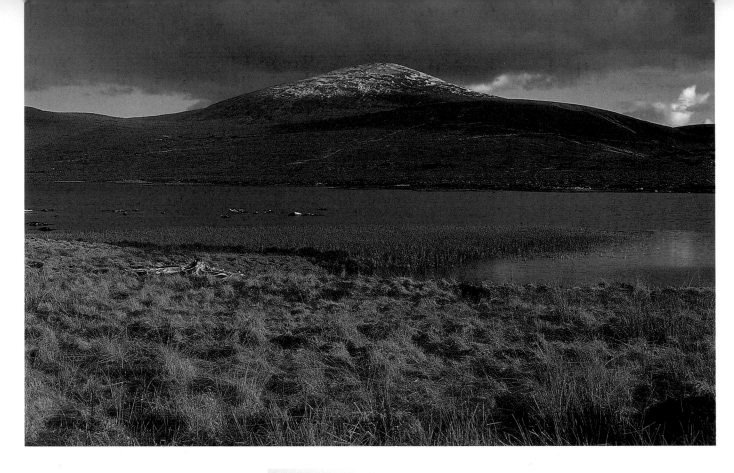

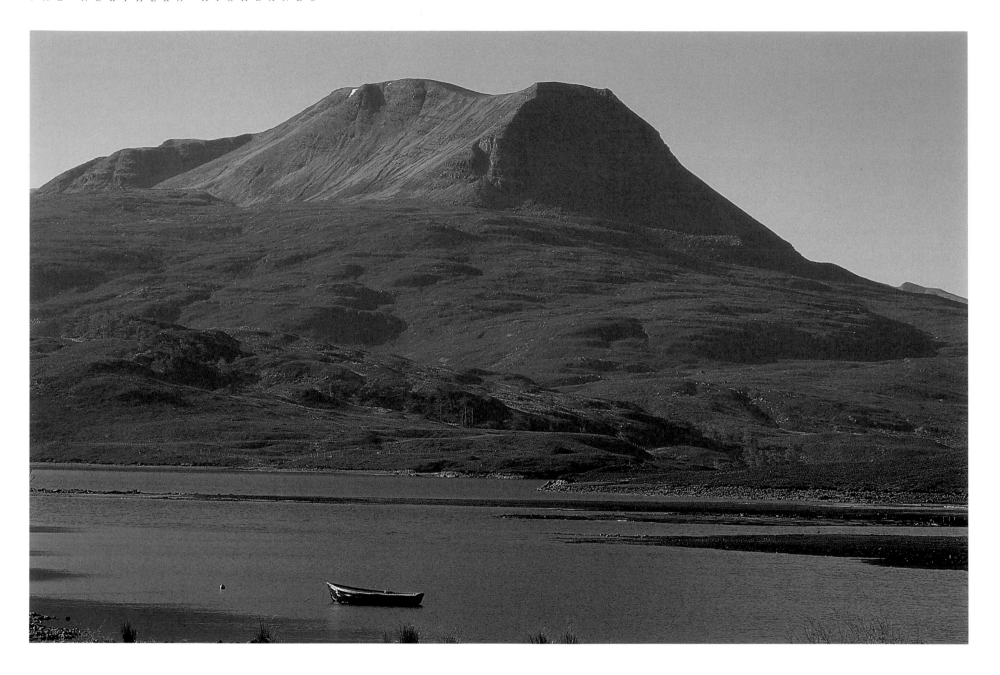

BAOSBHEINN (SGORR DUBH)

2,871ft/875m

Mountain of the face, the wizard's mountain, or mountain of the wicked person, witch or fury – Black peak

This mountain is most often associated with a wizard. This from the Gaelic 'baobh', though strictly speaking this word signifies a wicked person, witch or fury. 'Fiosaiche' is the more usual word for wizard, and can also mean a soothsayer, or man of knowledge. A possibility lies in an origin in the Norse 'beidhis-fjall' meaning hunting hill, with the Norse 'fjall' translated later to the Gaelic 'bheinn'.

Locally the peak is referred to as the mountain of the face. By way of explanation it is pointed out that the early morning light catching the craggy end of the ridge facing towards Gairloch

sometimes suggests the form of a human head. This is supported by older spellings of the name as 'bus-bheinn', which comes from the Gaelic 'badhais-bhinn', or 'baoghais-bhinn', derivations of 'bathais' to give forehead hill. Thus the likeness to a human face seems well established.
Left Baosbheinn from Loch Bad an Sgalaig (*David May*)

BEINN AN EOIN

2,805ft/855m

Mountain of the bird

The nature of the bird is not indicated but it is unlikely to have been the eagle as this is usually accorded special status by use of the Gaelic 'iolaire'. This suggests that this was a hill rich in birdlife, either as a breeding ground or where wildfowl were plentiful. It is a fairly common name for a hill.

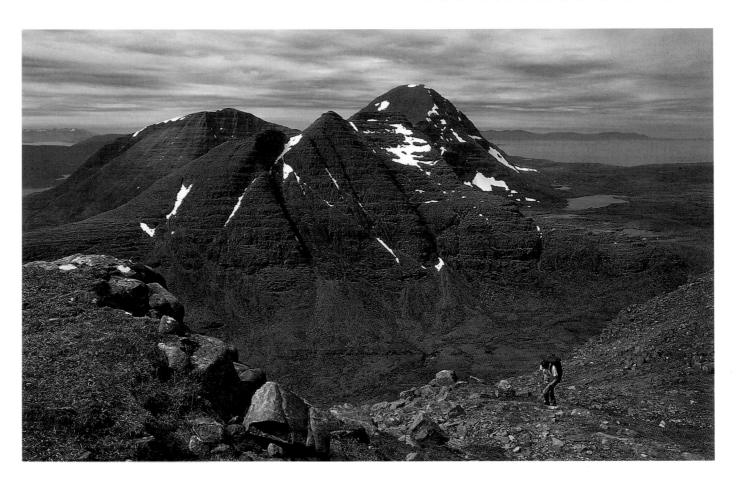

BEINN DEARG

2,999ft/914m

Red mountain

This is one of several red mountains. Some take their name from the russet heather and some from the colour of the rocks from which they are cast. The red here is the blood-red of the sandstone which at sunset glows with a hint of crimson.

As the mountain at the heart of the Torridon giants it provides a unique viewpoint looking to the heart of Liathach's northern corries, an unusual perspective of Beinn Alligin, and across the watery wastes of the Flowerdale Forest.

Above Beinn Alligin from Beinn Dearg (*Jim Teesdale*)

Left The ridge of Beinn an Eoin (*Lorraine Nicholson*)

SGORR NAN LOCHAN UAINE

2,857ft/871m

Peak of the green lochs

The green lochs take their name from their colour which comes from an algae present in the water. They lie in cups scraped from the underlying rock-shelf and, as the high point closest to them, this proximity was an obvious means of identifying this peak. The lochs also have char in them, a remnant fish species from the Ice Age.

Right Sgorr nan Lochain Uaine from Beinn Liath Mhor (*Clarrie Pashley*)

MEALL A' GHIUBHAIS

2,910ft/887m

Hill of the pine tree

It is pleasing to be able to record that this hill still maintains a link with the pines from which it took its name. The trees are true Scots pines, the progenitors of which stood on the hillslopes at a time when the people hereabouts gave the mountain title.

The provision of a convenient path to the upper reaches of this mountain places the summit within the ability of most walkers staying at Kinlochewe. The large summit cairn bears witness to its status as a favoured belvedere for it enjoys superb views along the length of Loch Maree.

Above Loch Maree from Meall a' Ghiubhais (*Jim Teesdale*)

RUADH-STAC BEAG

2,839ft/896m

Little red peak, or small red conical hill

This outlier of the Beinn Eighe ridge is the smaller of the two, and like the main peak of the range bears a similar title. As with its bigger counterpart it takes its name from the great tiered buttresses of Torridon sandstone which form the bedrock of its towering stack.

Right Ruadh-stac Beag from Beinn Eighe (*Clarrie Pashley*)

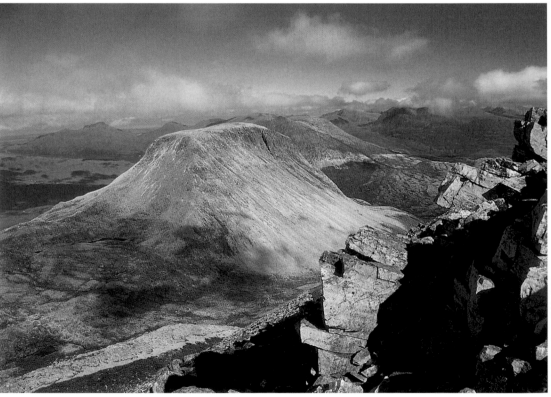

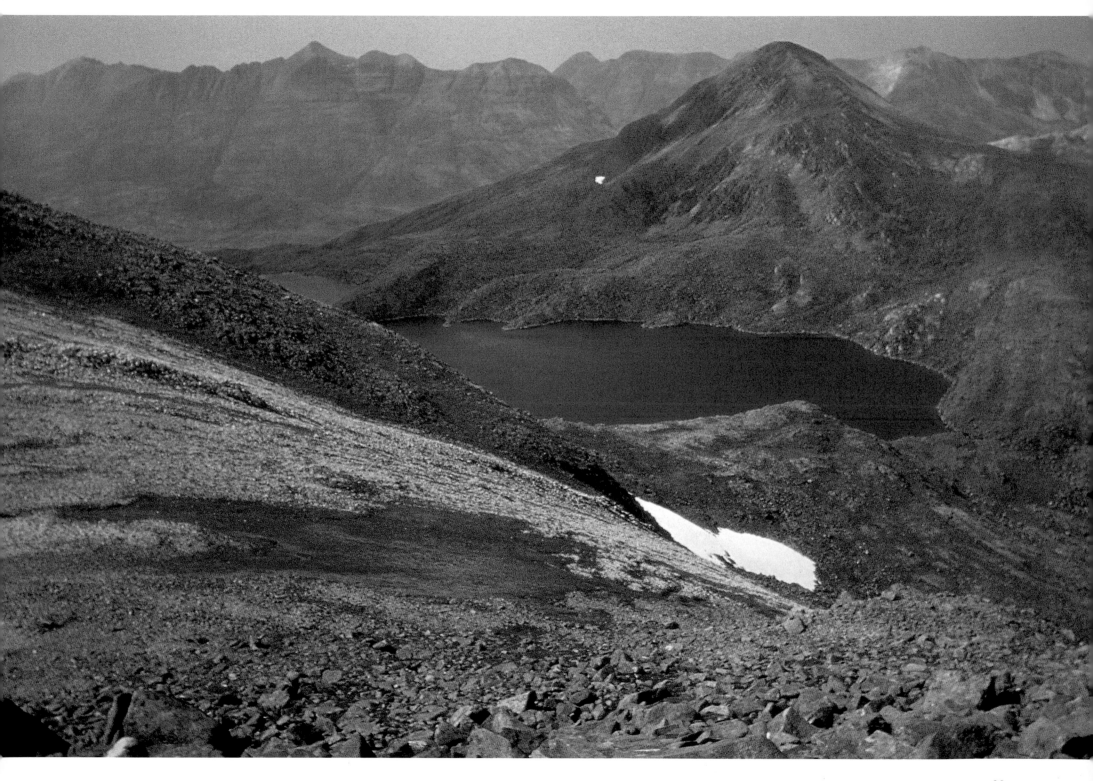

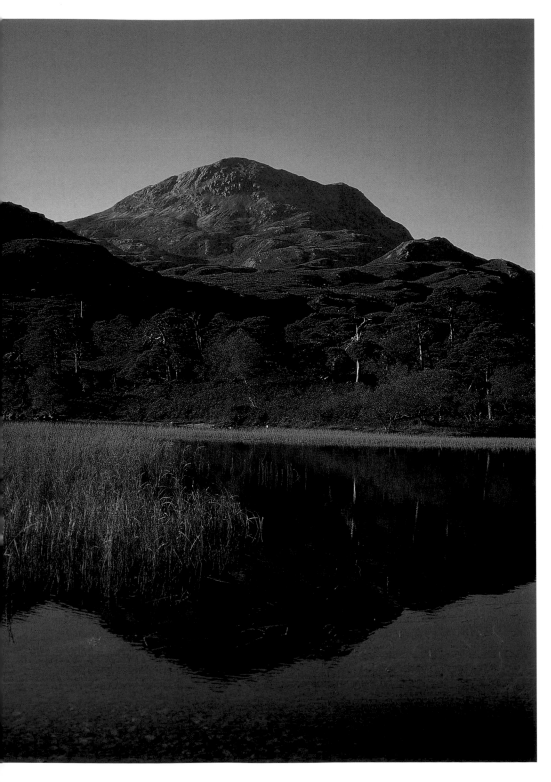

SGURR DUBH

2,565ft/782m

Black peak

Blackened with weeping streams which seep from an upper spring-line, a band of crags deters direct access to the summit on approaches from the Torridon road. Lying on a northern slope the deep-red rocks are dark with shadow for much of the day which adds to their gloomy appearance – hence the black peak.

Left Sgurr Dubh from Loch Clair (*Ian Evans*)

BEINN DAMH

2,959ft/902m

Stag mountain

This is one of many mountains associated with stags, most probably because the beasts on this hill were particularly fine specimens. The hill is better known for a curious semi-circle of lighter rock which breaks the uniform grey of the screes immediately below the summit. This is the 'stirrup mark', seen to best advantage from the west when travelling the road from Kishorn to Shieldaig where it lies closest to the water at the head of Loch Damh.

Below Beinn Damh from Loch an Loin (*Clarrie Pashley*)

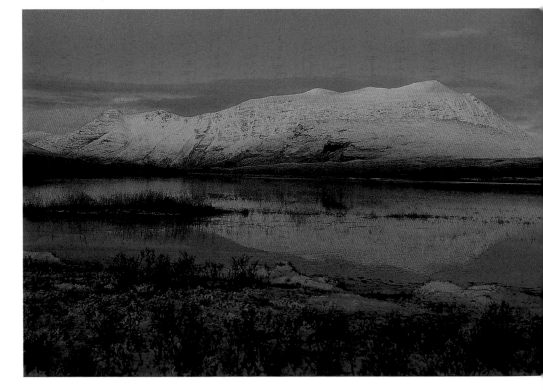

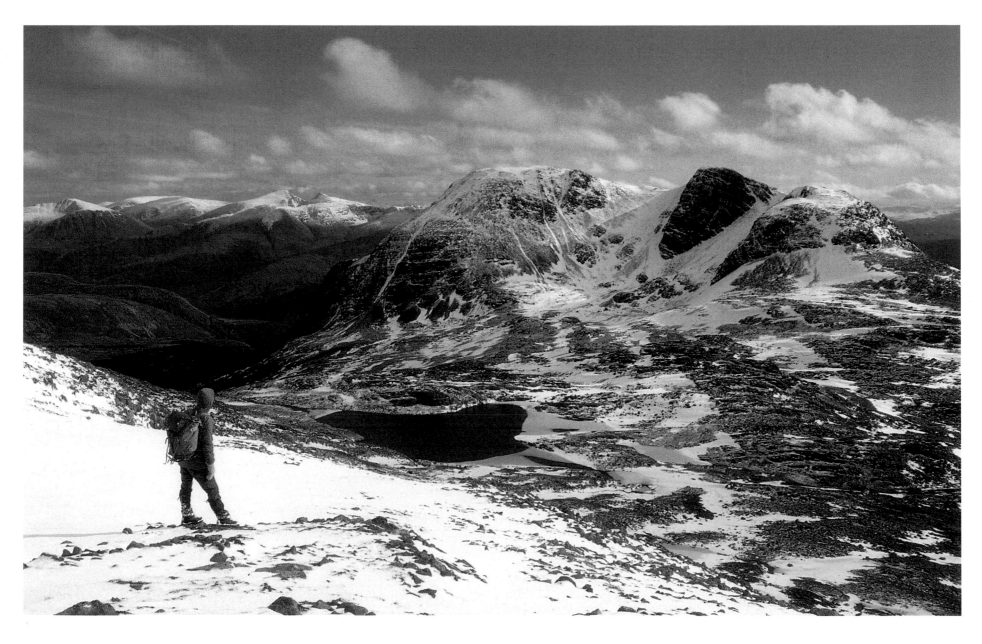

FUAR THOLL

2,976ft/907m

The cold hollow, or hole

It is unclear which corrie attracted the title which was eventually adopted as the name of this magnificent hill. The northern hollow is assuredly Mainreachan, from the Gaelic 'mainnrichean', stock folds, a name also applied to the cliffed heights to the west and south. The broad open corrie immediately to the south of the summit is Coire Dubh so that the most likely candidate is the deep eastern basin shaded by the south cliffs. As the most easily recognised feature of this peak when viewed from Glen Carron there would be logic in applying the name to the whole hill as a means of identifying an hitherto un-named peak.

Above Fuar Tholl from Sgorr Ruadh (*Alan O'Brien*)

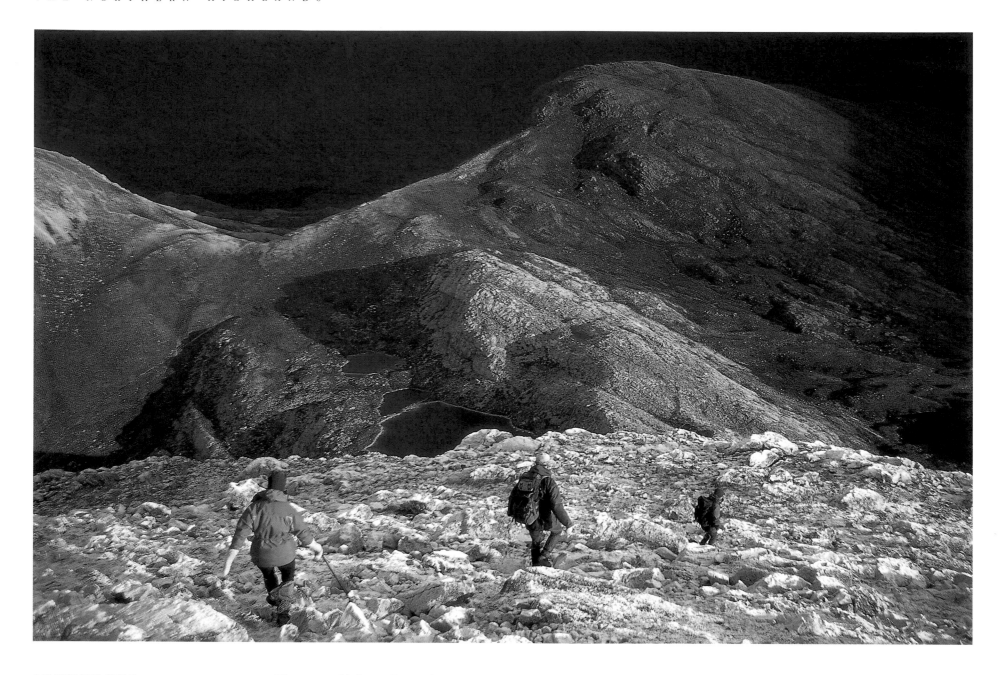

AN RUADH-STAC

2,926ft/892m

The steep red hill, the red stack, or the red conical hill

The steep red hill is well named and the title assuredly deserved as those who approach its summit by way of the path across the pass to the north east will confirm. Here the precipitate slabs are scaled close to an edge, giving airy views into a watery hollow tucked in its northern folds.

Above The slabs on An Ruadh-stac (*Hugh Munro*)

Right An Ruadh-stac from the south east (*Ian Evans*)

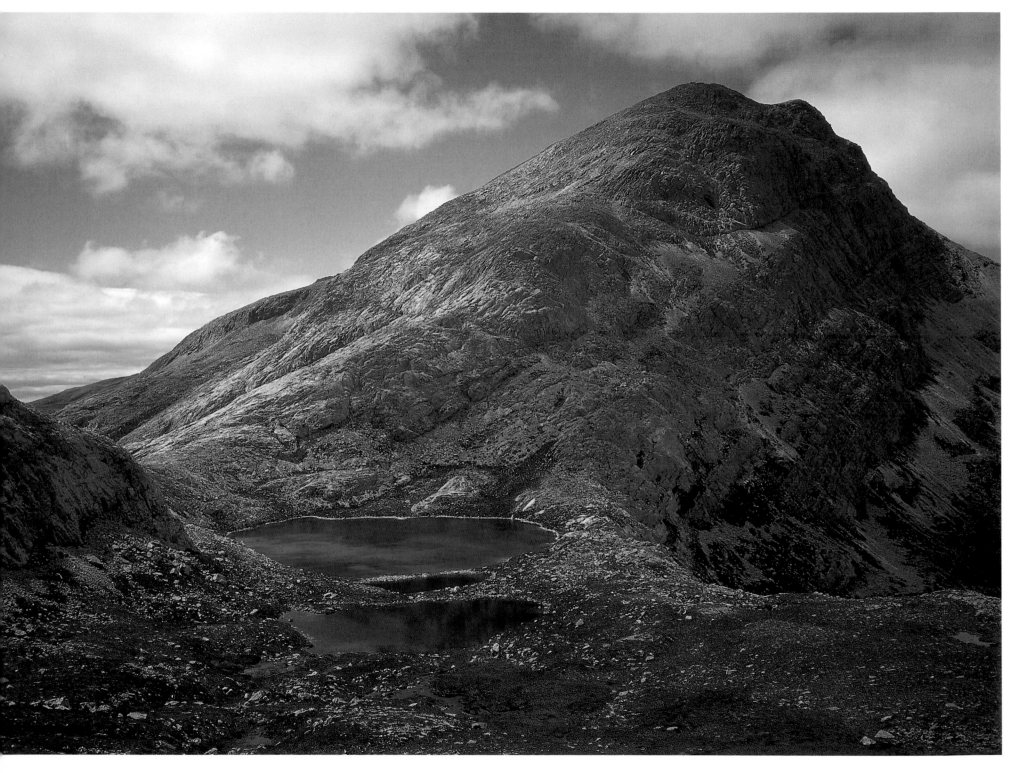

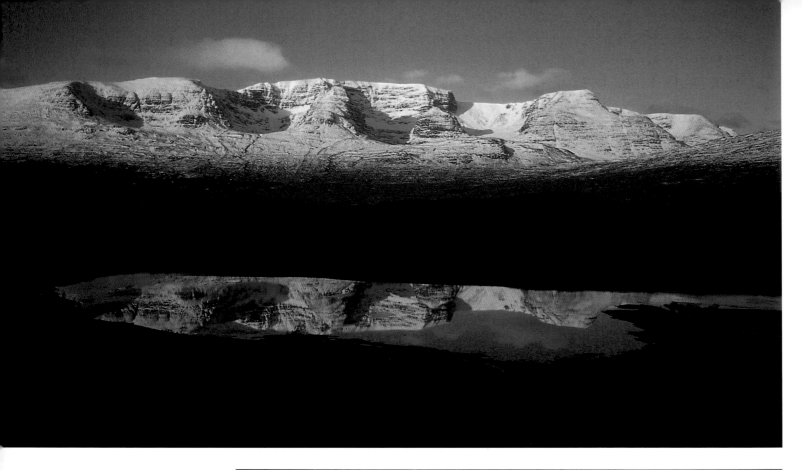

BEINN BHAN

2,939ft/896m

The white or fair mountain

The older spelling of the name was A'Bhinn Bhan which confirms the name as the white hill. 'Ban' is the most common of the Gaelic words to denote whiteness, and there are many examples of white hills to be found. None, however, surpasses this mountain, which has no fewer than six deep hollows cupped in the bosom of an array of eastern cliffs, and out-thrust spurs. The gloom of these cavernous cauldrons contrasts sharply with the white light reflected from the clipped turf of a broad summit ridge.

Left Beinn Bhan from Loch Gaineamach (*Bert Barnett*)

Left below Coire na Poite, Beinn Bhan (*Martin Ross*)

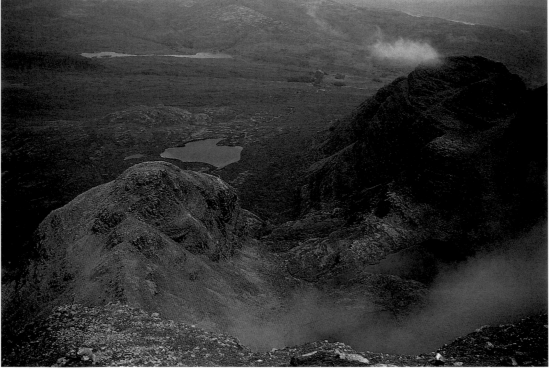

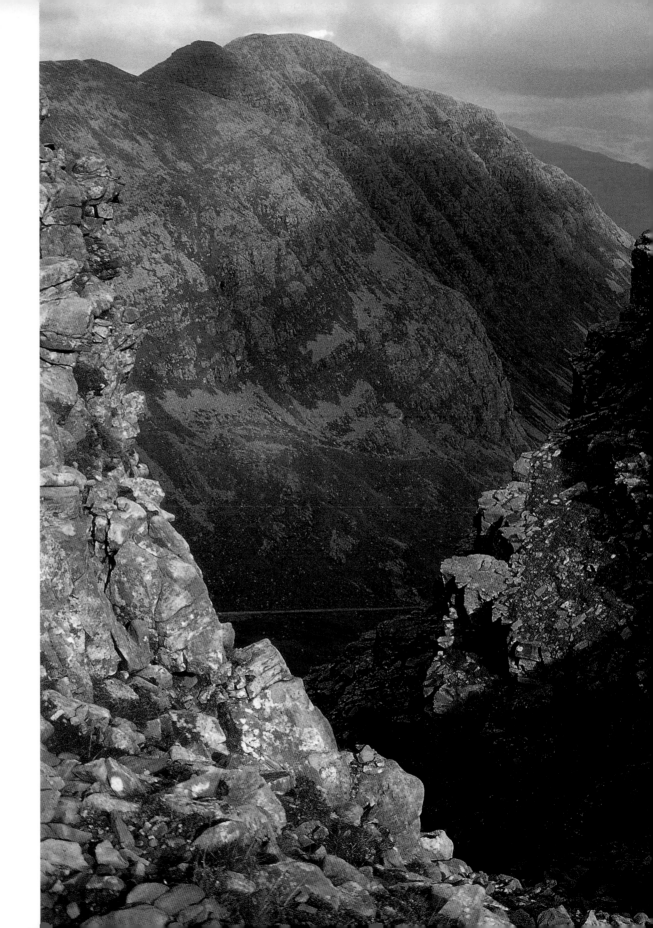

SGURR A' CHAORACHAIN

2,598ft/792m

*The peak blazing like fire, the peak
of the white, boiling, tumbling
torrent, or the peak of the field of
berries*

Older manuscripts give the name
Sgurr na Caorach, a name rooted
in 'caoir', a blaze of fire. A
secondary meaning is torrent. The
mountain's cliffs are russet
sandstone, and catching the
evening light may well give the
appearance of being ablaze. Any

torrent would have to be the
tumbling Russell Burn which
finds a source in the steep
headwall of Coire nan Arr. The
latter part of the name might also
be a corruption of 'caorach'
suggesting a link with berries,
particularly rowans, for the
mountain has at one time also
gone by the name of Beinn a'
Chaoruinn.

Right Sgurr a' Chaorachain from
Meall Gorm (*Clarrie Pashley*)

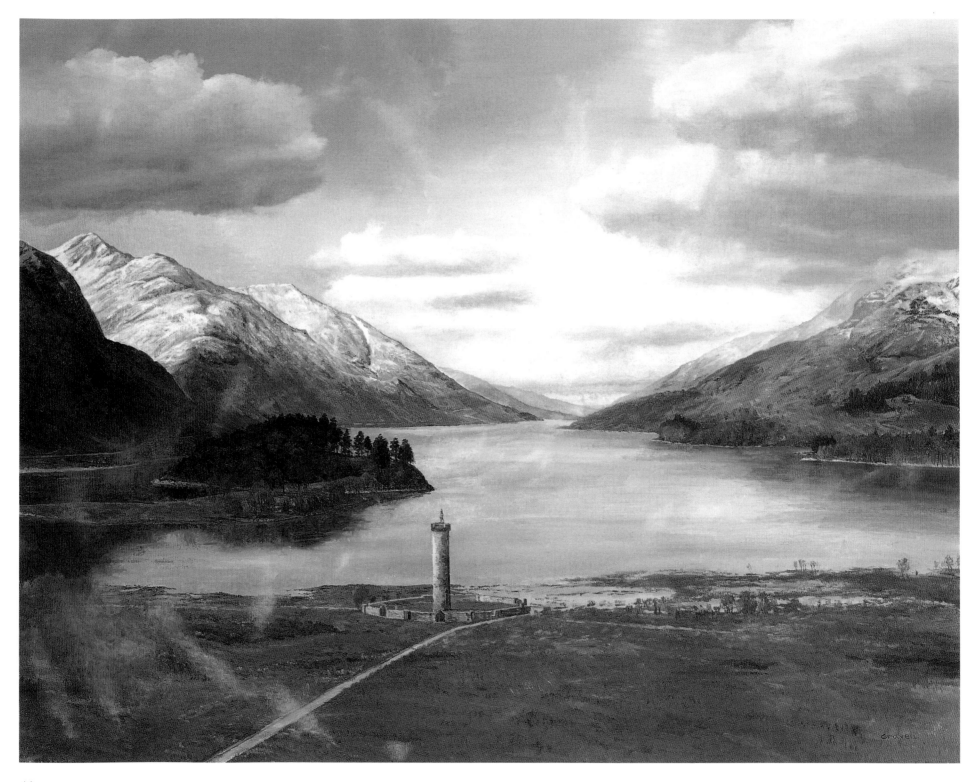

THE WEST HIGHLANDS

THIS IS THE LAND OF THE ROMANTIC WEST, NEVER FAR from the sea or from one of the many lochs which penetrate the mountains beyond the Great Glen. Here lie the great sea-lanes of Loch Duich, Loch Hourn, Loch Nevis, the Sound of Arisaig, and Loch Sunart, each with surrounding mountains offering vistas of the flotilla of islands of the Inner Hebrides. Knoydart of the Rough Bounds leads the roll call of ancient lands rich in legends of the fugitive Prince Charles Edward Stuart. Moidart and Ardgour excite the heart of those seeking new visions of mountain and sea from peaks known only to the dedicated Corbetteer.

Left Sgurr Ghiubhsachain and Loch Shiel (*Paul Craven*)

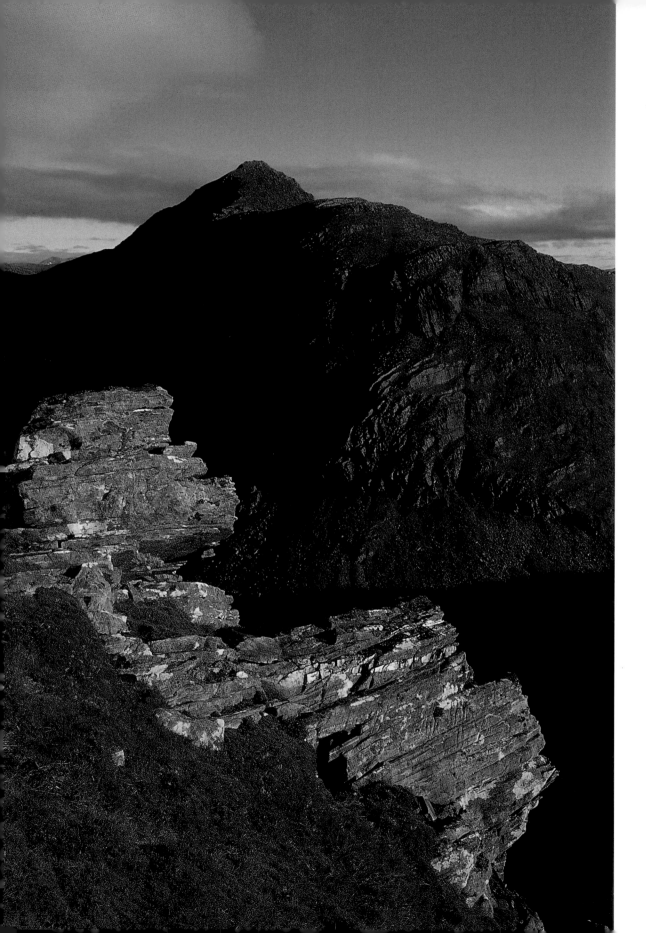

BEINN THARSUINN

2,831ft/863m

The transverse, or crosswise, mountain

There are several mountains bearing 'tarsuinn' in the name and all have an axis which runs counter to the overall grain of the land. This hill is no different in that it runs counter to the general thrust of the east–west line of mountains north of Loch Monar, and sits obliquely to Sgurr Choinnich at the end of the chain.

Bidein a' Choire Sheasgaich and Lurg Mhor complete a horseshoe of hills around the head of the loch. Their protecting bands of crags are best seen from a small platform, replete with lochan, below and to the south of the cairn.

Left Bidein a' Choire Sheasgaich from Beinn Tharsuinn (*Martin Ross*)

SGURR NA FEARTAIG

2,829ft/862m

The peak of the sea pink, or thrift

Sometimes spelt as Sgurr na Fiantag, the name is taken from 'feartag', the sea pink, which is not confined to the coast but can also be found on several exposed ridges. The plant is prevalent in the district and not too far distant there is another peak of the same name at the foot of Loch Monar.

The ridge west of the summit cairn helps to extend a day on the high tops, with views westward towards a distant Cuillin on Skye.

Right Looking to Skye from Sgurr na Feartaig (*Jim Teesdale*)

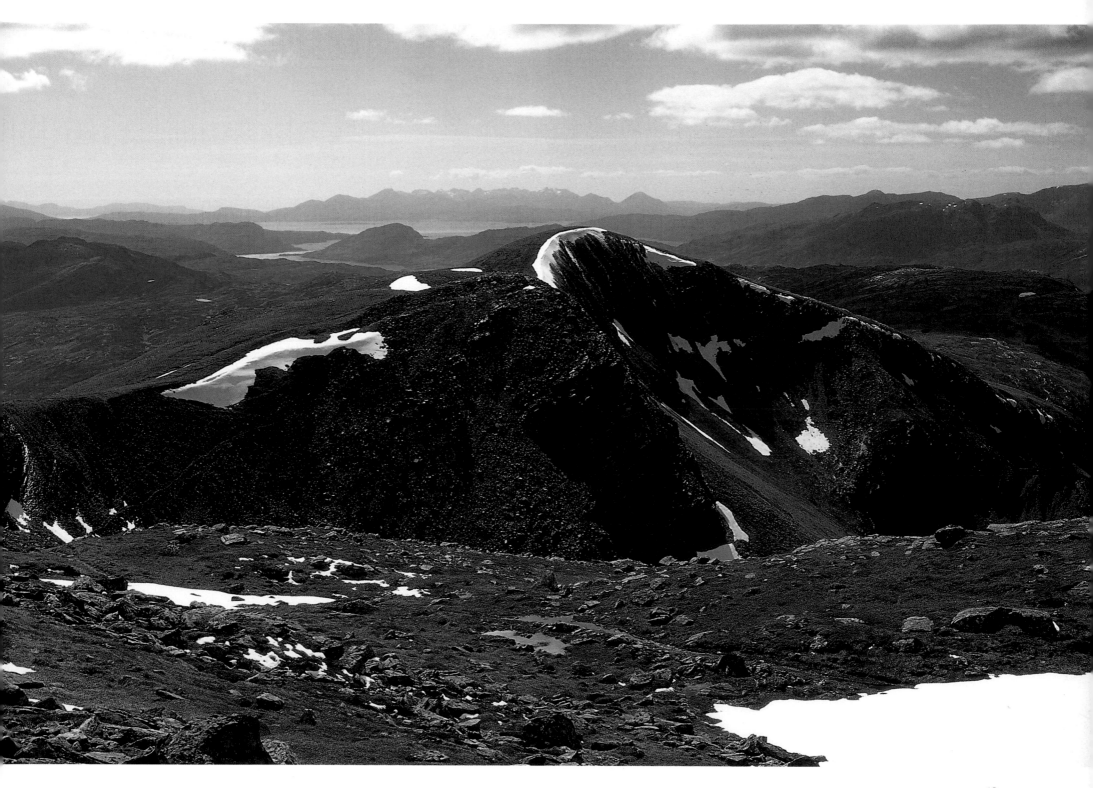

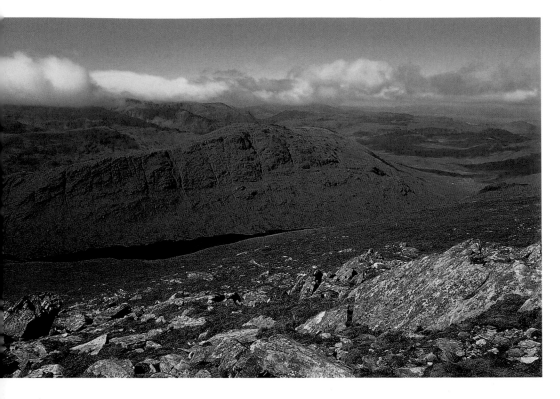

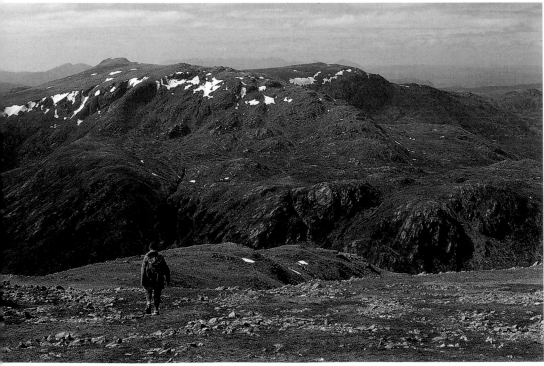

BEINN DRONAIG

2,615ft/797m

Hill of the knoll, ragged hill, humped mountain, or mountain of the little height
Watson's *Place Names of Ross and Cromarty*, published in 1904, postulates the probability of a name rooted in the Gaelic 'droineach', ragged. A better proposition is an origin from 'dronnag', meaning humped, or of little height. This seems the more likely when the mountain is seen from Loch Cruoshie to the south. Here, in full view, is a fine example of a mountain name taken from its physical characteristics, in appearance a long elongated hump of no great stature.

When seen from the high ground to the north the mountain shows the same elongated hump with its slopes ragged by gullies and grassed bluffs.
Left Beinn Dronaig from Lurg Mhor (*Martin Ross*)

FAOCHAIG

2,848ft/868m

The whelk, or little heathery hill
The name would appear to be from the Gaelic 'faochag', a whelk, and could indicate that shape was the determining factor in naming the mountain. More probably the word is a corruption of 'fraoch', heathery, a description which fits the conditions underfoot. There may also be some suggestion that the title is from 'froachag' which would indicate the presence of the whortleberry.

Seen from adjacent peaks the hill appears as a crumpled ridge giving more credence to the possibility of finding the whortleberry on its slopes.
Below left Faochaig from Aonach Buidhe (*Don Green*)

SGUMAN COINNTICH

2,884ft/879m

The mossy stack, or peak, or the mossy boat-bailer
'Sguman' in Gaelic can mean a headscarf created by folding a square of cloth diagonally corner to corner. For such to apply here the hill would have to be pointed which it is not. It seems therefore more appropriate to adopt the other Gaelic meaning of 'sguman', boat-bailer, which being round bottomed more appropriately describes the shape of this hill set above the sea-lane of Loch Long. Coinntich is mossy, and a reference to the mossed stones of the summit.
Right Looking down Loch Long to Skye from Sguman Coinntich (*Peter Collin*)

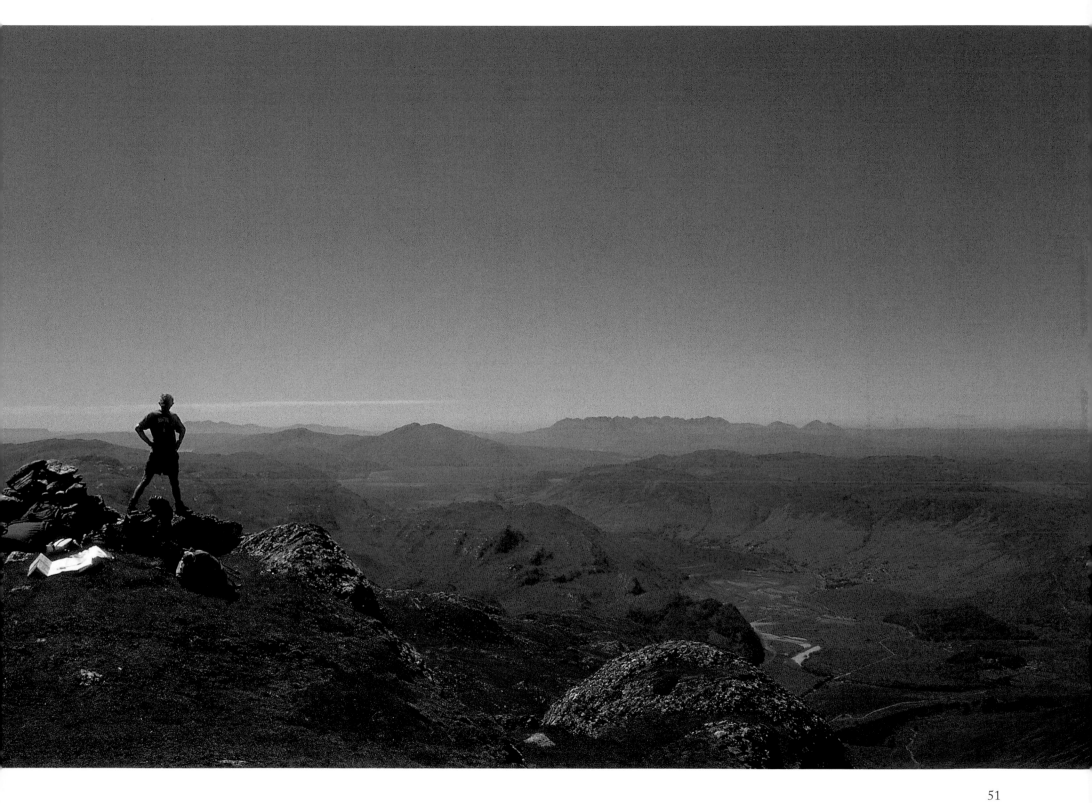

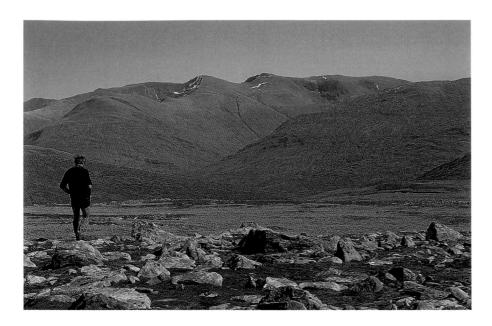

AONACH SHASUINN

2,913ft/888m

The ridge or height of the Englishman

'Sasunn' in the Gaelic means England, though the association with what to the Gael was a foreign country is difficult to determine. It is possible that there is a hidden link with the Hanoverian troops who were stationed in the garrison of Fort Augustus after Culloden. The redcoats regularly used the military road which ran along Glen Moriston and some may have been ambushed and killed whilst on patrol. Significantly this hill is not far from the hideout used by the fugitive Prince Charles Edward Stuart. His companions had made several punitive raids and two soldiers out of a 'party of seven had fallen victim to the vengeance of the band', as had an informer. It could be that a similar incident led to the burial of a redcoat caught on patrol in the upper reaches of Coire Dho or Gleann Fada, the name of the hill commemorating the long-forgotten incident.

Below Cnap na Stri and Aonach Shasuinn from Loch Beinn a' Mheadhoin (*Irvine Butterfield*)

AONACH BUIDHE

2,949ft/899m

Yellow ridge or height

'Aonach', a ridge, usually with steep sides, appropriately describes this hill's shape. A coverlet of dried grasses provides the deep yellow coloration which was a useful secondary means of identification.

In certain light, or in late summer, the grasses take on a more orange hue, adding a touch of colour in what might otherwise be regarded as an unremarkable hump.

Above Mam Sodhail from Aonach Buidhe (*Jim Teesdale*)

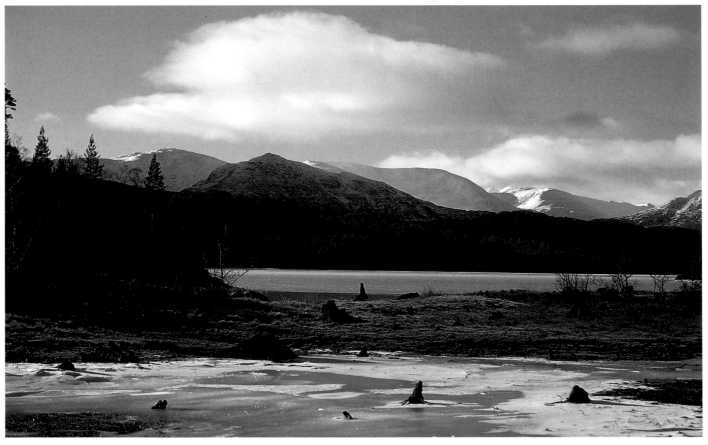

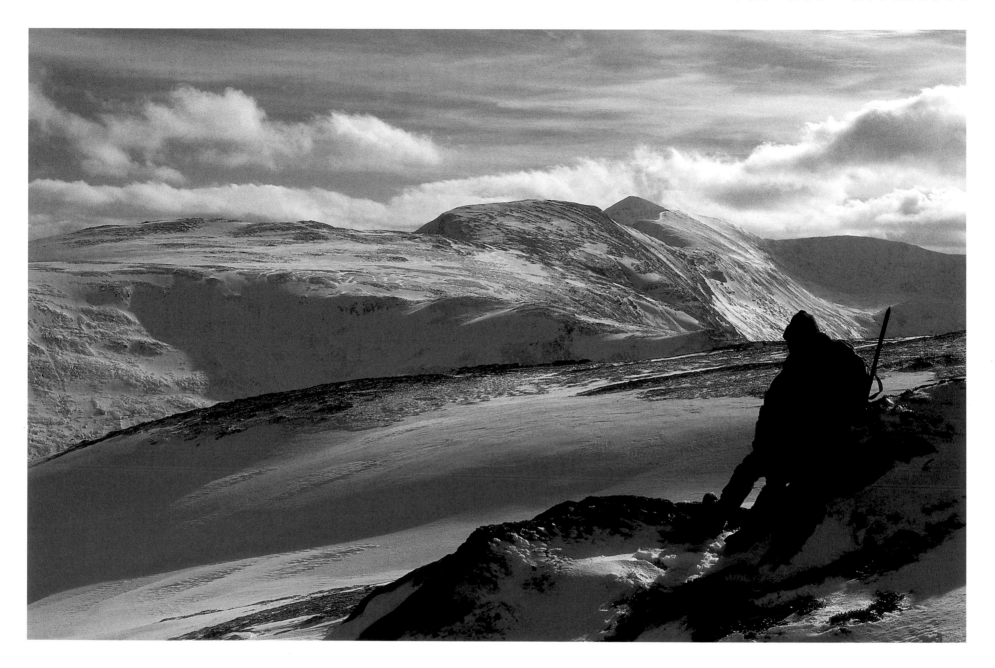

CARN A' CHOIRE GHAIRBH

2,838ft/865m

Cairn of the rough corrie

The rough corrie is the steep-walled hollow of the Allt Garbh, the rough stream, which rises under a southern col, Cadha Riabhach, or brindled pass, a name also suggesting a coverlet of scattered stones. This peak is attached to the eastern prong of the great cirque of peaks known coloquially as the Cluanie Horseshoe, and provides glimpses of the lesser-known corners of those peaks.

Above Sgurr nan Conbhairean from Carn a' Choire Ghairbh (*Jim Teesdale*)

SGURR A' BHAC CHAOLAIS

2,903ft/885m

Peak of the bank, or sandbank, of the narrows

The narrows are those of a sound or strait which here must relate to the long slender arm of Loch Hourn, stretching into the heart of these mountains. At some remove from the shore the name suggests that this was a viewpoint, looking down upon the inner reaches of the sea-lane. On closer acquaintance with the mountain visitors to the cairn find difficulty in catching a glimpse of Loch Hourn. As if to compensate for this disappointment, there is a view west along the ridge to the splintered crags of Sgurr na Sgine.

Below Sgurr a' Bhac Chaolais from Creag nan Damh (*John Allen*)

SGURR MHIC BHARRAICH

2,556ft/779m

Peak of the son of Maurice

Older spellings have given Sgurr 'ic Mharrais, meaning the peak of the son of Maurice, or MacVarish. The latter is the name given to a small clan attached to the MacDonalds who held sway over large parts of the western coast. Curiously this particular mountain lies on the bounds of territory held by the MacLeods, and the

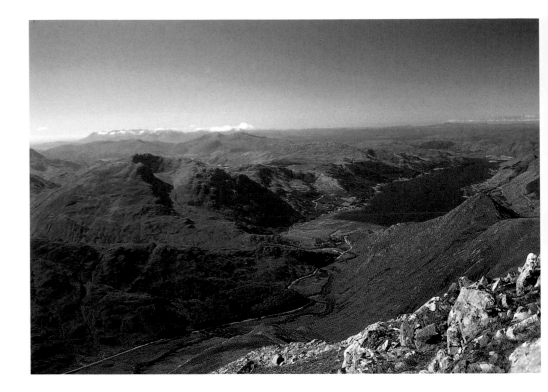

MacKenzies, so that whoever gave their name to the mountain may well have been a stranger of some notoriety.

The mountain attracts as a viewpoint of the higher steeples of the Five Sisters of Kintail. In the reverse direction this smaller peak suggests a dormant volcano with one side of the crater torn away.

Above Sgurr Mhic Bharraich and Loch Shiel from Sgurr Fhuaran (*Hugh Munro*)

BUIDHE BHEINN

2,903ft/885m

Yellow mountain

The colour is that of the tawny grasses which cover the lower slopes in abundance. These hint at the long blades and tussocky lumps that prove a hindrance to ascent and are to be found on the lower ground, and more immediately above the access paths which skirt the flank of the hill.

The summit affords a clear view along the length of Loch Hourn and to the hills ranged about the magnificent arm of the sea.

Right Beinn Sgritheall from Buidhe Bheinn (*Jim Teesdale*)

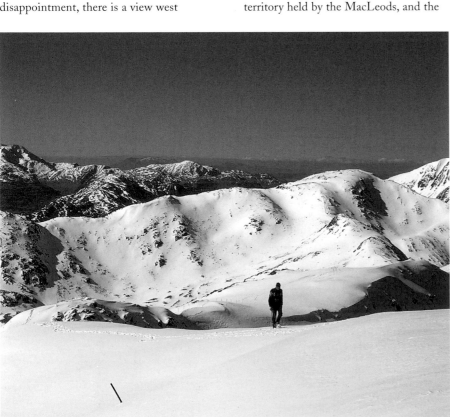

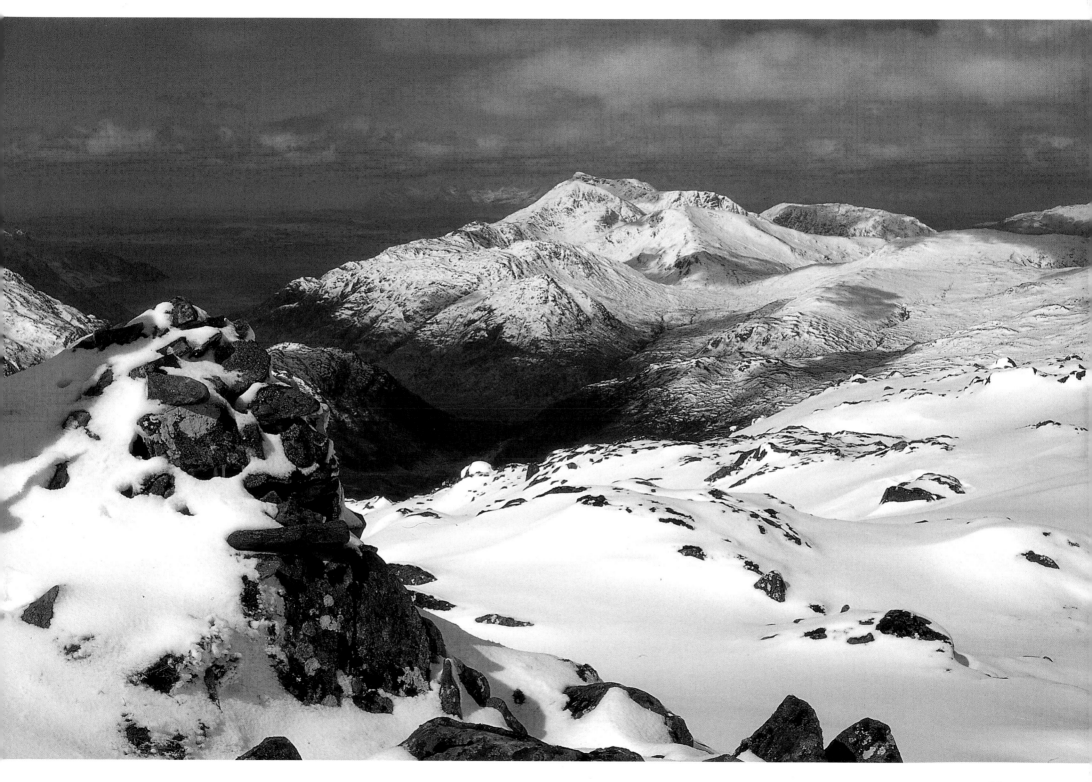

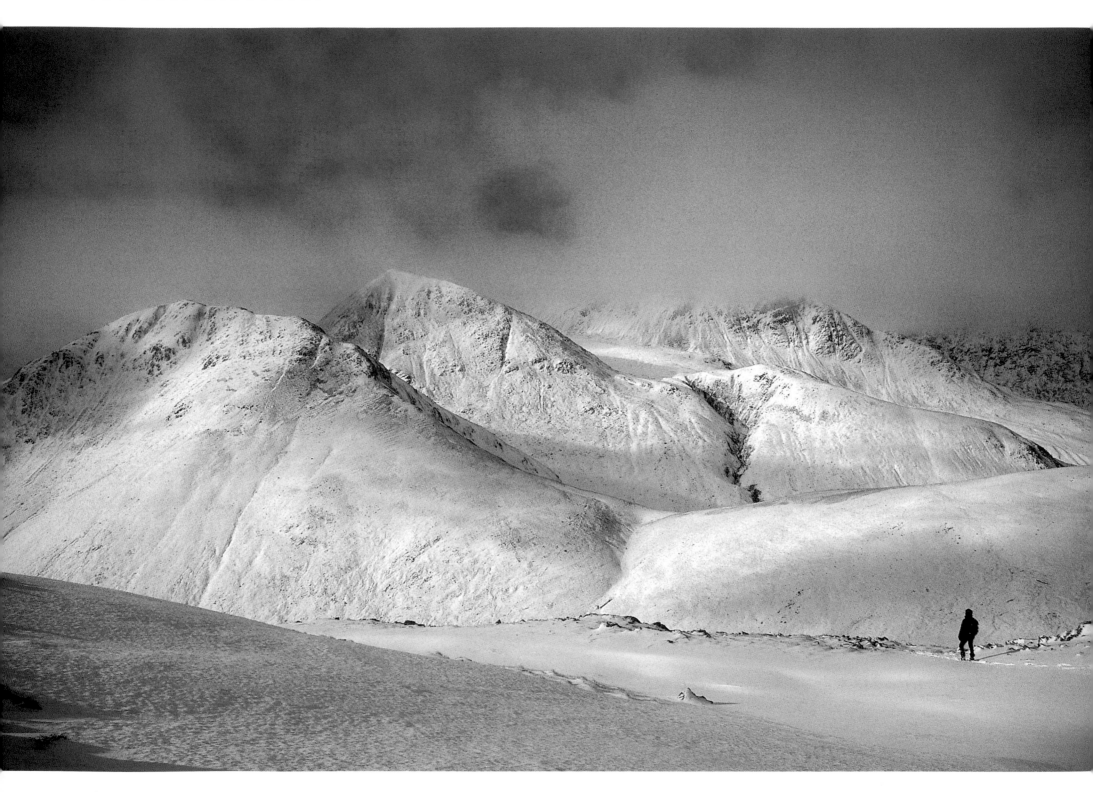

BEINN NA H-EAGLAISE

2,641ft/805m

Mountain of the church

This is one of two mountains of the same name in the North-West Highlands, the church here referred to as that at Arnisdale at the foot of the mountain. The association with a religious establishment suggests that the church was one of those founded by the Celtic missionaries. This link no longer remains as the present church at Arnisdale is Presbyterian, and the naming of the mountain certainly predates this establishment.

Above Loch Hourn and Beinn na Caillich from Beinn na h-Eaglaise (*Malcolm Nash*)

BEINN NAN CAORACH

2,539ft/774m

Hill of the sheep, or hill of the rowan berries

Sheep were only kept in small numbers by the original inhabitants of the Highlands as they destroyed too much of the natural vegetation. Cattle were the main source of wealth and there are therefore examples of place names associated with cows and herding. This hill stands out as one of the few examples where sheep are specifically mentioned. 'Caorach' may be a corruption of 'caorann', the rowan, which is a widely distributed name given to mountains in the Highlands.

Left Beinn Sgritheall and Beinn na h-Eaglaise from Beinn nan Caorach (*Malcolm Nash*)

SGURR AN AIRGID

2,759ft/841m

Peak of the silver, or money

The Gaelic 'airgid', can mean either silver or money so that whatever the choice the mountain certainly has riches of some kind to its credit. Was a cache of money buried here by the Spaniards who bombarded Eilean Donan Castle and fought at the Battle of Glenshiel in 1719? It is known that they escaped across the hills to surrender somewhere at the head of Loch Duich. Perhaps the prize of booty was shared hereabouts?

The mountain does not detach itself significantly from the adjacent hills to appear as a peak of great note but there is reward in ascent and the prize of fine views from the summit cairn.

Below Westwards view down Loch Duich from Sgurr an Airgid (*Peter Collin*)

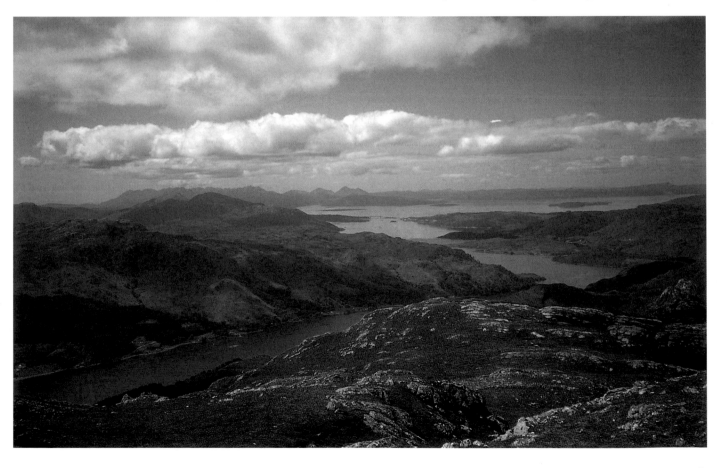

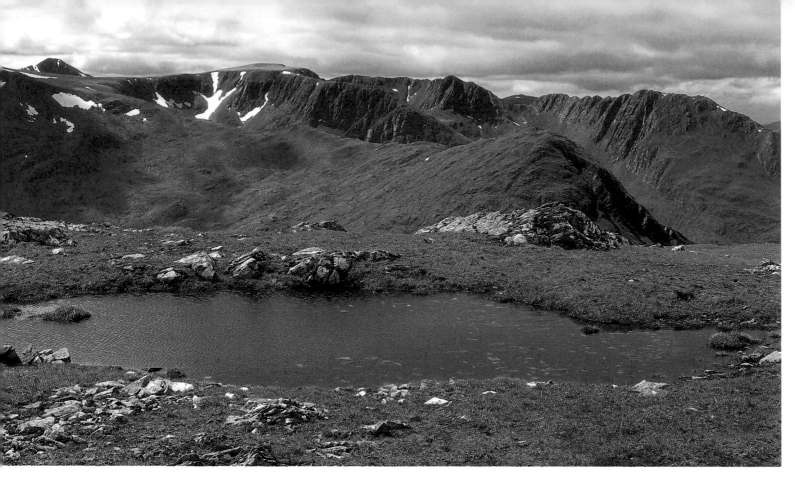

AM BATHACH

2,618ft/798m

The byre

The mountain's shape is supposed to resemble that of a cowshed or byre and, as the name implies, provides a link with times when cattle provided the mainstay of the Highland economy.

The ridge is frequently used to gain height as a precursor to the assault on the higher Ciste Dhubh, or crossed in descent from this Munro. As such this makes this Corbett one of those most easily combined with the ascent of a neighbouring Munro.

Below Looking to Loch Cluanie from the ridge of Am Bathach (*Jim Teesdale*)

SGURR GAORSAIC

2,752ft/839m

Peak of the thrill or horror

The origin of the word 'gaorsaic' is difficult to determine. Whatever interpretation is arrived at must equally apply to the stream, loch and glen of the same name, which lie along the mountain's western margins. A derivation from 'gaorr', thrill or horror, seems to have been accepted by most translators, but this lacks conviction and seems of doubtful authenticity. The word may also mean filth, or gore, but this could not really be applied to the features of the lower ground, marshy though the area may be. The spelling of the name bears some resemblance to 'gaorsach', and though the mountain's slopes may be cursed for their steepness, to liken the hill to a bawd or slut would be too unkind.

Viewed from the lower ground the mountain is steep and rises to a distinct top so that it is surprising to find that it carries a lochan high on the shoulder immediately below the summit. This provides a high vantage with the whole array of Beinn Fhada's cliffs seen across the glen to the south west.

Above The cliffs of Beinn Fhada from Sgurr Gaorsaic (*Jim Teesdale*)

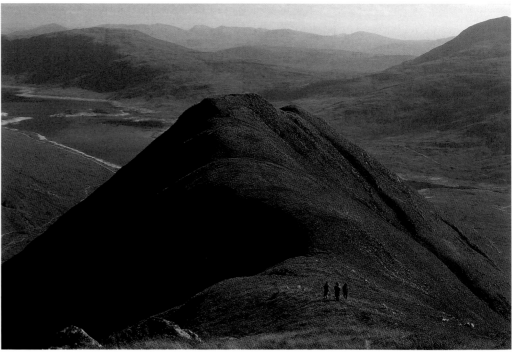

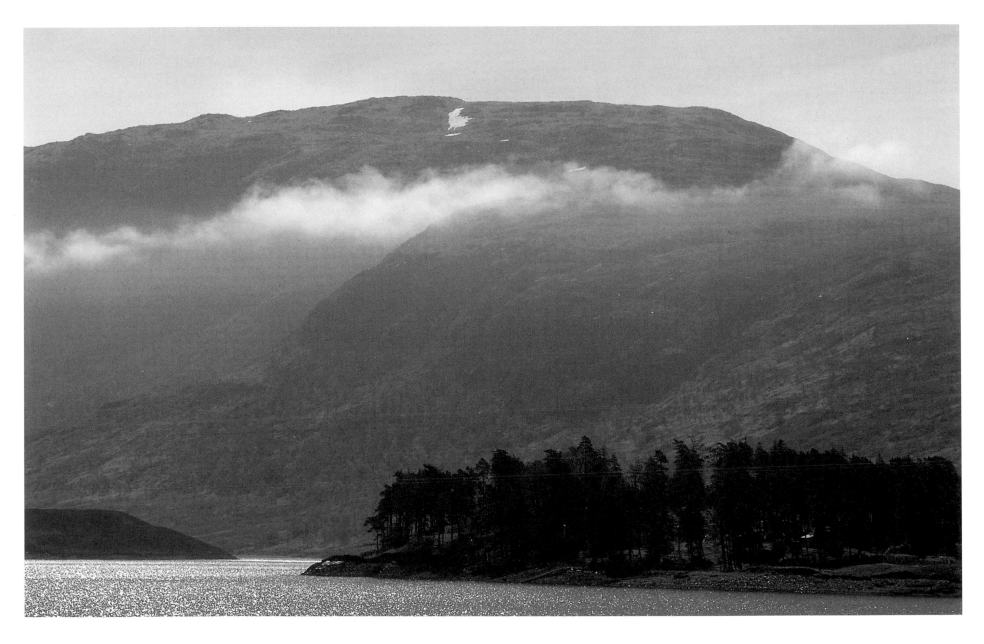

DRUIM NAN CNAMH

(BEINN LOINNE)

2588ft/789m

Ridge of the bone or spine

In Gaelic 'cnaimh an droma' is literally the bone of the back, or spine. This long hill above Loch Cluanie has many small lumps of exposed rock along its ridge which closely resemble the vertebrae of the spine, so it is very perceptively named.

The central height, Beinn Loinne, has a name taken from the same source as that of nearby Loch Loyne, which comes from the Gaelic 'loinn', to shimmer or glitter. This suggests a quality of light reflection which becomes more apparent after

showers when large expanses of wet rock on the mountain's back and flanks sparkle in the sun.

Above Druim nan Cnamh from Loch Cluanie (*David May*)

59

MEALL DUBH

2585ft/788m

Black hill

As a broad rounded hill the Gaelic 'meall' is an appropriate description of the shape of the summit. The presence of other heights on the long-backed ridge to the west whose names are associated with white (Carn Ban), and red (Carn Dearg) indicate an affinity with their coverlet of grass and heather. The black element of Meall Dubh is either the peat of the lower ground or the dark outcrops which buttress the summit.

Lying close to the Great Glen the sprawl of the Monadhliath is seen from an unusual quarter and further south a glimpse of the distinctive bulge of Ben Nevis behind the hill ranges above Loch Garry.

Left A glimpse of Ben Nevis from Meall Dubh (*Richard Wood*)

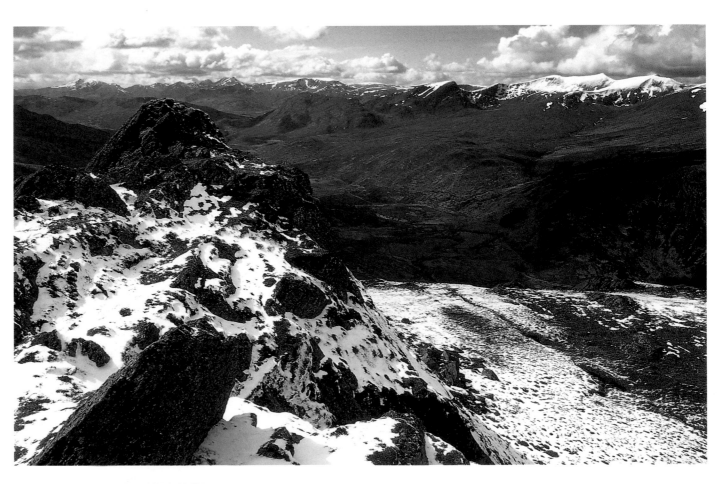

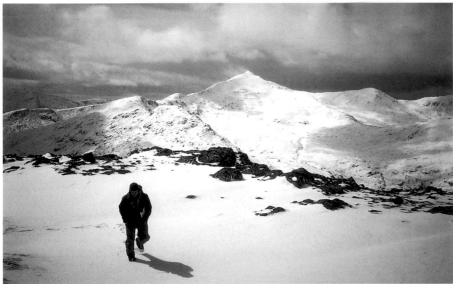

SGORR NA DIOLLAID

2,684ft/818m

Peak of the saddle

The shape of the hill's crest, or the twin rocks of its summit outcrops, accounts for the title, though locally the hill is known as 'The Sleeping Warrior'.

This is a magnificent hill from which to view the surrounding ranges of Strathfarrar, Cannich, and Affric, having topped out on the higher of the summit stacks.

Above Looking west along Glen Strathfarrar from Sgorr na Diollaid (*Jim Teesdale*)

Left Sgorr na Diollaid from Sgurr na Ruaidhe (*David May*)

BEINN A' BHA'ACH ARD

2,828ft/862m

The mountain of the high byre

The name is more properly Beinn a' Bhathaich Aird, from the Gaelic 'bathach', a cow-house or byre, and 'ard', high or lofty. The byre from which the mountain took its name may well have been at the head of the Neaty Burn to the west as one of its feeder streams rises in Coire na Ba Odhair, the hollow of the dun cow.

The most easterly peak at the end of the chain above Glen Strathfarrar, it guards the entrance to this mountain sanctuary, and from Inverness and the old road to the north along the shores of the Beauly Firth is a most prominent landmark, regarded by local mountaineers as a useful beallweather.

Below Beinn a' Bha'ach Ard from the Beauly Firth (*Alan O'Brien*)

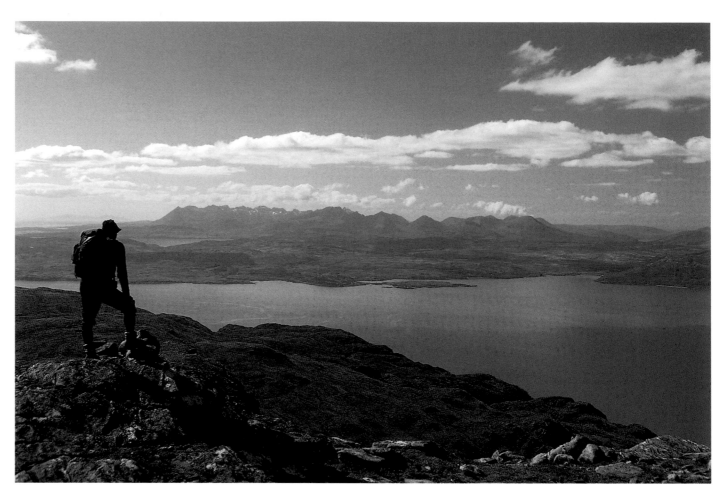

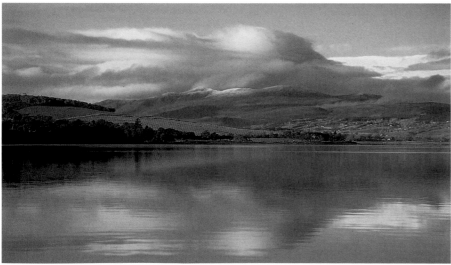

BEINN NA CAILLICH

2,575ft/785m

Old woman's hill

This is one of three hills which bear the same name to be found around the coast bordering the sounds visited, and settled, by the Norse seafarers. There are two on Skye. That above Broadford is held by local tradition to be the burial-place of a thirteenth-century Norwegian princess who died at Ord. She commanded that at her death her remains be placed where her spirit might forever breathe the winds which would come to her from 'Noroway ower the faem'. She is said to be buried under a massive summit cairn. The second Skye peak overlooks the narrows of Kyle Rhea where legend has it lie the bones of a Fingalian giantess with a hoard of gold. Could this Knoydart mountain of the old lady also have similar associations?

Above Skye and the Sound of Sleat from Beinn na Caillich (*Irvine Butterfield*)

SGURR COIRE CHOINNICHEAN

2,611ft/796m

Peak of the mossy corrie

The mossy corrie is that tucked under the
northern scarps of the mountain where,
shielded from the sun for the greater part
of the day, ground moist with the
frequent showers harbours the mosses.
The mountain's shape is that of a true
sgurr, or sharp pointed peak, and a sure
landmark when seen from the boat on
passage from Mallaig to Inverie.
Below Sgurr Choinnichean and
Ladhar Bheinn from Loch Nevis
(*Ian A. Robertson*)

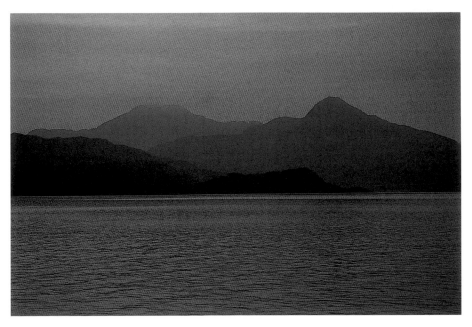

BEINN BHUIDHE

2,805ft/855m

Yellow mountain

The mountain is another of several of
similar name and, like the others, takes
its name from the pale yellow of the
grasses which are to be found on its
slopes. Mountaineers ascending from the
Yellow Pass west of the summit will
encounter these thick tawny grasses in
the northern corrie.

A low evening light from the setting
sun serves to emphasise the colour of the
grasses turning the yellow into gold.
Above Beinn Bhuidhe from Gleann an
Dubh-Lochain (*Richard Wood*)

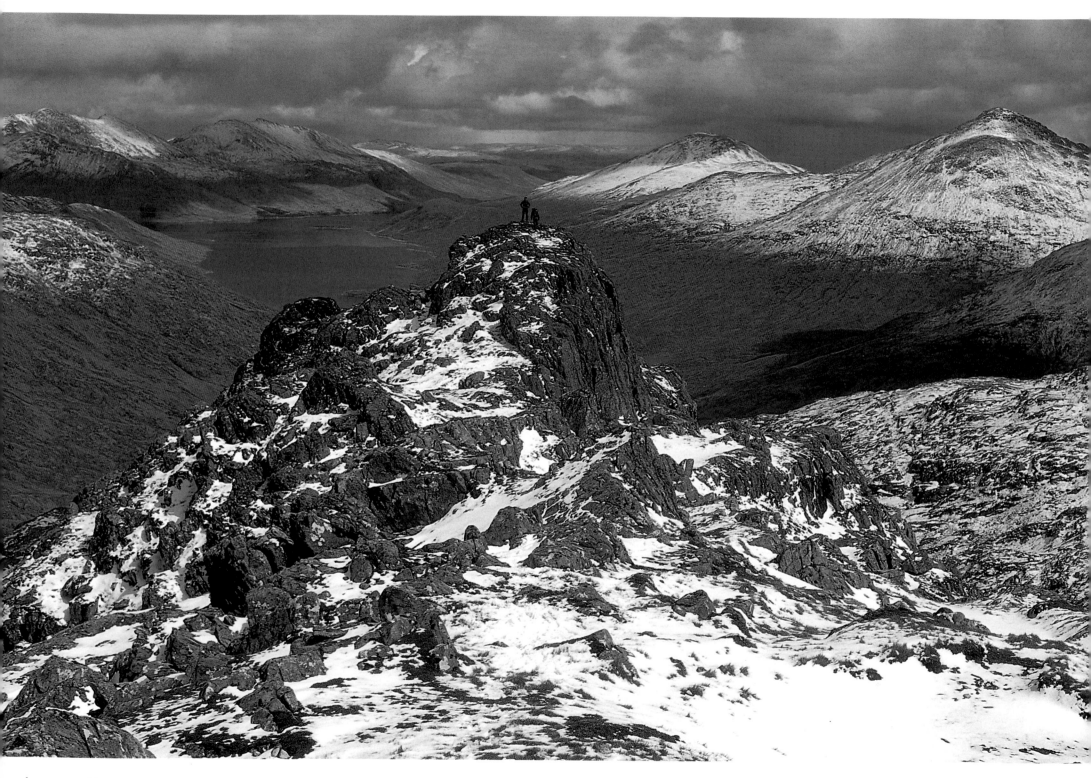

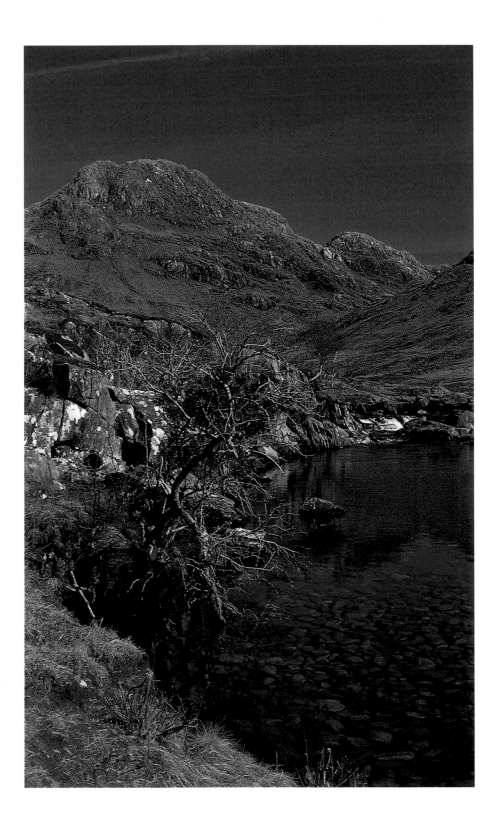

BEN ADEN

2,910ft/887m

The mountain of the face

The Gaelic 'aodain', or 'aodann' has here been corrupted. Translated as face, visage, or countenance, there must here be some reference to the mountain's features as seen from the lower ground about Carnach. These are the rocks and cliffs which support the summit on this side of the hill.

On ascents taken from the head of Loch Quoich there are other rocks to give entertaining short scrambles to their crown the better to survey the sweep of the hills about the loch.

Opposite Loch Quoich from the eastern approach to Ben Aden's summit (*Jim Teesdale*)

Left Ben Aden from the River Carnach (*Martin Moar*)

SGURR A' CHOIRE-BHEITHE

2,995ft/913m

Peak of the birch tree corrie

The birch tree corrie lies under the northern fringe of the summit, and the streams which collect here feed a stream of the same name. Birches are very common in the Highlands, so this corrie must have had some significance. As birch provides an excellent fuel such a resource would have been welcomed locally.

To the hill wanderer the mountain is best remembered for the long knolly ridge which stretches from the shores of Loch Quoich to the gap of Mam Barrisdale above Loch Hourn. Whatever the conditions this hill is a strenuous outing, the traverse being particularly so in winter.

Below Druim Cosaidh from Sgurr a' Choire-bheithe (*Alan O'Brien*)

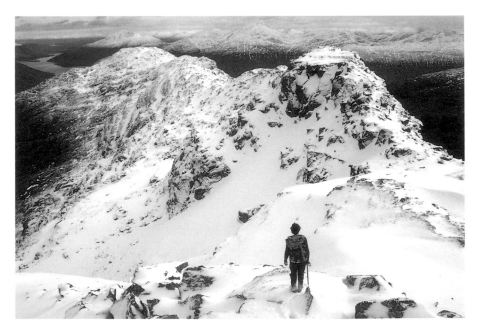

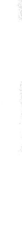

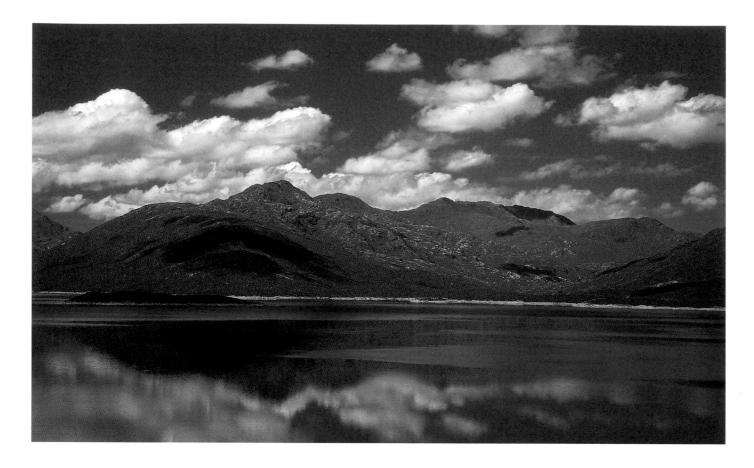

CARN MOR

2,720ft/829m

Big cairn, or big hill

This peak is big in the sense that it looms large at the head of Loch Morar, which it appears to dominate when seen from the west. In this respect it fulfils a similar function to Sgurr na Ciche in relation to Loch Nevis as a useful landmark. Carn can mean a hill resembling a conical pile of stones though this is misleading given that the majority occur on the swollen tops of the eastern hills. In the hill names of the west it is unusual, and could fairly be taken here to resemble a conical pile of stones. In that regard the hill is a particularly effective exponent.

The mountain's link with Loch Morar is all too apparent for, as with many a western hill, the moating loch leads the eye towards the sea-lanes of the Inner Hebrides.

Right Loch Morar from Carn Mor (*Jim Teesdale*)

SGURR NAN EUGALLT

2,933ft/894m

Peak of the death stream or precipices

Death stream from 'eug', death, and 'allt', a stream sounds a dramatic warning to those who venture on this hill. The one clue to the location of this stream so feared by the Gael is in the retention of the single word Eugallt on the larger scale maps of the Ordnance Survey. This would place the stream on the hill's most precipitous flank, which plunges to the depths of upper Glen Barrisdale. An ancient pathway between Loch Quoich and Barrisdale fords many such streams and must have been a dangerous passage through these hills. In an area notorious for its inclement weather, where streams are quick to rise, knowledge of such difficulties would be valued.

There is a local tradition that it was in the shadow of this peak that a fugitive Bonnie Prince Charlie nearly fell to his death. This happened whilst crossing the boulder-strewn head of the Allt Loch an Lagain Aintheich during a desperate night crossing of the hills to avoid detection by a cordon of Hanoverian troops encamped in Gleann Cosaidh.

The hill forms a part of a welter of hills around the head of Loch Quoich, and standing on the loch's northern shore close to the site of Glenquoich Lodge those familiar with the story can trace the route across the hills, and pick out the gap in the ridge which the Prince and his companions crossed to reach Coireshubh beside the road to Kinloch Hourn.

Above Sgurr nan Eugallt and Loch Quoich (*Irvine Butterfield*)

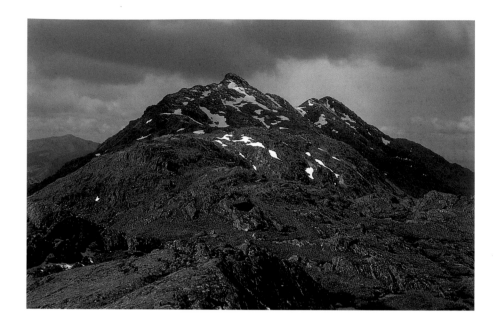

SGURR NA H-AIDE

(BIDEIN A' CHABHAIR)

2,844ft/867m

Peak of the hat, or point, or pinnacle
of the hawk

As seen from the usual route of approach by way of Glen Dessarry, the mountain's shape does not immediately suggest that of a hat, but it may well be that we must look at the mountain from the head of Loch Morar to obtain the desired effect. Residents in the long abandoned settlements of Kinlochmorar would have a clear view of the hill side-on and in imagination see its twin summits as a crumpled hat. The main summit is sharply pointed and a good representative of the 'bidein' genre, and may well have been a resting place, or nesting site of the hawk in search of an inaccessible ledge.

The one-inch maps of the Ordnance Survey gave the name Sgurr na h-Aide, though this is more properly the name of the lower western summit. Bidein a' Chabhair is the correct title for the eastern top and the mountain's true peak. Both are now named on the later metric editions of the map.

Above Sgurr na h-Aide from Druim Coire nan Laogh (*Roger Holme*)

SGURR MHURLAGAIN

2,887ft/880m

Peak of the bag-shaped sea inlet, or peak of
the wool basket

The name is maybe derived from 'mhuir'lag' which literally translates as sack-shaped sea inlets, as to the west of the present cottage at Murlaggan there are one or two small bays on Loch Arkaig. Anciently spelt as Murlagen and Moirvalagane the name of the settlement suggests a derivation from the Gaelic 'murbhalgan'. There are other examples of similar names given the settlements on bends of rivers, or bays, which are likened to the shapes of bags or sacks.

There is a Murlagan in the Rannoch area of Perthshire which is there translated as 'an abundance of reeds'. This would not be an inappropriate description of the reedy shores of Loch Arkaig and might equally apply to the mountain above.

The link with a wool basket may, at first, appear more tenuous as it comes from 'murlag', a canoe-shaped basket for holding wool. The possibility here is revealed when the mountain is seen from high ground to the north as it displays two long spurs cradling a long narrow corrie.

SGURR AN FHUARAIN

2,956ft/901m

Peak of the springs or small streams

The name may come from 'fuaran', a spring. Alternatively the presence of an 'i' in the spelling may hint at an origin in 'urain' which could come from 'odhar-choin', wolf peak, or an old word for water – 'our'. The one-inch maps produced by Bartholomews often retained the old spelling and they gave the name Sgurr an Uran. The precipitous flank of the mountain on the Glen Kingie side carries a multitude of small incised streams, and would appear to support a link with these watercourses.

Right Sgurr an Fhuarain from Gairich (*Tom Rix*)

Below Sgurr Mhurlagain from Gairich (*Martin Ross*)

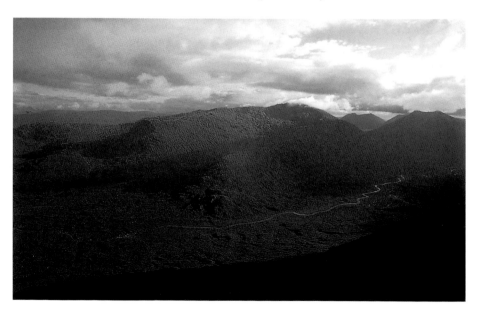

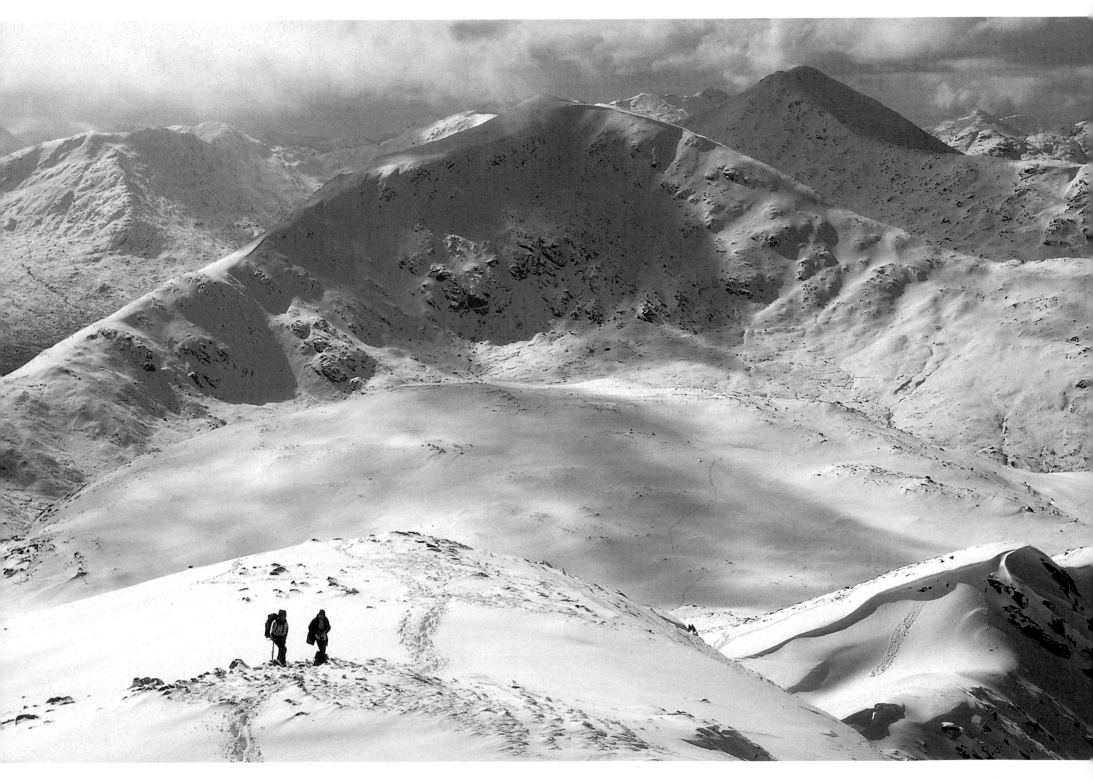

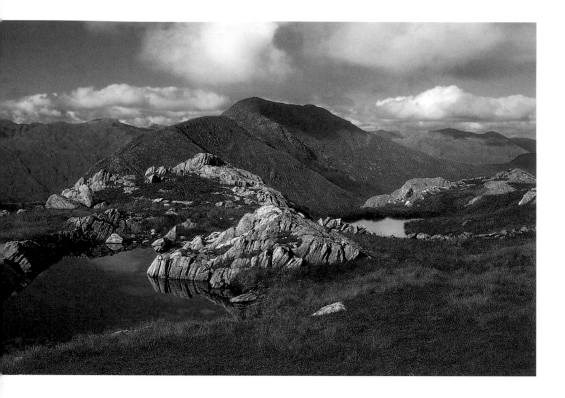

SGURR COS NA BREACHD-LAOIDH

2,739ft/835m

Peak of the hollow of the speckled fawns, or peak of the cave of the bonny calf

The name-ending 'laoidh' is a misspelling of 'laoigh', a calf, which is here intended to convey a deer calf, or fawn. The use of the Gaelic 'cos' hints that the feature looked for is more crevice than cave and would, in this instance, indicate a quiet corner where deer secreted their young. This might well lie in the folds of a tributary of the Allt Coire nan Uth, which would be singularly appropriate as 'uth' is an udder, and this hollow would be a popular haven for the hinds to feed their offspring.

The crown, replete with tiny pool, is one of the cirque of hills around the head of Glen Kingie, and may be traversed on a crossing of the ridge to the higher Sgurr Mor.

Above Sgurr Beag and Sgurr Mor from Sgurr Cos na Breachd-laoidh (*Hugh Munro*)

FRAOCH BHEINN

2,815ft/858m

Heathery mountain

Of the hills grouped along the bounds of Glen Dessarry this carries the greatest cloak of heather and instantly recognised if its name were to indicate the presence of the plant, and the unsuitability of the hill for grazing.

A landslip on an eastern face at the head of Coire na Cloiche Mhoir produced fissuring of the mountain's edge and cuts in the turf along the crest to provide interest on the ascent to a cairn with extensive views east and south to the Great Glen.

Below Ben Nevis from Fraoch Bheinn (*Tom Rix*)

STREAP

2,982ft/909m

Climbing, scaling, or a climb

The word 'streap' means the act of climbing or scaling, or can mean a struggle or scramble. This neatly encapsulates the impression given by the mountain which confronts its aspirant conquerors with one of the steepest and most persistent of climbs. Whichever route of ascent is chosen from the surrounding glens this mountain is a tough proposition and is deservedly titled.

The mountain has several tops the highest of which, Streap Comlaidh, twins the summit in grandeur of form and prospect.

Right Streap ridge from Meall an Uillt Chaoil (*Mark Gear*)

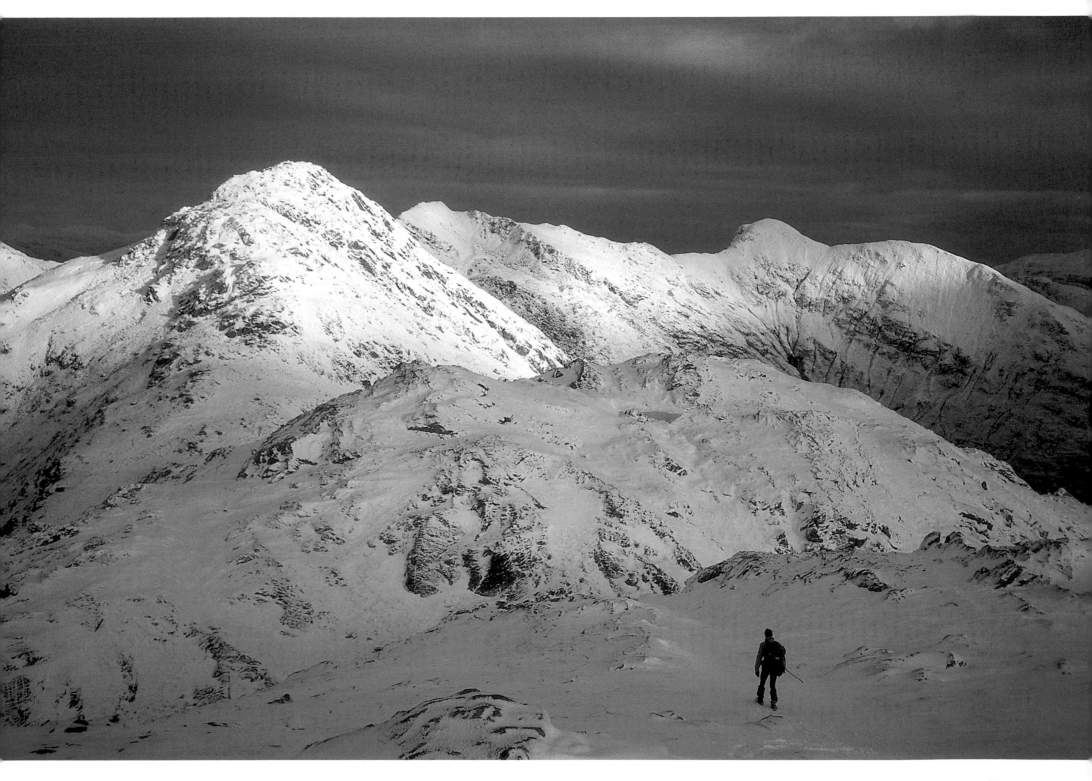

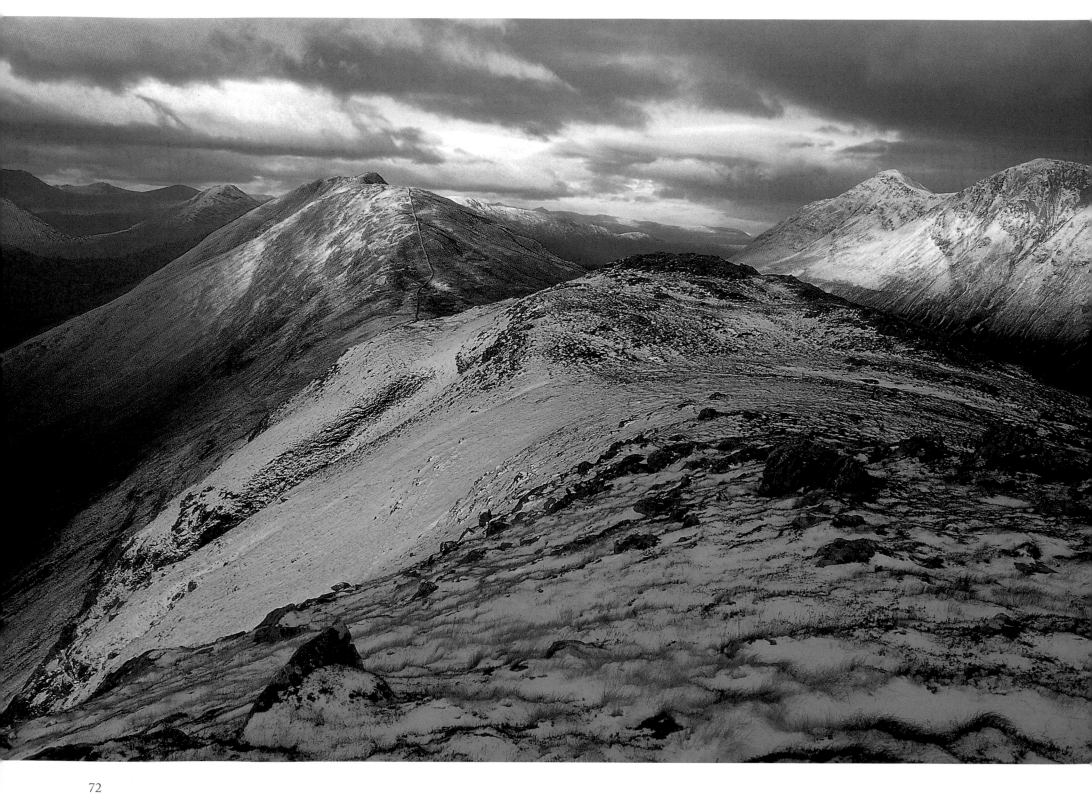

BRAIGH NAN UAMHACHAN

2,510ft/765m

Slope, or mountain of the caves

Any caves are more like fissures in the rock tumbles on the slopes at the south-eastern end of the mountain. None are marked on the Ordnance Survey maps and the only clue to their whereabouts lie in the names of the old ruin at Dail nan Uamhachan (field of the caves), the slope above it and the stream which drains that slope. The use of the adjectival 'seann', meaning old, in the name of the stream suggests that when the names were given to these features the caves were probably collapsed or overgrown.

The feature most remarked upon by those who traverse the mountain's lengthy back is the presence of a wall which leaves the ridge just below the summit hump. *Left* Ridge to Braigh nan Uamhachan from Na h-Uamhachan (*Jim Teesdale*)

SGURR AN UTHA

2,611ft/796m

Peak of the udder

The name refers to the shape of the mountain which to those tending their cattle in Glen Finnan appeared in the shape of a cow's udder. This connection to the former inhabitants of the glen is recorded in the annals of Bonnie Prince Charlie's wanderings as his companion was able to secure milk locally whilst the Prince hid out on neighbouring Fraoch-bheinn.

The rough crown of the mountain looks northwards to the hills ranged above Glen Pean and to the deep wedge at the head of Glen Finnan which separates them from the towering bulk of Streap. *Below* Sgurr Thuilm and Streap from Sgurr an Utha (*Irvine Butterfield*)

MEALL A' PHUBUILL

2,539ft/774m

Hill of the tent

The name of this hill is rather unusual in that it relates to an object more familiar to walkers than those who named it. The name itself is a corruption of 'puball', and was most probably given to it by those who formerly lived in Gleann Suileag to the south. Seen from this direction the hill can resemble the shape of the rounded tents of the travelling folk or tinkers, once seen in the West Highlands. These were constructed of a frame of curved limbs of willow or other pliable wood, covered overall with a tarpaulin or canvas sheet.

This is another of those bland hills which requires a view to make its ascent worthwhile, with the prospect of Ben Nevis to the east that most favoured by the photographer. *Above* Ben Nevis from Meall a' Phubuill (*Tom Rix*)

BEINN BHAN

2,611ft/796m

The white or fair mountain

The mountain has no rocks or other features which could suggest that the white is permanent and here we have to fall back on local knowledge. It is said that snow lies on this hill earlier than any other in the district, and it is this whiteness which led to the name.

Below Ben Nevis from Beinn Bhan (*Jim Teesdale*)

MEALL NA H-EILDE

2,749ft/838m

Hill of the hinds

The mountain is so-called as under its lee slopes the corries afforded shelter from the westerly gales, and here too was provision of good feeding for nursing hinds. A fugitive Prince Charles Edward Stuart also knew the hill as he hid out on the adjacent summit of Meall an Tagraidh without the benefit of fire or cover, and though it hailed is said to have slept all

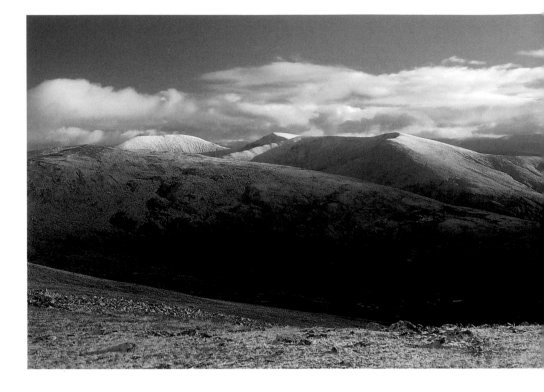

that day's forenoon in his plaid and wet stockings.

Above Sron a' Choire Ghairbh and Meall na Teanga from Meall na h-Eilde (*Jim Convery*)

GEAL CHARN

2,638ft/804m

White hill

There are numerous Geal Charns and their pale hue is due to the colour of the lighter grasses which thrive as a result of late-lying snows. Most lie in the Central Grampians around Strath Spey or Loch Laggan so this peak is more isolated than the others. Nonetheless the snow lying in its eastern corrie is protected from the influence of the warm south-westerlies, and in late spring may help pick out the mountain from its neighbours which are similar in shape. Those who attain its summit will hope for fine weather so that they might enjoy a clear prospect of the hills along Loch Arkaig to the Rough Bounds of Knoydart.

Right Looking west from the summit of Geal Charn (*Mark Gear*)

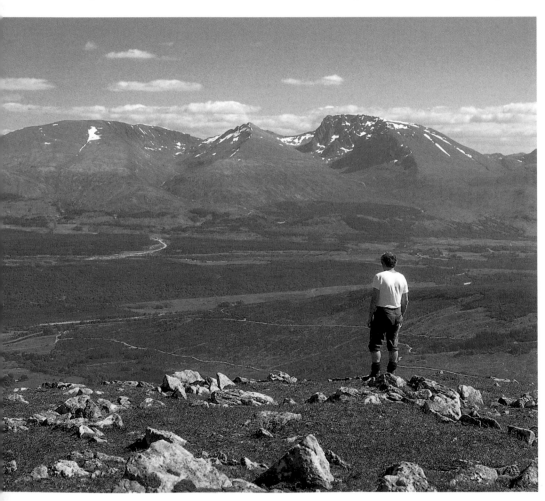

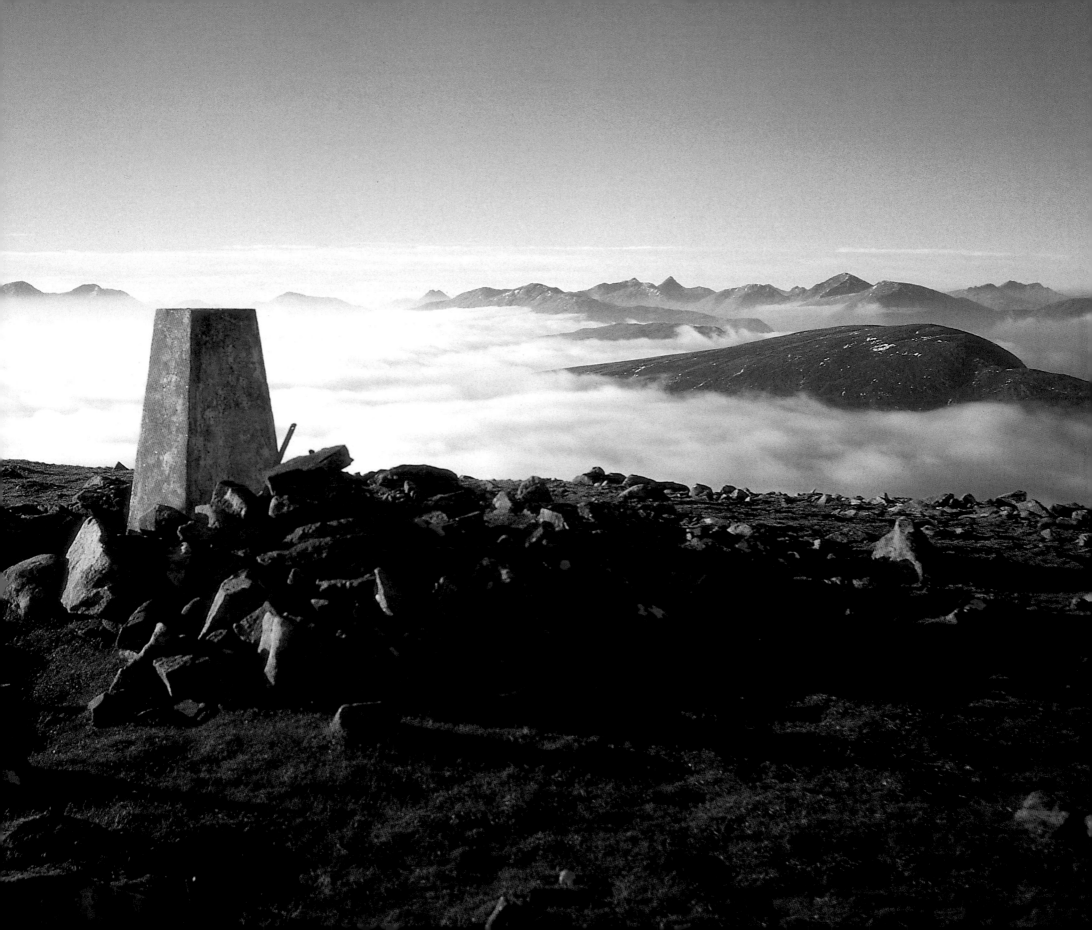

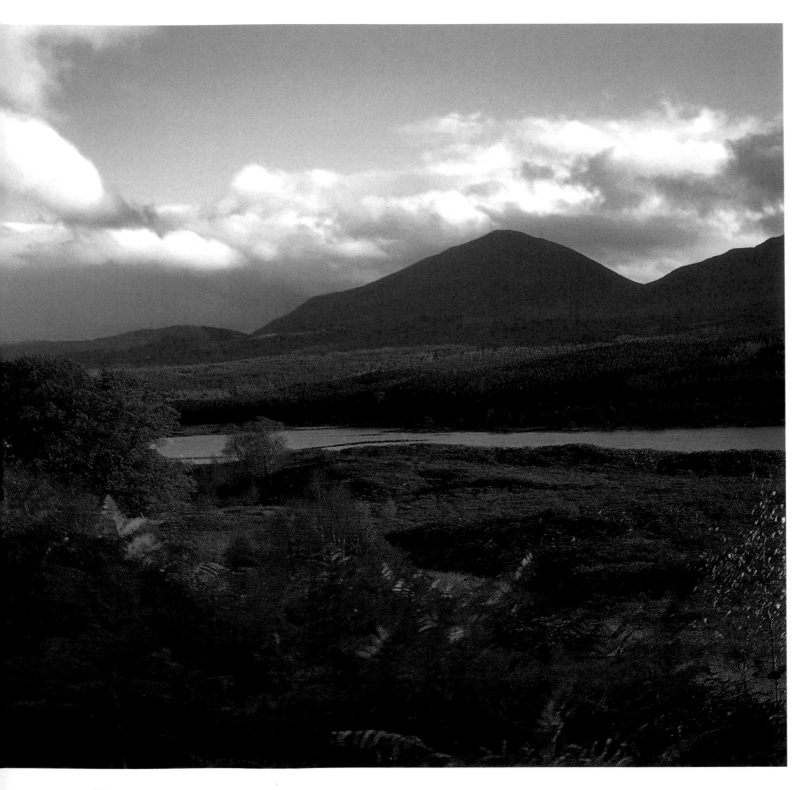

BEN TEE

2,956ft/901m

Mountain of the fairy hillock, or faery hill

'In old maps and books "tee" was spelt "sidh" and "shee", from the Gaelic "sithe", fairies,' wrote Edward C. Ellice in his *Place Names of Glengarry and Glenquoich*. As one familiar with the district he knew that the hill was locally known as Glengarry's Bowling Green. The lack of scarce a square yard of green on the summit of a hill of steep, rock-strewn slopes would not, he concluded, be conducive to a game of bowls. Fairies were said to join in the game and to hoist bowls over the rocks and to race down the hillside for those which went astray.

Seen from the west the mountain has a distinctive conical shape so typical of the true fairy hill and the name could as well be an abbreviated form of 'Beinn an t-sithein'.

Left Ben Tee and Loch Garry
(*Lorraine Nicholson*)

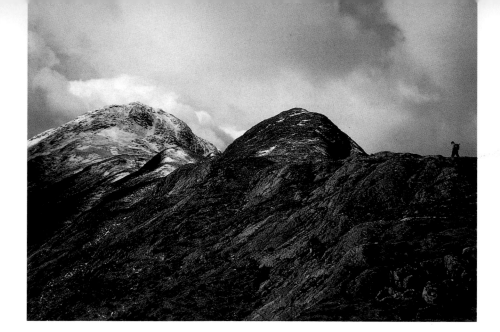

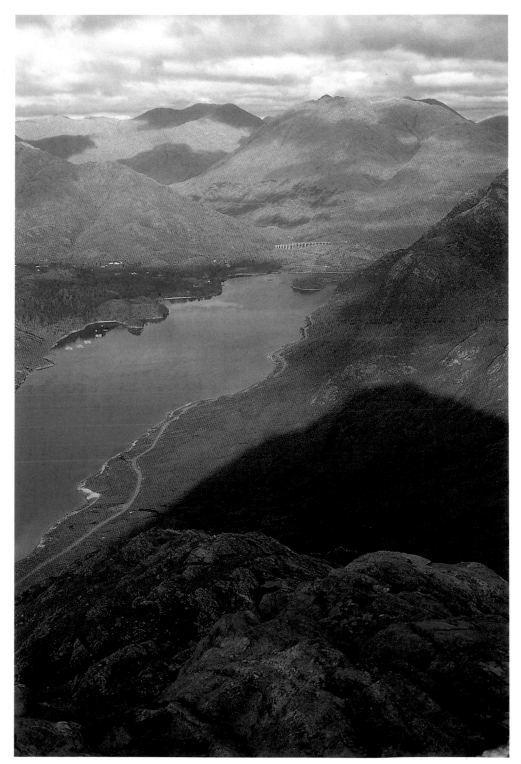

SGORR CRAOBH A' CHAORAINN

2,543ft/775m

Peak of the branch of the rowan tree

As a 'sgorr' the mountain has a definite peak and an association with rowan trees, a common one in the highlands. If 'craobh' were taken to mean tree this would be repetitive given that 'chaorainn' is a derivative of 'caorann', a rowan tree. 'Craobh' must therefore be significant in itself and mean 'branch'. This may well have been a figurative means of naming the high point on a spur of the massif of which it forms a part, with rowans as the predominant tree to be found thereabouts.

On acquaintance the terrain is rough with many a rocky outcrop. The summit itself is girdled with minor crags so that the abiding memory is of a very rugged hill.

Above The approach to the summit of Sgorr Craobh a' Chaorainn (*Richard Wood*)

SGURR GHIUBHSACHAIN

2,785ft/849m

Peak of the fir wood

This is the dominant peak of those which crowd a western skyline as seen from the head of Loch Eil. It also sits in the most commanding position above the head of Coire Ghiubhsachain from which it obviously drew title. Remnants of the fir woods are still to be seen at the mountain's foot, and the house of Geusachan beside the loch also bears testament to the presence of firs.

This hill also enjoys the grander view down to Loch Shiel than that from neighbouring Sgorr Craobh a' Chaorainn. At the head of the loch the railway viaduct, the first concrete structure of its kind, appears toy-like against the deep throat of Glen Finnan which it spans at this point.

Right Glen Finnan and Loch Shiel from Sgurr Ghiubhsachain (*Jim Teesdale*)

BEINN RESIPOL

2,772ft/845m

Mountain of the horse farmstead, or the cairn above the pool

A Norse origin for the name has been suggested from 'hross bolstadr' to give mountain of the horse farmstead, though this might more likely apply to the name of the farm bearing the same name, which lies at the mountain's foot by the shores of Loch Sunart. The alternative explanation plays on the word 'poll', which means a pit or pool, and suggests 'hreysi poll', the cairn above the pool. In truth neither has a certainty about it and whatever its origins it is better to accept that the name is a corruption of the Gaelic or Norse which allows the mountain to retain its element of mystery.

Below Loch Shiel, Eigg and Rum from Beinn Resipol (*Alan O'Brien*)

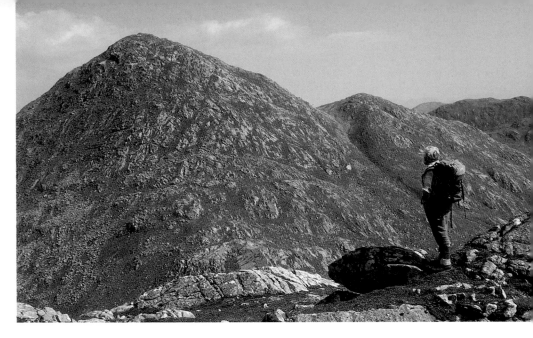

SGURR DHOMHNUILL

2,913ft/888m

Donald's peak

This imposing peak commands the head of Glen Scaddle to the east and the headwaters of the Strontian River which flows south west to Loch Sunart. As the most impressive height in Ardgour it attracts immediate attention. The land hereabouts was a part of the heartland of the MacDonald 'Lords of the Isles' who held sway in a vast territory along Scotland's western seaboard. So sure were the chieftains of the Clan Donald of their undisputed rights that they were for long able to defy the might of the king himself and the naming of one of the finest mountains in the district was but one way of reflecting their power and dominion.

Above Sgurr Dhomhnuill from Druim Garbh (*Tom Rix*)

BEINN NA H-UAMHA

2,500ft/762m

Mountain of the caves

It is most unlikely that visitors to this hill will seek out the caves as these lie in a rough recess to the north of the mountain's rocky summit. Equally difficult of access is a single cavity on an eastern shoulder, simply marked 'An Uamh', the cave, on the larger scale map of the Ordnance Survey.

Before metric recalibration of the height confirmed it to be of Corbett status the mountain rarely attracted attention. Those who come to know the mountain will count its dismissal an error of judgement on their part as its rough shoulders add character to the hill which enjoys an unusual perspective along the sea-lanes of Loch Linnhe and Loch Leven.

Right Beinn na h-Uamha looking to Ballachulish and Glen Coe (*Peter Collin*)

GARBH BHEINN

2,903ft/885m

The rough mountain

Many of the mountains in the district of Ardgour display large areas of rock, which break through the thin coverlet of heath. Most could be termed rough so that this peak must have been deemed particularly so. Like the other peaks which bear the name the mountain lies in an area of high rainfall which prevents the spread of grass over the exposed rocks. Fine cliffs buttressing the summit emphasise its rugged character, and are a popular haunt of the climber.

Below Loch Linnhe from Sron a' Ghairbh Choire Bhig, Garbh Bheinn (*Ian Evans*)

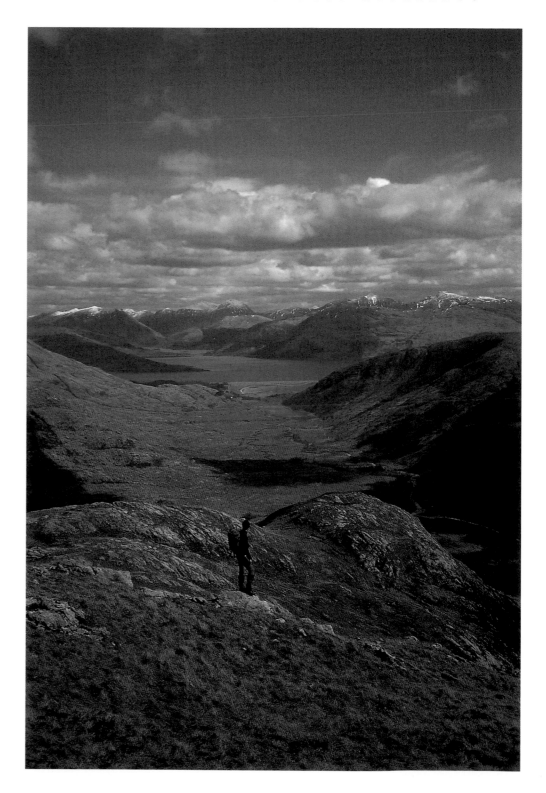

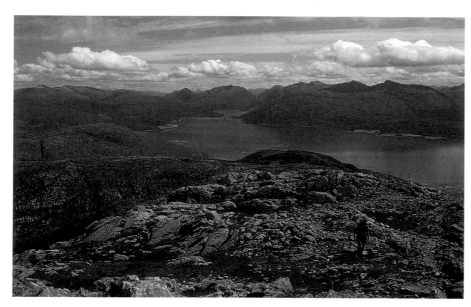

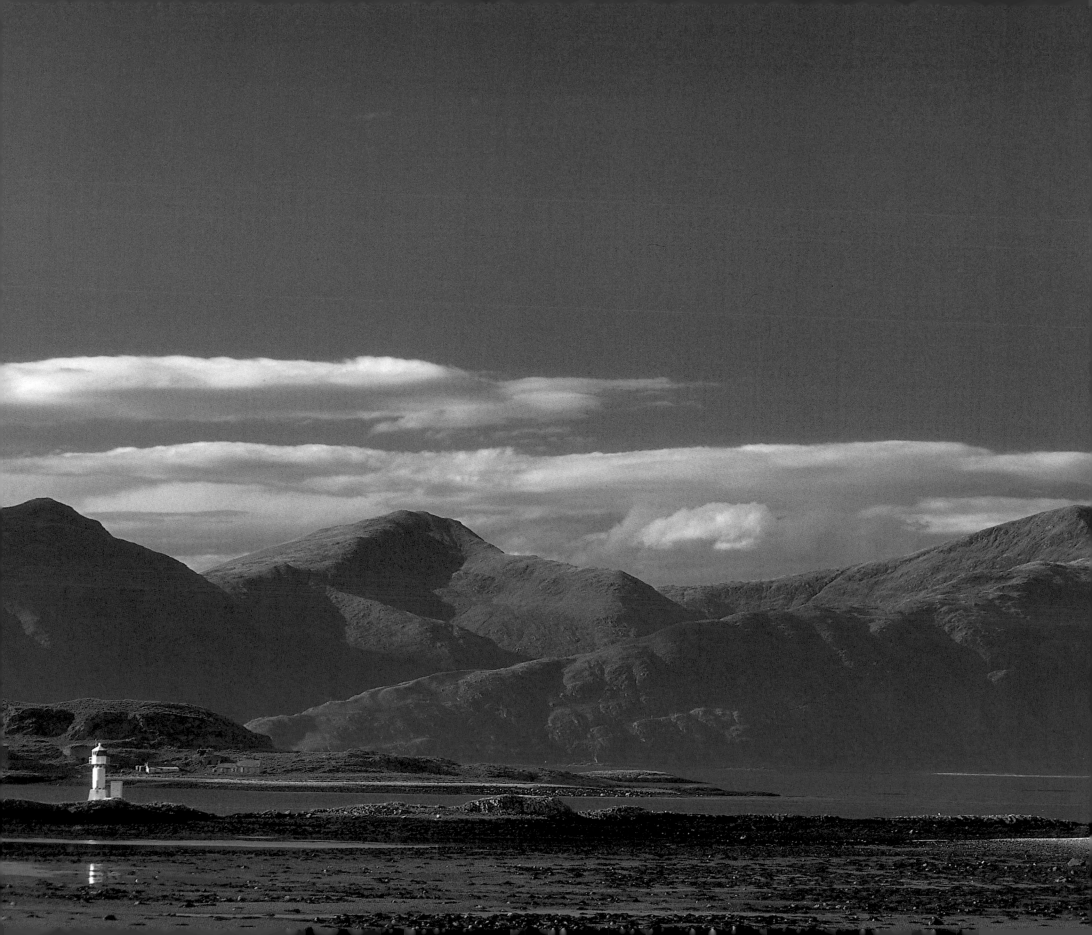

CREACH BHEINN

2,798ft/853m

Mountain of the spoil or plunder, or bare, windswept hill

There are three mountains of this name which gives some idea of the prevalence of cattle raidings as part of the culture of the clans in times past. The mountain sits above the head of Glen Galmadale, a cul-de-sac easily defended and rich in pasture on which to feed the stolen herds. The term 'creach' may also refer to a bare windswept hill. This too may be appropriate as the western gales sweeping in from the sea reach the hill unhindered, to scour its summit. This uninterrupted vista was one of the reasons that the mountain was chosen as one site for the earlier Ordnance Survey triangulation. Walls built to protect the surveyors' tents from the blasts may still be seen immediately below the summit, and are still recorded as 'camp' on the map.

Left Fuar Bheinn and Creach Bheinn from Port Appin (*Stuart Rae*)

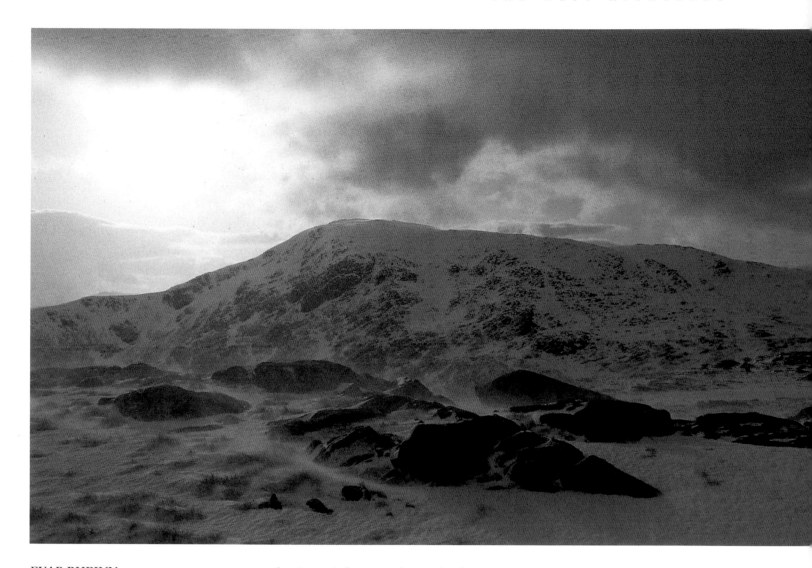

FUAR BHEINN

2,513ft/766m

The cold mountain

As the title of the neighbouring mountain may have an alternative translation which suggests that it is windswept, the cold nature of this hill may well be derived from the same exposure to the driving south-westerly winds. Snow comes when the winter winds veer north westerly when it is sometimes possible to experience Arctic conditions on the tops. Such periods are usually brief as the warmer air of the Gulf Stream predominates in these western sea-lapped hills.

Above Fuar Bheinn from Meall nan Each (*Richard Wood*)

81

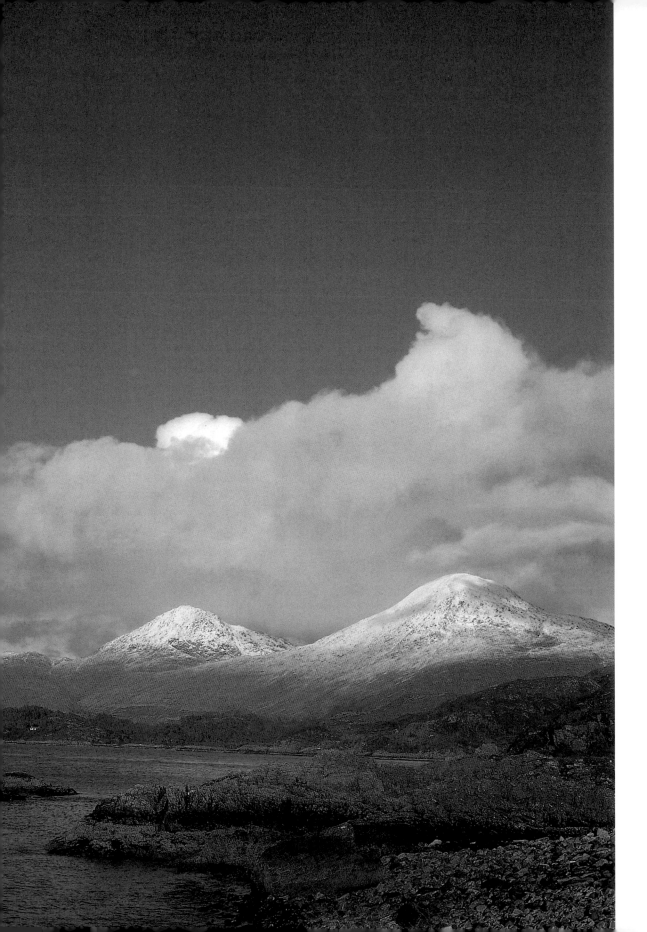

ROIS-BHEINN
(FOISBHEINN)

2,894ft/882m

The mountain of the showers,
or headland hill

The name is usually assumed to
be an incorrect spelling of 'frois-
bheinn', mountain of showers,
though quite why a hill in an area
noted for its persistent rainfall
should be singled out remains
unexplained. 'Frois' is more
correctly a shower of grain but
this is hard to justify given the
lack of suitable arable ground
along the mountain's foot. 'Ros',
meaning headland, is not a
commonplace in hill names but
given the proximity to the sea
may explain the interpretation as
'ros-bheinn', headland hill.

Left An Stac and Rois-bheinn
from Irine (*Irvine Butterfield*)

SGURR NA BA GLAISE

2,867ft/874m

Peak of the grey cow

The name of this hill is another
associated with the herding of
cattle which were a measure of the
Highlanders' wealth in times past.
Most of these were black or dark
red in colour so that a grey cow
would stand out from the rest of
the herd. The many ruins at
Assary and Ulgary at the head of
Glen Moidart are all that remains
of a once thriving community.
Here on the grassy slopes that
climb to the mountain crest cattle
would find their pasturage and in
all probability one of their number
became attached to the hill.

Right Looking east along the
ridge from Sgurr na Ba Glaise
(*Jim Teesdale*)

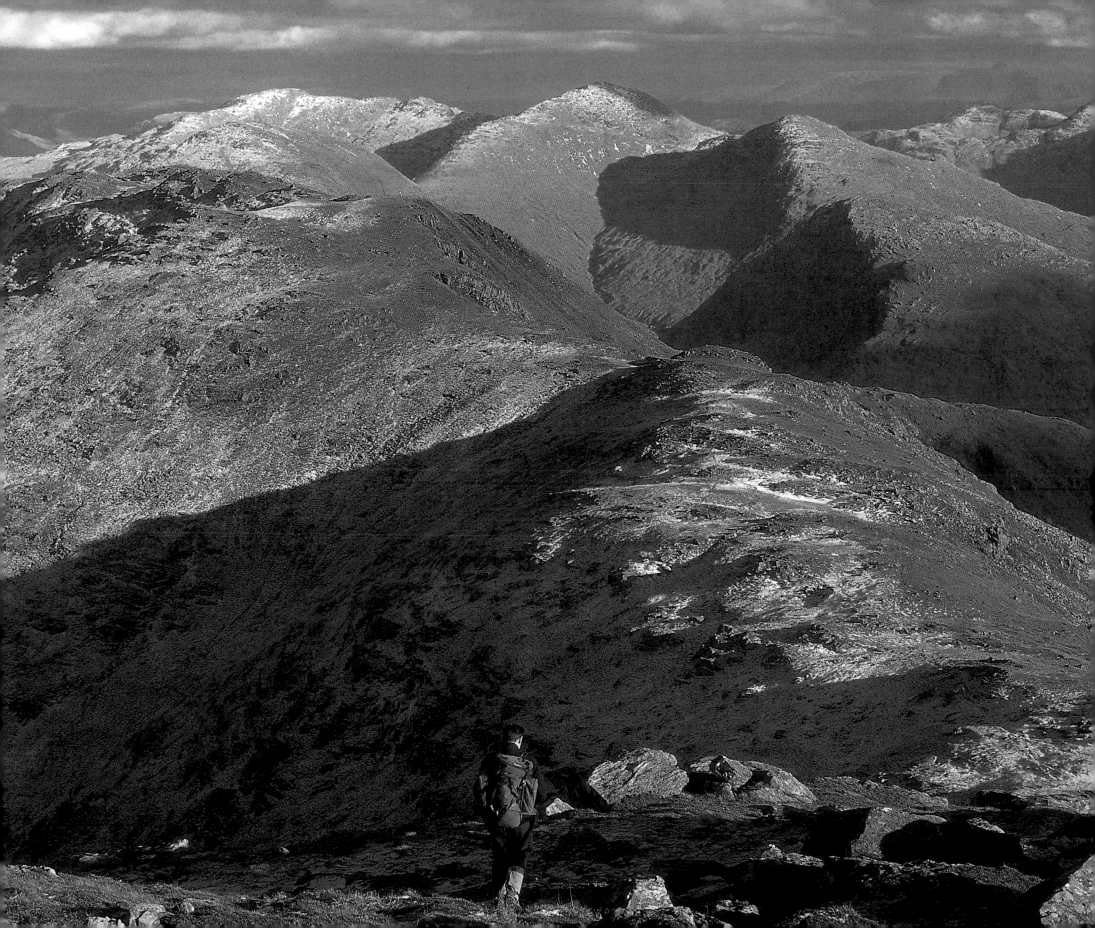

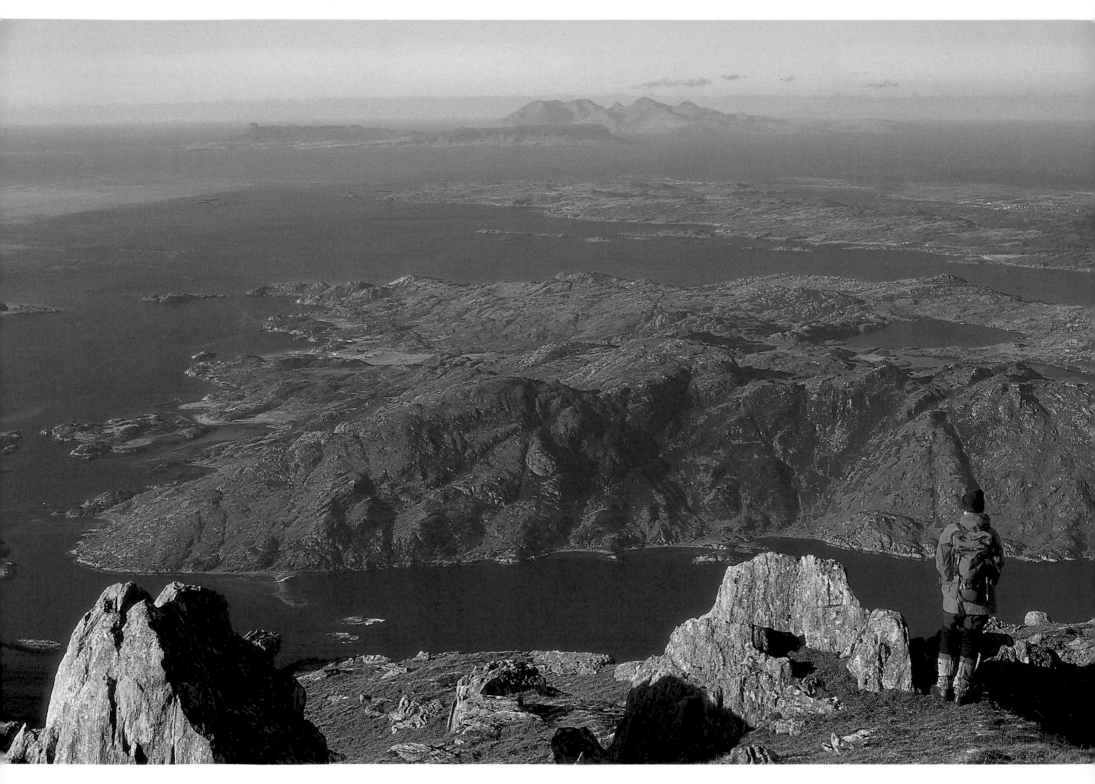

AN STAC

2,670ft/814m

The stack

Conical in shape, and rough with outcrops, the hill has a distinctive appearance not unlike that of a sea stack set apart from a headland, which here would be the bold mass of Rois-bheinn.

Proximity to the sea makes the name seem all the more appropriate and no appreciation of the mountain would be complete without its lapping waters.

Left Looking to Eigg and Rum from the summit of An Stac (*Jim Teesdale*)

Right Beinn Mhic Cedidh and Beinn Odhar Bheag from Druim Fiaclach (*Ian A. Robertson*)

BEINN ODHAR BHEAG

2,894ft/882m

The little dun-coloured, or tawny, mountain

Although its lower slopes are thick with the pale grasses which gave it colour this peak is smaller in bulk than its twin, Beinn Odhar Mhor, and therefore classed as such by title to become the 'little mountain'. This is a classic example of the use of the term 'bheag'. As the greater height of the two mountains it was this feature alone which gained it a place in Corbett's list, though it should feature in any self-respecting mountaineer's itinerary for its views are superb.

Right Looking down Loch Shiel from Beinn Odhar Bheag (*Irvine Butterfield*)

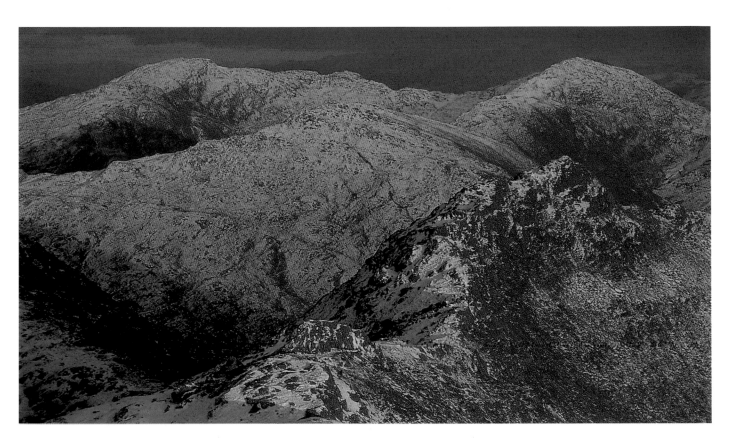

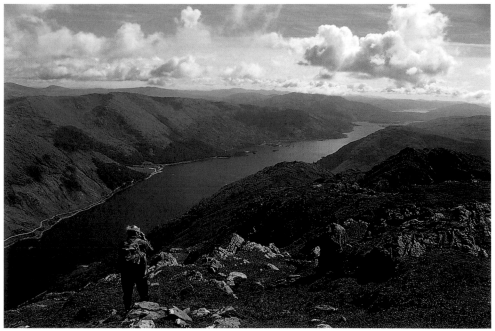

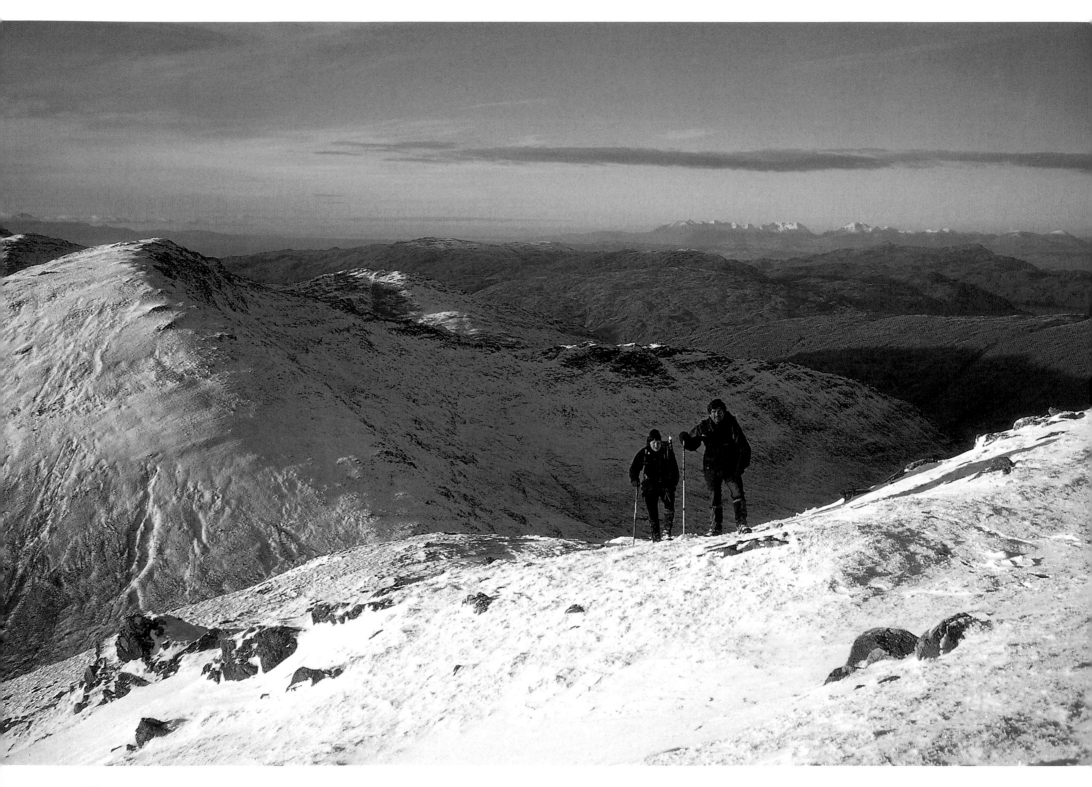

BEINN MHIC CEDIDH

2,569ft/783m

Hill of the son of Katie, or Kitty

The difficult word to decipher in the title of this hill is 'cedidh', pronounced 'kaytee'. As it is preceded by 'mhic', which means son of, the name is a personal one, and is therefore possibly Katie, or Kitty, a shortened version of Kathleen, or Catherine.

This mountain suffered at the hands of the cartographers and was not identified as a Corbett until remapping and the revision of tables in 1980.

Left Beinn Mhic Cedidh from Beinn Odhar Bheag (*Hugh Munro*)

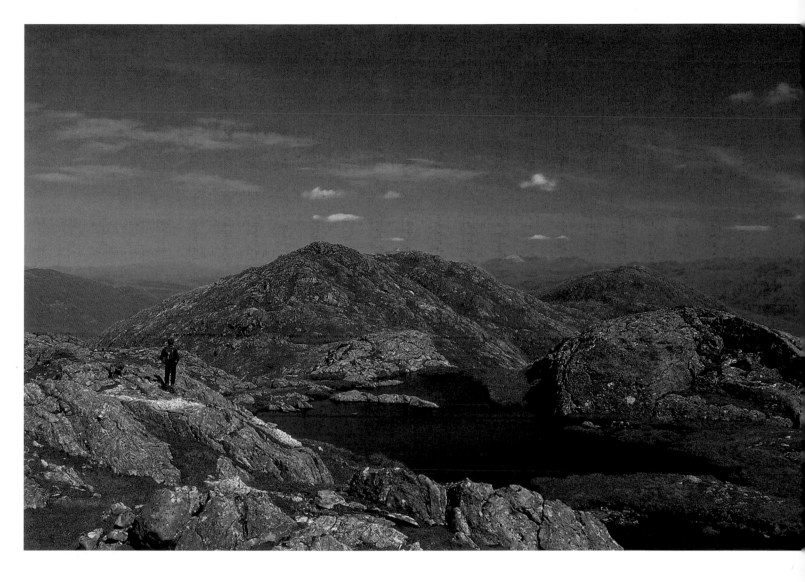

STOB A' BHEALACH AN SGRIODAIN

(DRUIM TARSUINN/AN SGRIODAIN)

2,526ft/770m

Peak of the pass of screes – Transverse, or crosswise, ridge – The screes

Over the years there has been some difficulty in obtaining the correct, and locally accepted, name for this hill. Corbett's original list gave Druim Tarsuinn which clearly refers to the ridge set at an angle to the main thrust of the ridge between the upper reaches of Glen Scaddle and Cona Glen. It was not until the revision of Corbett's Tables in 1990 that the name was considered inappropriate. As was custom and practice the word 'stob' was adopted for the word peak which, in turn, was associated with the most readily identified feature, here the ancient pass across the ridge on the route between Glen Hurich and Glenfinnan.

The ridge is typical of many of the hills in this area with a vertebrae of exposed rock breaking through a thin coverlet of grass.

Above Meall Mor and Stob a' Chuir from Stob a' Bhealach an Sgriodain (*Irvine Butterfield*)

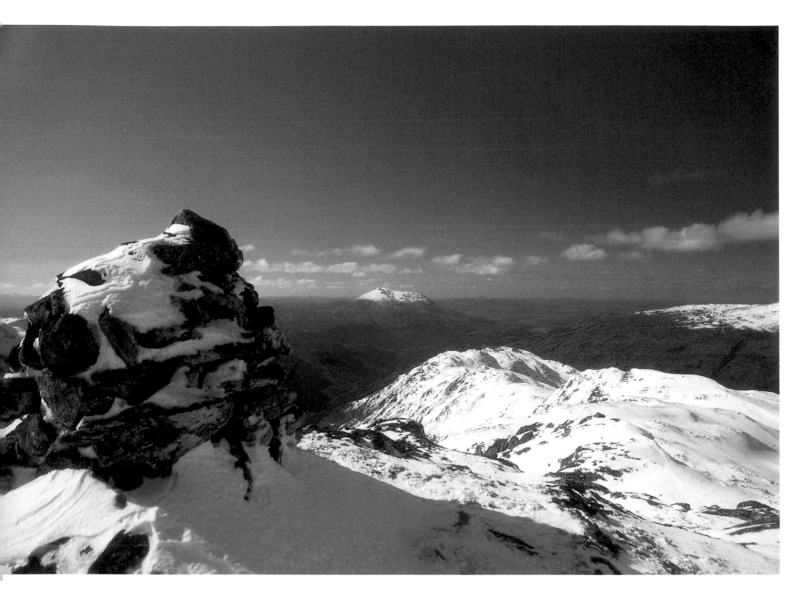

STOB COIRE A' CHEARCAILL

2,529ft/771m

The peak of the circular corrie

Chearcaill comes from 'cearcall', a hoop, so that a literal translation would be peak of the corrie, or hollow, of the hoops. This is intended to convey that the lines of stratification run around the corrie wall like a series of hoops. This has been interpreted as the more readily understood circular corrie.

Summit views are extensive with all the hills about Loch Linnhe and Loch Eil stretching into the distance line upon line. Closer at hand the Ardgour hills catch the eye with the mighty anvil of Garbh Bheinn ever present on the near horizon. *Right* To Garbh Bheinn from Sgurr an Iubhair, Stob Coire a' Chearcaill (*Tom Rix*)

CARN NA NATHRACH

2,579ft/786m

Cairn of the adder, or serpent

As the only poisonous snake encountered in the Highlands the presence of adders in numbers would be closely monitored and the name here probably signals such a danger. There are stories of serpents of more ominous intent but none so far as I can find relating to such a beast on this hill.

The serpentine length of the hill has many a knot and knoll from which to survey the country round about. As with many a western location there is an inevitability in the choice of view, that to the western seaboard and the shapely Beinn Resipol enjoying most favour. *Above* Beinn Resipol from summit cairn, Carn na Nathrach (*Richard Wood*)

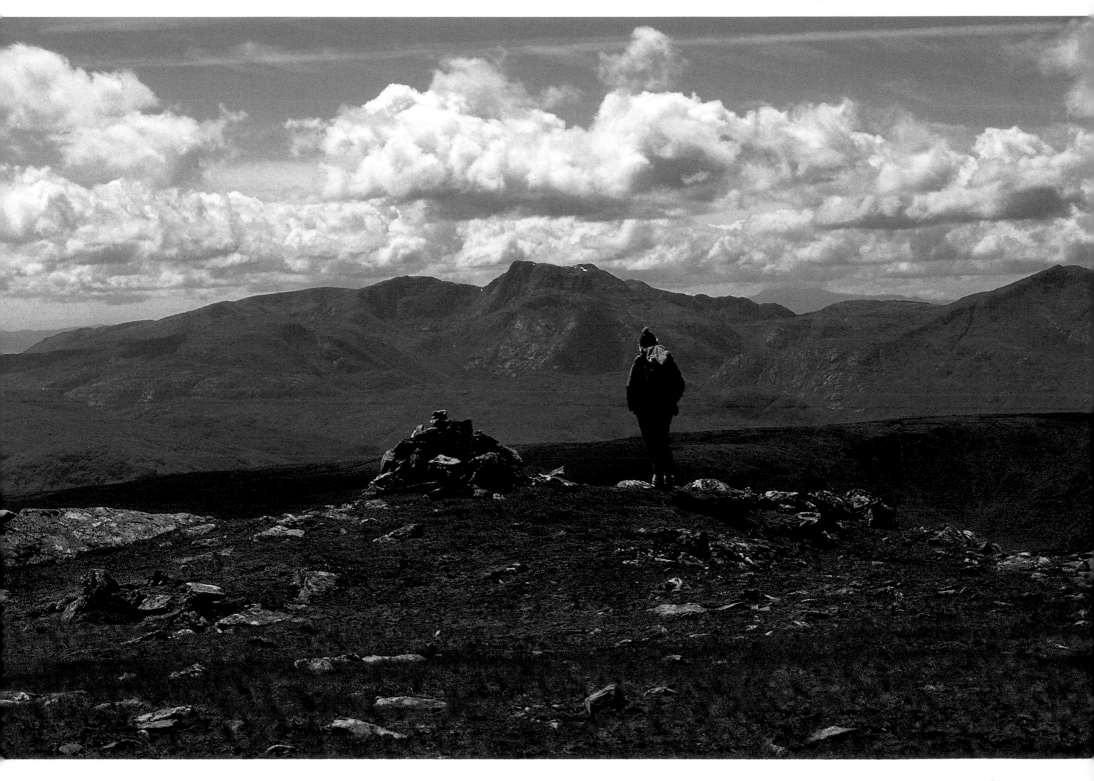

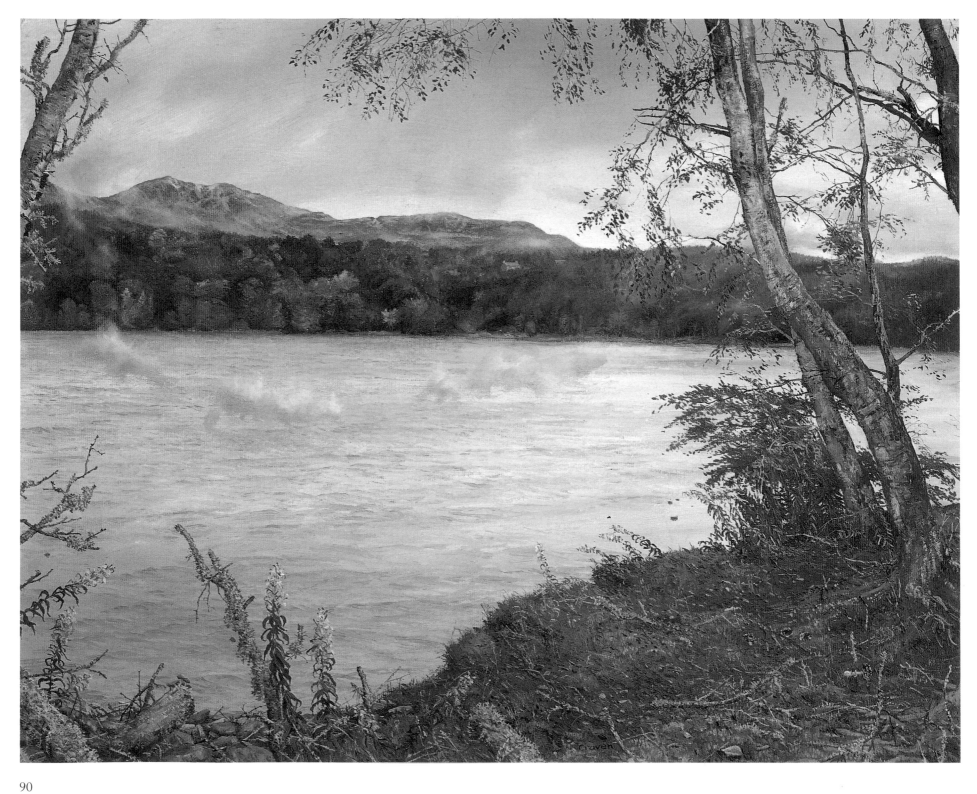

THE CAIRNGORMS

OUTLIERS TO SOME OF BRITAIN'S HIGHEST PEAKS, THESE lower and more singular hills mark the bounds of glaciated glens leading to the central massif. They lack none of the atmosphere of the lonely glens and expansive plateau from which, like their greater brethren, they were carved. Broad-backed heathery summits are the high promenades where walkers are ever-conscious of space and the vast distances and broad spread of the greater Cairngorm plateau, ever-present on the immediate horizon.

Left Ben Vrackie from Loch Faskally (*Paul Craven*)

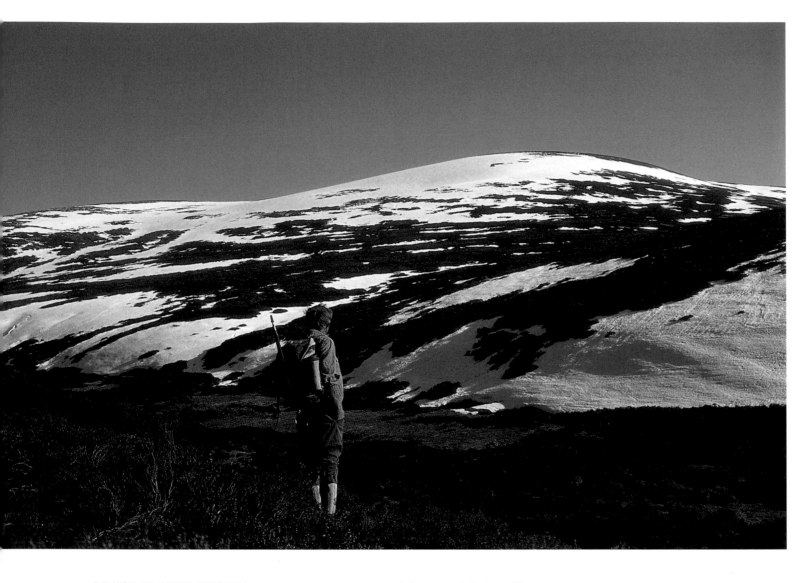

MEALLACH MOR

2,523ft/769m

The big hump, or great lumpy hill

'Meallach', lumpy, is a simple, and apt, description for a hill which enjoys separation from its near neighbours by dividing troughs which make this hill a most singular hump. To the east lies a vast sprawl of rounded hills, beyond which rise the higher Cairngorms. A more noteworthy view is that southwards to the steep walled hills flanking the cleft of the Gaick.

Right Looking to Gaick from the summit cairn, Meallach Mor (*Hugh Munro*)

LEATHAD AN TAOBHAIN

2,992ft/912m

Slope of the rafters

'Taobhan' is a side rafter, or the wattles which were laid across the rafters before the upper layer of thatch was put on to complete a roof. In appearance these are a series of parallel ribs and may hint at the appearance of the mountain's slopes. Thus the alternative name, slope of the ribbed side, would not be inappropriate. The ribbing effect is best illustrated when late snows still linger in the mountain's folds.

Above Leathad an Taobhain summit from the north (*Tom Rix*)

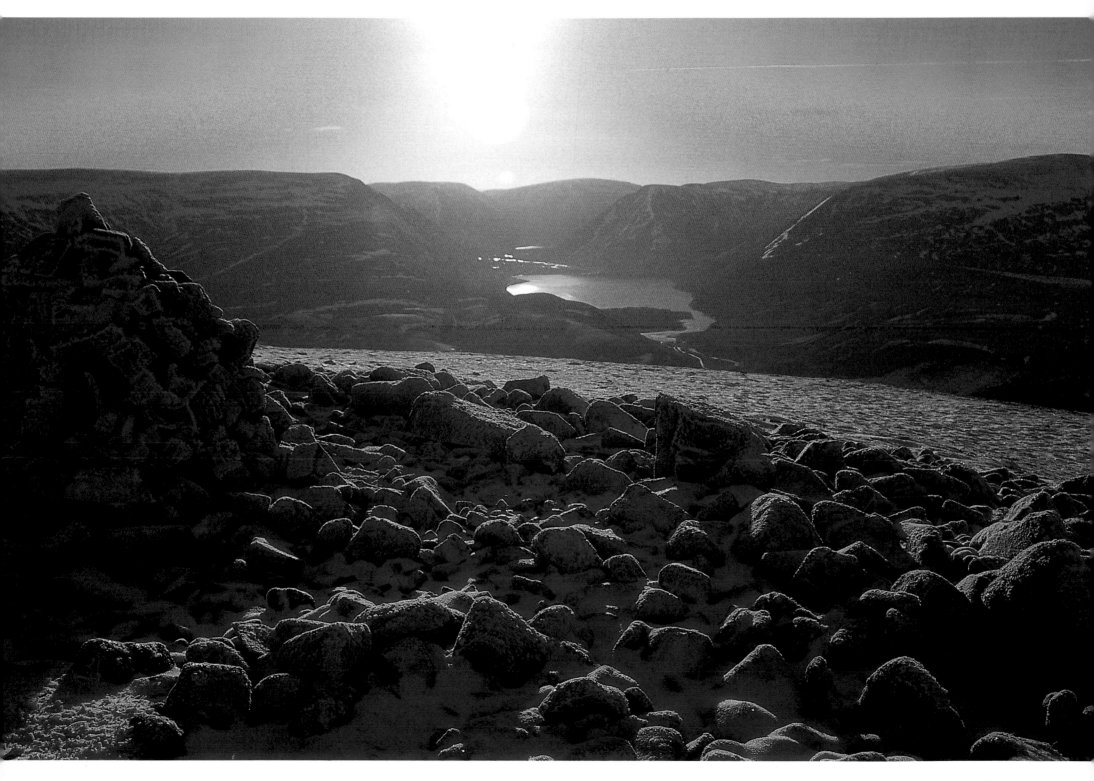

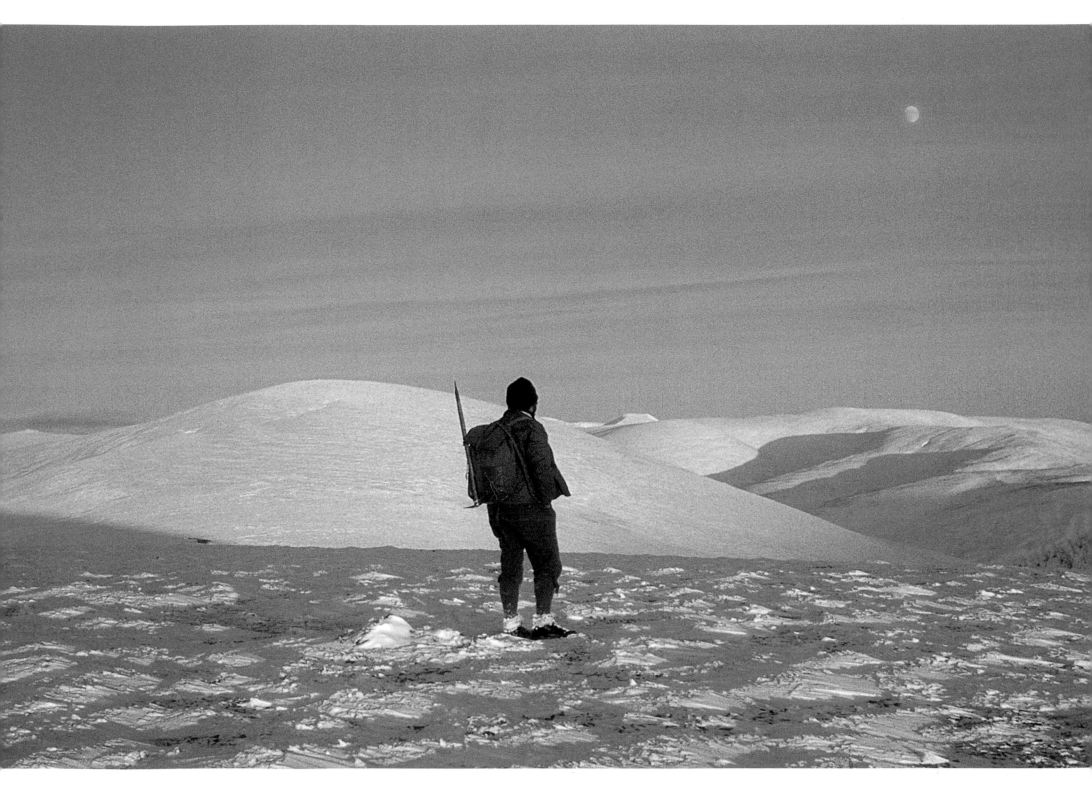

CARN DEARG MOR

2,812ft/857m

Big red hill, or cairn

The Gaelic 'dearg' is a blood-red colour with a hint of crimson. This is a name often applied where a hard granite rock intrudes through layers of grey schist. The red here is the prevailing granite of the Cairngorm massif, or to give the range its more correct title the Monadh Ruadh, the red moor.

There may be a redness too in the light of late evening and there is no finer place to be than on the summit at such a time to catch the last dying embers of the sun touching the high tops of the Cairngorm massif.

Left Looking to Cairn Toul from Carn Dearg Mor (*Irvine Butterfield*)

MEALL A' BHUACHAILLE

2,657ft/810m

Hill of the cowherd, or herdsman's hill

Here we have another reference to the predominant pursuit of the Highland people at a time when wealth was measured by the number of cattle owned. The hill also lies above the start of an ancient hill crossing, Lairig an Loaigh, used by the drovers in passage from the Spey to the Dee, en route to the southern trysts. As such it would be a significant waymark to the herdsmen.

Above right Meall a' Bhuachaille from Coire na Ciste (*Irvine Butterfield*)

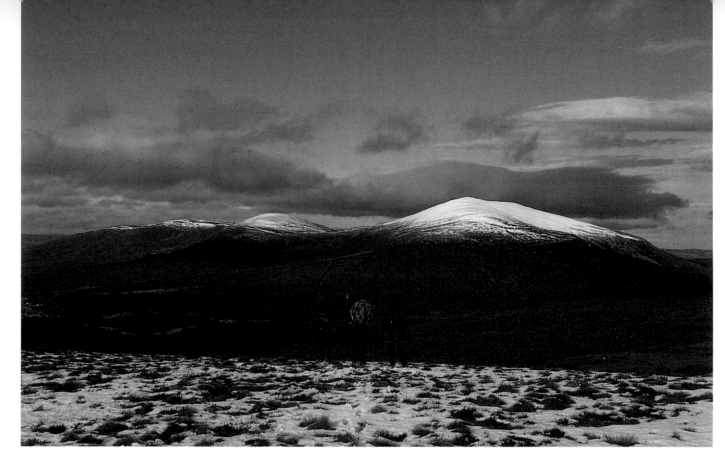

GEAL CHARN

2,693ft/821m

White hill

The fair, or pale, colour denoted by the use of the Gaelic 'geal' is usually translated as white. Pale or fair is more appropriate as it is intended to convey that the colour results from the presence of late-lying snow which prevents the growth of the darker heather at the expense of the lighter grasses.

The hill lies to the north of the main Cairngorm massif and so is easily overlooked in the presence of its mightier neighbours. Even though in view passers by in the Forest of Abernethy are seldom conscious of its identity.

Above Carn Bheadhair and Geal Charn from Ryvoan (*Irvine Butterfield*)

CREAG MHOR

2,936ft/895m

Big crag, or big rocky hill

'Creag' can be a cliff or precipice, or on occasion a rock of some note. Here there are some minor protective outcrops on the lower slopes, where large expanses of granite screes abound. A small granite tor marks the summit so that the chosen interpretation of the hill name may depend much upon one's own perspective.

Right The summit rocks, Creag Mhor (*Ronald Turnbull*)

MORVEN (MORRONE)

2,818ft/859m

Big hill, or nose

In the original Dee-side Gaelic the hill was known as Morbhuinn, big peak. This was easily anglicised to Morven, a name which still has some currency among older hill-walkers. In the last century a local guide by the name of Downie invented the name Morrone. This was accepted by visitors and, although not accepted in local parlance, did eventually pass into common usage, to be later adopted by the Ordnance Survey.

F.C. Diack in his unpublished records of local place names notes that around Braemar the hill was known as Mor-vinn, which phonetically sounds in pronunciation very much like 'mor-rone'. This he later confirmed, but criticised the Ordnance Survey for adopting this as mor-shron, big nose, on their first map.

This appears to be supported by MacPherson's *Royal Braemar* published in 1906 which gives the name 'Morbhinn', or 'morving', big hill. It might also be a corruption of 'Mor roin', big point, which occurs on some of the earlier maps of 1807–9. This was supported by another researcher by name of Macgillvray who wrote of 'a large hill named Morrone – Mor-sthroithe'. The hill is undeniably a prominent point overlooking the township of Braemar with expansive panoramas to be had of the high Cairngorms.

Left To the high Cairngorms from Morven (*Irvine Butterfield*)

SGOR MOR

2,667ft/813m

The big rock or great peak

Sgors are the terminology of the Eastern Grampians to indicate a rocky-topped hill or sometimes the presence of a rocky notch or cleft. This hill might be more correctly An Sgor Mor, the big rocky hill. The big rock from which the hill derives its title is a prominent granite tor which sits on the high point at the western end of the ridge. If it is a rocky cleft we seek then the near presence of the long defile of the Lairig Ghru flanked by the rock walls of The Devil's Point provides the sought-for nuance.

Right Looking to the Devil's Point and the Lairig Ghru from Sgor Mor (*Hugh Munro*)

96

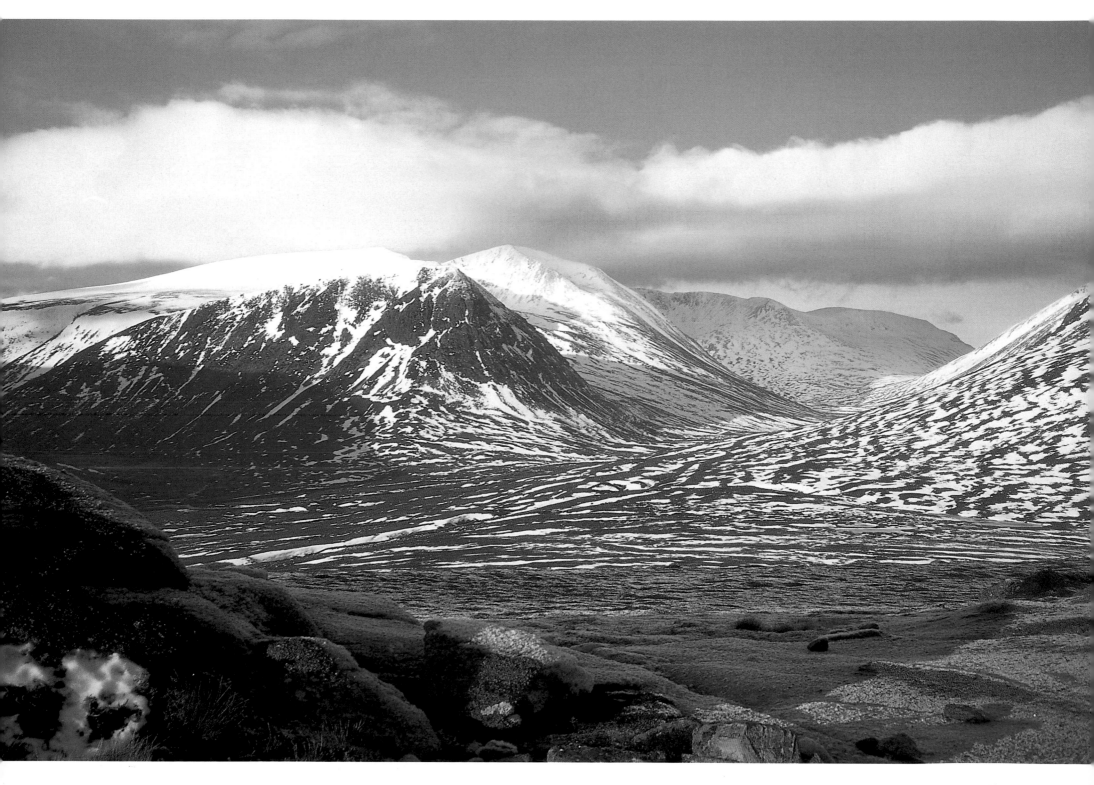

CULARDOCH

2,953ft/900m

Back of the high place, or big-backed high place

The name is more properly Cul Ardoch Mor meaning a big-back high place. Roy's maps give Coulardochie, suggesting the name was possibly Cul Ardachaidh Mor in its original form.

The name could also be from cul, meaning back of, and 'fardach', a dwelling house. The house here might be the seat of the Farquharsons of Invercauld who are said to have obtained the mountain and lands hereabouts from the king.

The story goes that a stranger appeared at the house of Findla Mor, the first chief, who was later killed at the battle of Pinkie. The chief fed and hosted the stranger, and the following morning accompanied him a considerable distance to direct his steps across the Bealach Dearg. The chief later received a letter appointing him Royal Standard-bearer for Scotland, and confirmed him in his possession of the property. The 'stranger' was none other than the king who thus acknowledged his hospitality to travellers.
Above Culardoch from Gelder Shiel (*Ronald Turnbull*)

CARN LIATH

2,928ft/962m

Grey cairn

Old Invercauld maps and a few of the older inhabitants knew this peak as 'the hill or the top of liath corry beg' (Liath-choire Beag). The greyness here suggests the screes which break through the hill's heather coverlet. Only Liath-choire Mhor is shown on present-day maps and this rises in the dip between the mountain's twin tops. As both summits are of equal height this suggests that the hill-top referred to on the older maps was that at the western point of the ridge. That this had pre-eminence is borne out by the fact that at one time it was listed as the Corbett and known by the name Creag an Dail Bheag, hill of the little field. The actual crag blunts the western slope above the river Gairn and has a counterpart on the opposite bank, Creag an Dail Mhor.

Below Carn Liath and Culardoch from Morrone (*Irvine Butterfield*)

CARN NA DROCHAIDE

2,684ft/818m

Hill of the bridge

At various times the name has appeared in map and manuscript as 'Cairndrochet', 'Cairndrochat', 'Carn Drochit', 'Carn Droughd' and 'Carn dryochat'.

There was a recognised ford on the Dee and the bridge here may refer to such a point of crossing, or bridging, of the river. As seen from Braemar the mountain is not dissimilar in profile to the old humped-backed bridges and it is this which may also account for the name. Lying close to the higher mountains its easy ascent appeals to those in search of glimpses of the Cairngorm giants.
Right Cairn Toul from Carn na Drochaide (*David May*)

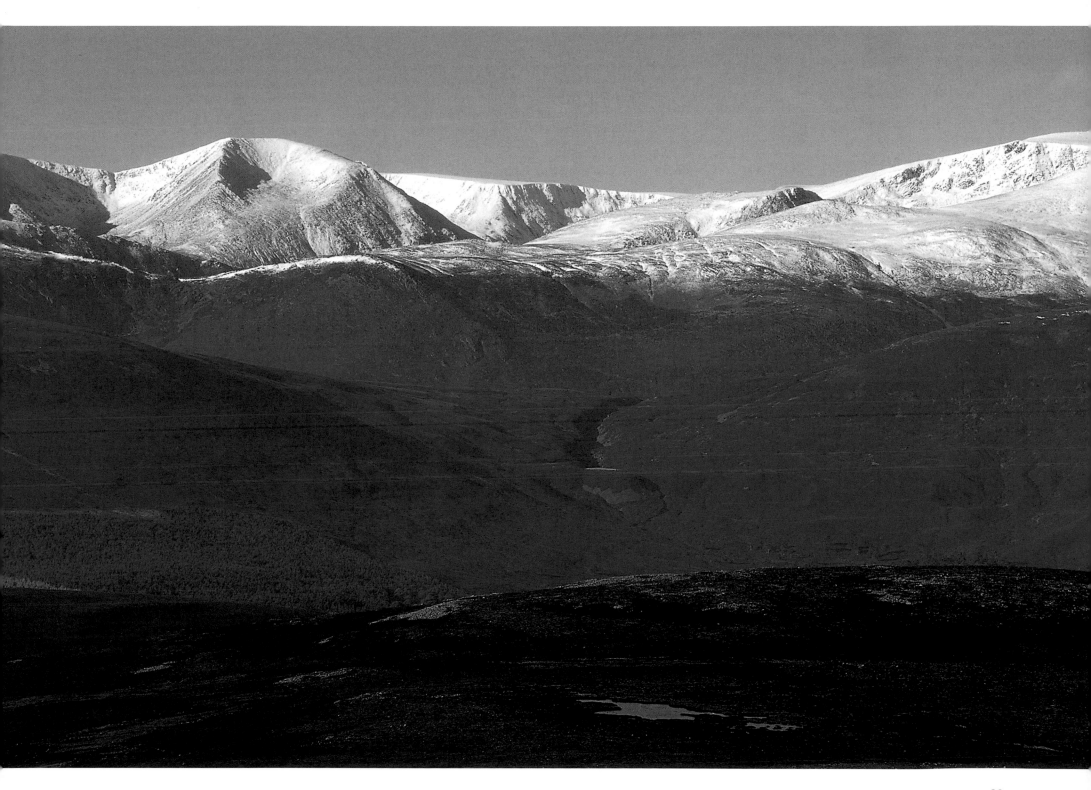

CARN MOR

2,638ft/804m

Big cairn, or hill

This is the highest and most extensive mountain spread in the Ladder Hills so that its title is simple and factual. The name applied to the range has its roots in 'aradh', a ladder, a term often applied to hills with ridges across them. Originally Monadh an Araidh, and correctly translated as 'the Ladder Hills', they are currently so mapped.

The most favoured round of these hills is by way of the deserted settlement of Scalan and it is easy to see why such a lonely spot was chosen for a seminary. A few trees beside a solitary farm house speak of a time when many inhabited these isolated glens, and provide a reminder that the great flanks of these heathery hills once echoed to the calls of men.

Right Carn Mor from Scalan (*Irvine Butterfield*)

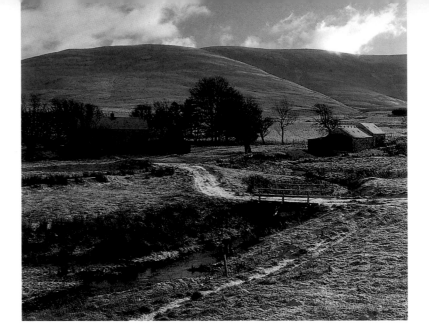

CORRYHABBIE HILL

2,562ft/781m

Origin unknown

The first element of the name suggests an origin in the Gaelic 'coire' and on occasions the mountain name has appeared as Corriehabbie. It has been speculated that the first element may also stem from 'corban', white. The second element 'habbie' is more problematical and though tenuous there may be some link to 'abaid', an abbey, or monk's cowl.

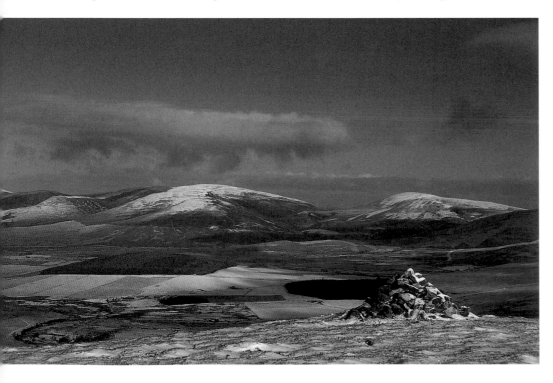

This would provide a possible derivation from Coire na h-abaid, the hollow of the monk's cowl.

This may not be quite so far-fetched as in the area close by adherents of the persecuted Roman Catholic faith built their seminary at Scalan. The ruins in the shadow of Carn Mor look across to the mountain.

Left Corryhabbie Hill and Cook's Cairn from Cairn Dulack (*Irvine Butterfield*)

BEN TIRRAN (THE GOET)

2,939ft/896m

Hill of dry corn (origin unknown)

The source of this hill's name is obscure and is almost certainly a corruption of a long-forgotten incident recorded in the local Gaelic dialect. Pronounced 'turran', the closest suggestion is noted in *Munro's Tables* as probably a derivative of 'tuireann', lightning. This gives little clue as to why the mountain has an association

of such peculiarity. 'Tuireann' might equally be a spark from an anvil but again no other corroborative evidence is forthcoming.

It is suggested that the derivation may lie in the Gaelic 'tir', land, and 'ran', a drawling or melancholy cry. The latter could hint at the call of the curlew, which commonly inhabit such sprawling upland moors, and this mountain is certainly such a place.

Equally elusive is the origin of the name 'The Goet', a local name given to the hill. Though somewhat tenuous there may be a link to the Gaelic 'gort', standing corn, a field, or an enclosure. Corn has been grown on the lower ground in Glen Clova along the mountain's foot and it could be that the ground here favoured the production of one of the staple crops in days gone by.

Right Loch Wharral from Ben Tirran (*Tom Rix*)

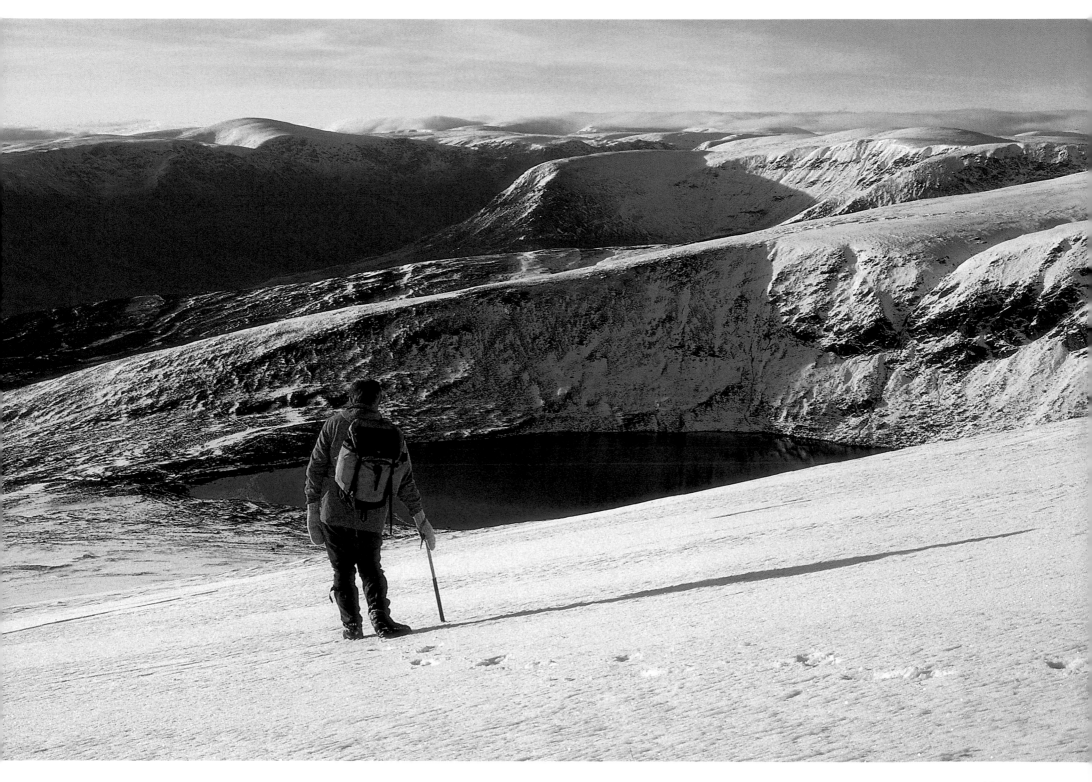

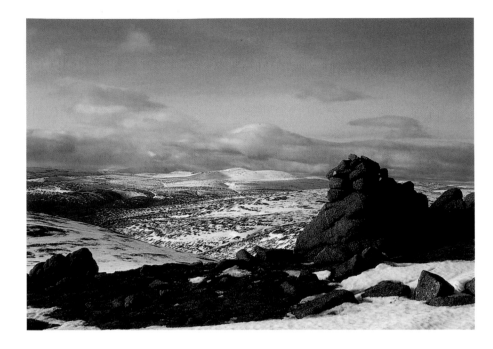

MOUNT BATTOCK

2,552ft/778m

Hill of birches, chump hill, or tufted hill

The name is derived from the Gaelic Monadh Beathach, hill of the birches. Others contend that 'battock' comes from an old word for chump, this being the end of a lump of wool. There is also a suggestion that the name was originally 'monadh badach', tufted hill, suggesting that the going underfoot will be a problematic tumble of coarse heather or grassy hummocks. Both are encountered on the hill.

This is one of several hills in the Eastern Grampians to include the word Mount in its title. This comes from the Scots 'mounth' meaning a high moorland, or more literally a mountain mass that hinders travellers. The Mounth was the name given to the range of hills now known as The Grampians. The latter title now exists in truncated form as the area of high plateau south of the River Dee.

Above Mount Keen from Mount Battock (*Irvine Butterfield*)

BEN GULABIN

2,644ft/806m

Hill of the curlew, hill of the beaked bird, or beaked mountain

Ancient spellings give the name Ben Gulbin, or Ben Gulvin, from 'gulban', a beak. It may also by a derivative of 'guilbeach', a curlew. This bird with its long curved beak is also known as the whimbrel. The name Gulbin occurs in several locations which have some association with the legendary Fingalians. The near presence of a mountain associated with the hunting of boar is significant as the Fingalians were great hunters. These hills all lay claim to be the last resting place of Diarmaid, his lover Grainne, and their two white hounds.

The legend tells of Diarmaid, who stole Fingal's queen, Grainne. Diarmaid slew the great boar of Ben Gulabin and, seeking revenge, Fingal asked him to measure the beast with his bare foot. The unsuspecting Dairmaid's foot was pierced by the boar's poisoned bristles and he died, wherupon the heartbroken Grainne flung herself on an arrow and killed herself. The pair are said to be buried with their faithful hounds on Tom Dairmaid. This hillock, topped by four short standing stones, can be found behind the farm at Tomb across the river from the Spittal Hotel.

Below Ben Gulabin from Tomb of Dairmaid (*Irvine Butterfield*)

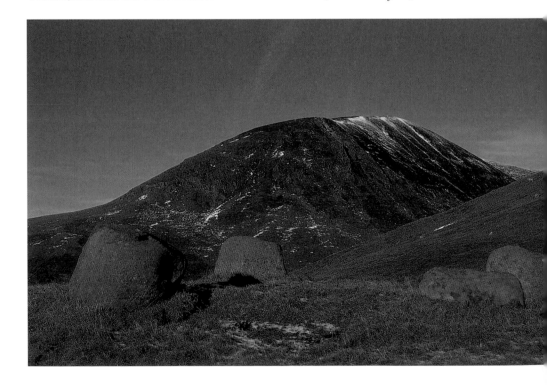

MONAMENACH

2,648ft/807m

Middle hill or mountain

The Gaelic 'monadh mheadhonach', the middle mountain, indicates its central position between other hills. As one of a whole range of rolling hills this aspect of the hill's character is best appreciated from a distance. Various vantage points along the glen of the Shee Water to the west help to identify the distinct dips in the broad ridge extending from the Glas Maol massif, and confirms that this hill sits between Black Hill and Mealna Letter. From the lower ground on this western side Craigenloch Hill might easily be mistaken for the rounded mass of Monamenach, whose summit peers shyly over a shoulder.

Right Monamenach and Craigenloch Hill from Westerton of Runavey (*Irvine Butterfield*)

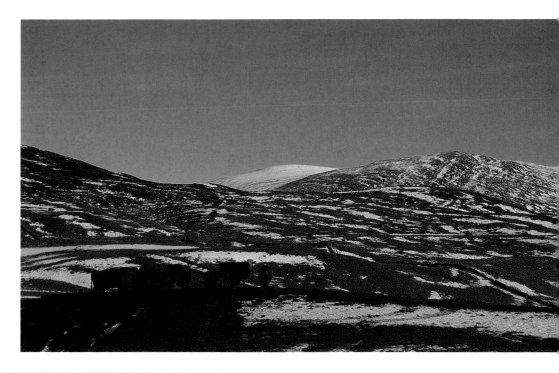

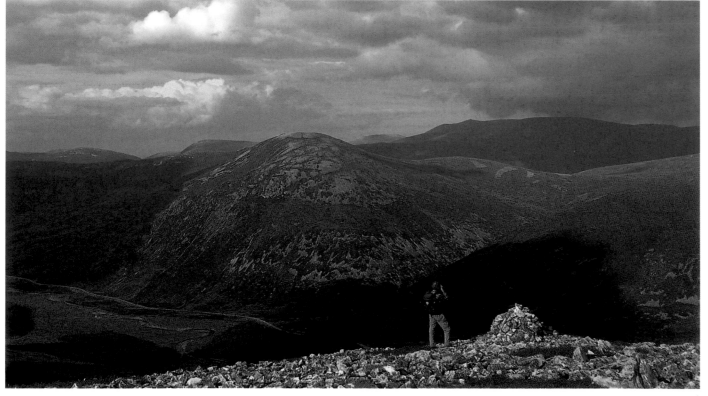

CREAG NAN GABHAR

2,736ft/834m

Crag of the goats

An old Invercauld map gives 'Rocks of Craig-na-goir' on the north-western corner of the hill above the road along Glen Clunie. Thus the hill's name seems to have been established at a time when the presence of goats was of some interest to the local inhabitants.

The hill lacks presence, being little more than one of a range of rolling hills along the east side of Glen Clunie, and some other chosen viewpoint is needed to capture the ambience of this particular hill.

Left Creag nan Gabhar and Lochnagar from Sgor Mor (*Irvine Butterfield*)

CARN EALASAID

2,598ft/792m

Exaggerated hill, or Elizabeth's cairn or hill

One of the rare Scottish hill names connected to a lady, but who this particular Elizabeth was goes unrecorded. Local pronunciation suggests that the name should be Carn Aillsichte, exaggerated mountain, in the sense that it is very great or extensive. Compared to other hills ranged on the north side of Strath Don the hill does appear to be the largest in both height and breadth, and this suggests the most plausible explanation for the name.

Below Carn Ealasaid from Inchmore (*Irvine Butterfield*)

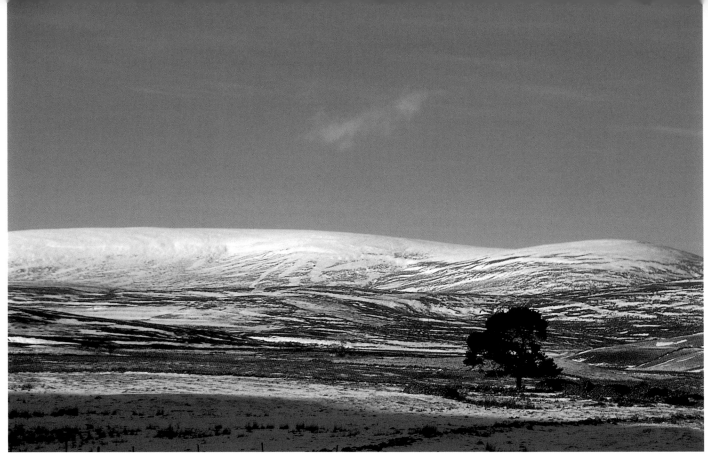

BROWN COW HILL

(CARN SAWVIE or
CARN NA SAOBHAIDH)

2,720ft/829m

Brown cow hill (Cairn of the fox's den)

A' Bho Dhonn, the 'Bow Gouln' of Roy's map, 'bo-dhonn', 'Bowown', 'Bovown' and the coloquial Doric rendition 'Broon Coo', all suggest a long association or links to a brown cow, possibly from the days when cattle were the mainstay of the Highland economy. Further emphasis is given to this link as the hill's southern slope carries the late-lingering crescent of a snow-drift well into early summer. This is known locally as the White Calf which in summer shows as the lighter coloured grasses stencilled into the darker heath.

Seton Gordon, noted for his collections of local folklore, was told by the old Balmoral stalkers that this was the Brown Cow's White Calf, and that they used this name.

Above Brown Cow Hill from Balnaan (*Irvine Butterfield*)

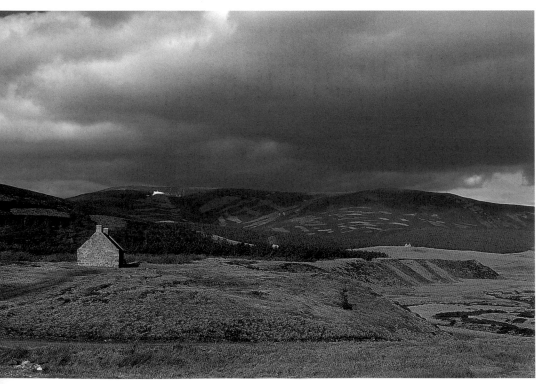

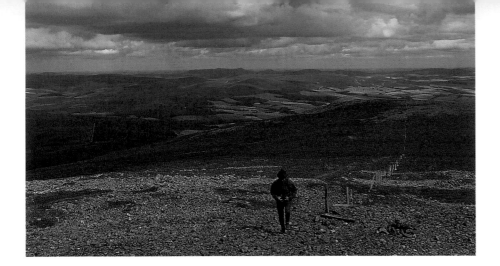

MORVEN

2,857ft/871m

Big nose or hill

Old names of Morvine, Morevene and Mons de Morving all suggest that this hill has long been regarded as a prominent landmark, and certainly dominates the views around Aboyne. As the commanding height above the Howe of Cromar there seems little doubt that the name was intended to convey that this was an impressive hill, hence 'mor bheinn', big hill. It obviously delighted the much-travelled Thomas Pennant who, in 1769, wrote in rapturous tones, 'One of the great mountains to the West is styled the hill Morven, is of stupendous height, and on the side next to Cromar almost perpendicular'. Later Byron, who spent boyhood summers at Ballaterach on the Dee, opposite Cambus o' May, commemorates it as his 'Morven of snow'.

In summer it is a popular ascent with extensive views to the Aberdeenshire countryside, with the prominent teat of Bennachie easily identified beyond a patchwork of fields around the waters of the Dee and the Don.

Above Looking east to Bennachie from Morven (*Irvine Butterfield*)

CONACHRAIG

2,838ft/865m

High rocks, jumble of rocks, or combination of rocks

The prefix 'con' usually means joined together or with, and here a hill linked to neighbouring Lochnagar. This is also a similar connotation in the Gaelic 'conachreag', here suggesting a linking rock; or the name may simply mean 'with crags or rocks'. As there are broken cliffs and rocky protrusions on the lower slopes, and small tors and rocks on the crest of its several tops, the name variously, and appropriately, may be interpreted to mean high rocks or a combination of rocks. The name may also be derived from a combination of 'conach', cotton-grass, and 'creag', rock, to produce cotton-grass rock.

Below The corrie of Lochnagar from Conachraig (*John Allen*)

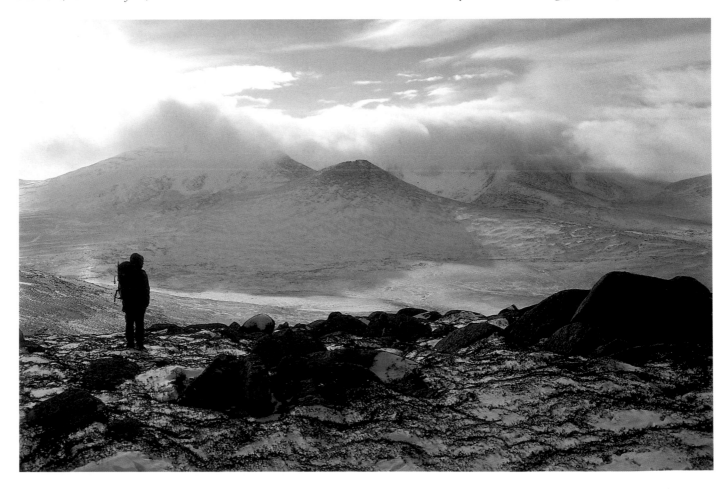

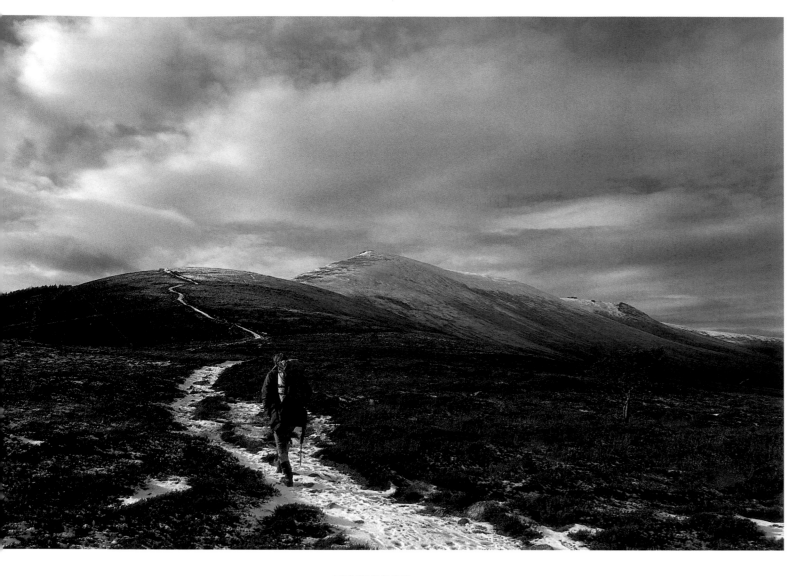

BEN VRACKIE
(BEINN BHREACAIDH)
2,759ft/841m

Speckled mountain

Old Gaelic spelling gives 'Beinn Bhragaigh', and on Stobie's map 'Ben-bhraekie' suggests a continuing link to the hill's acceptance as a speckled mountain.

The hill is composed of a chaotic mix of black schists, grey micaschists, white quartzite and greenish epidiorite. It is the various screes, and soils, with their associated plants that give the mountain its 'speckle'. This jumble of colours manifests itself when walkers approaching the summit by the tourist path are confronted by a patchwork of grey screes, dark heather, and light grasses on the mountain's south-western slopes.

Right Ben Vrackie and Loch a' Choire (*Irvine Butterfield*)

BEN RINNES
(SCURRAN OF
LOCHERLANDOCH)
2,756ft/840m

Headland hill, or hill of the sharp points

There is an Old Irish word 'rind' meaning a headland but it is highly unlikely that the influence of the Scots who settled in the west extended this far. Much more likely is the Gaelic connection and here the word 'rinn' is significant as it indicates a promontory, or sharp point. In the latter usage the granite tors of the summit give this great whale-back of a mountain such a culmination. The Scurrans as they are called would provide the sharp points.

Above Roy's Hill and Ben Rinnes from Round Hill (*Irvine Butterfield*)

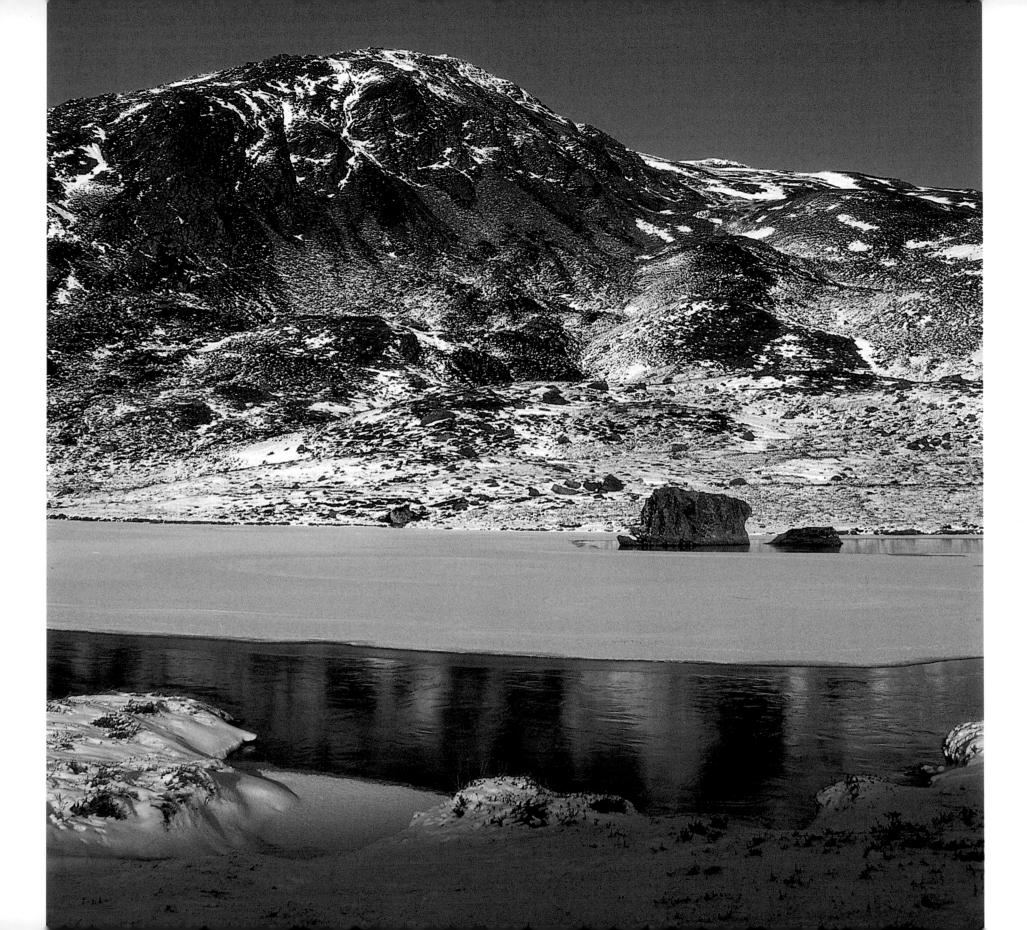

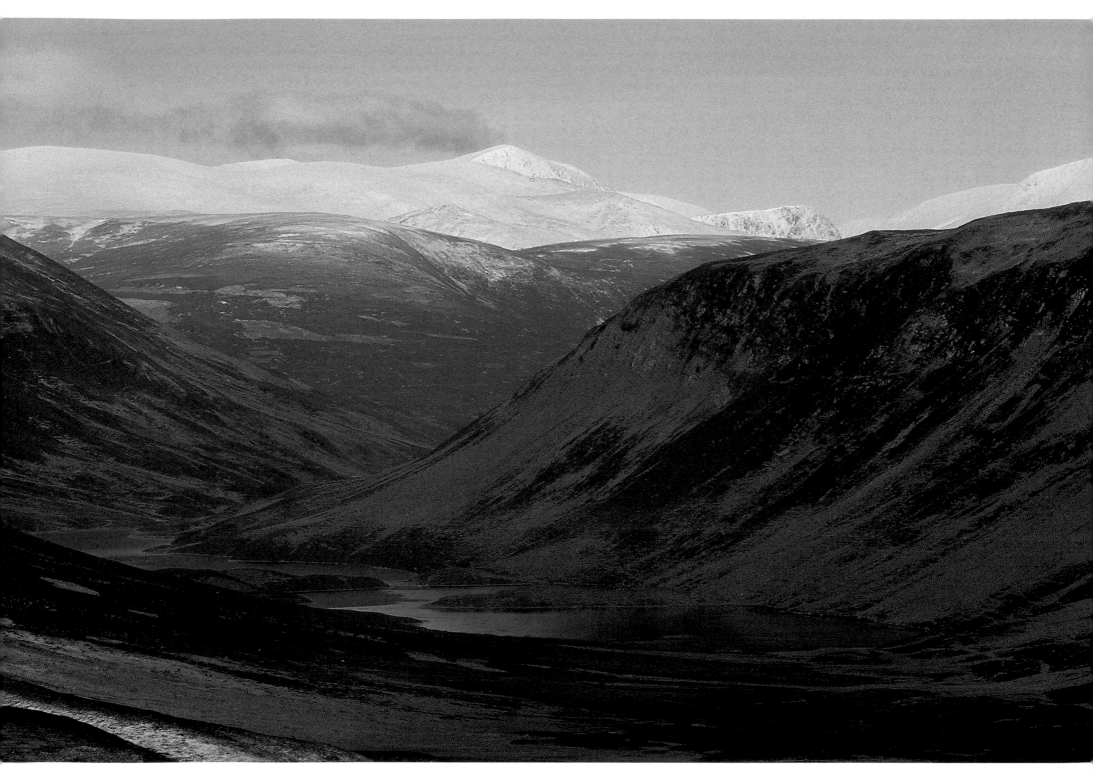

BEN VUIRICH

2,962ft/903m

Mountain, or hill, of howling

Given the presence of deer there is a natural tendency to think of 'vurich' as a derivative of 'buirich', roaring. Recorded by Stobie as Ben Vuroch the name is said to have its origins in the distant past when wolves still roamed the Highlands. Thus the name is probably a corruption, or derivative, of a Gaelic word for howling, as the mountain is reputed to be so-called from the howling of the wolves.

Like many of the Grampian Corbetts it could be dismissed as yet another rounded eminence so that the view from it must by some means make up for the lack of interest. Such is provided by the views to the hidden side of Beinn a' Ghlo and the secretive Loch Loch, and beyond to the high peak of Cairn Toul in the heart of the Cairngorms.

Left Loch Loch, Cairn Toul and The Devil's Point from Ben Vuirich (*Malcolm Nash*)

BEINN MHEADHONACH

2,956ft/901m

Middle hill

Stobie's map gave the name Benvenoch, a near phonetic rendering of the Gaelic title. Seen from the Vale of Atholl this peak stands out in its central position between the two hills of Beinn a' Chait and Carn a' Chlamain, each distanced from it by the deeply incised Gleann Diridh and Gleann Mhairc. Respite from the climb may be enjoyed beside an old cairn which looks across the rift of Glen Tilt to the bold heathered flanks of Beinn a' Ghlo.

Below Beinn a' Ghlo from Beinn Mheadhonach (*Irvine Butterfield*)

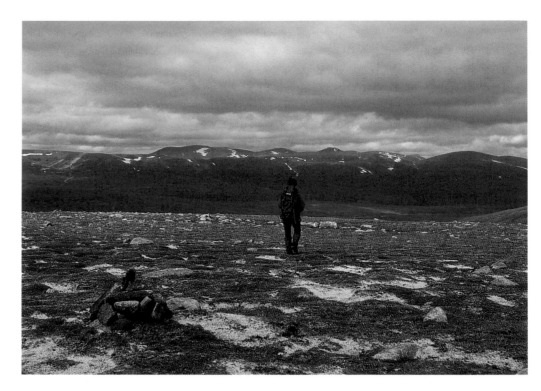

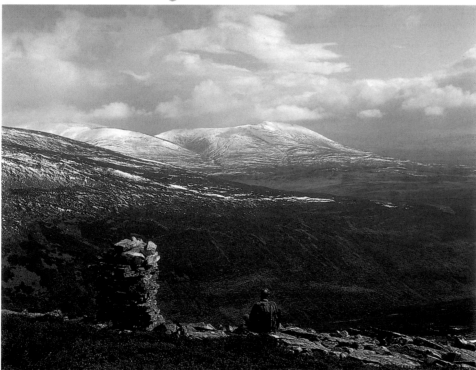

BEINN BHREAC

2,992ft/912m

Speckled mountain

Another hill noted on Stobie's map which identified the hill as Ben-ebreck, which was almost certainly a spelling intended to record the Beinn a' Breac of the native Gaelic speakers. 'Breac' is here 'Bhreac', dappled or speckled, a description often applied to hillslopes where patches of scree and heather are intermingled. The mix of greys, greens and browns breaking out one from the other here seen as a hillside patterned with screes, whose weeping grey scars push through the dark brown of the heather.

Above Looking to Carn Toul from Stob Coire nan Cisteachan, Beinn Bhreac (*Irvine Butterfield*)

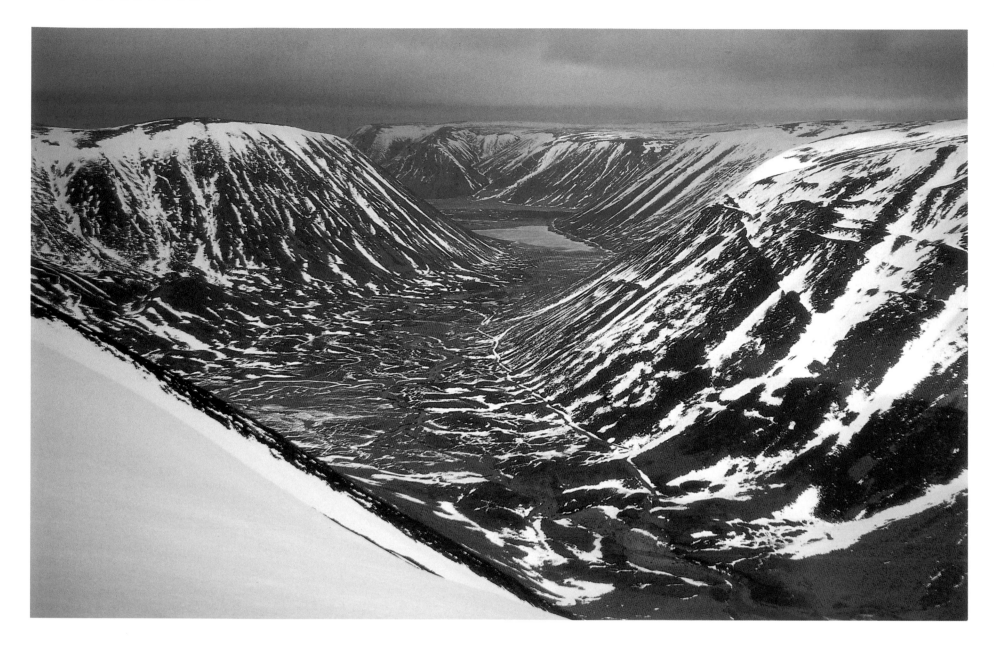

AN DUN

2,713ft/827m

The fort or eminence

The Gaelic 'dun' usually indicates the presence of a prehistoric hillfort, or a hilltop used as a defensive site. This hill summit has one of the most impressive natural fortifications in Scotland, and although commanding the southern portal of the Gaick Pass, there is no evidence to suggest that it was ever a site used for defence.

Stobie records the hill as 'Dune' and would not be blind to the significance of its location and the military potential. Its narrow battlement, with drops of 1000ft on all sides, provides a lookout post on one of the few breaches in the defensive wall of The Mounth.

Above Gaick Pass from An Dun

(*Hugh Munro*)

MAOL CREAG AN LOCH
(CRAIG AN LOCH/
A'CHAOIRNICH)

2,871ft/875m

Hill of the crag of the loch (Crag of the loch/The rowan hill)

Craig an Loch was the means of identifying the hill on Stobie's map and this, or derivations of a like name, seems well established. In *In the high Grampians*, a record of his experiences in the Forest of Gaick and Western Cairngorms, Richard Perry refers to the northern nose of the hill as A'Chaoirnich in both map and glossary. This he translates as 'The Rowan Hill'. This name is still current on the maps of the Ordnance Survey, as is Creag an Loch which relates to the brow of crags running above, and parallel to, the loch in the throat of the Gaick Pass. On the old Bartholomew's half-inch maps the northern point, given as An Caorunnach, retains the link with the rowan but no map has sought to record a title for the actual summit point. The mountain's summit is so level a plain that either title when applied to the whole mountain has equal merit.

Right Loch an Dun and Maol Creag an Loch from An Dun (*Don Green*)

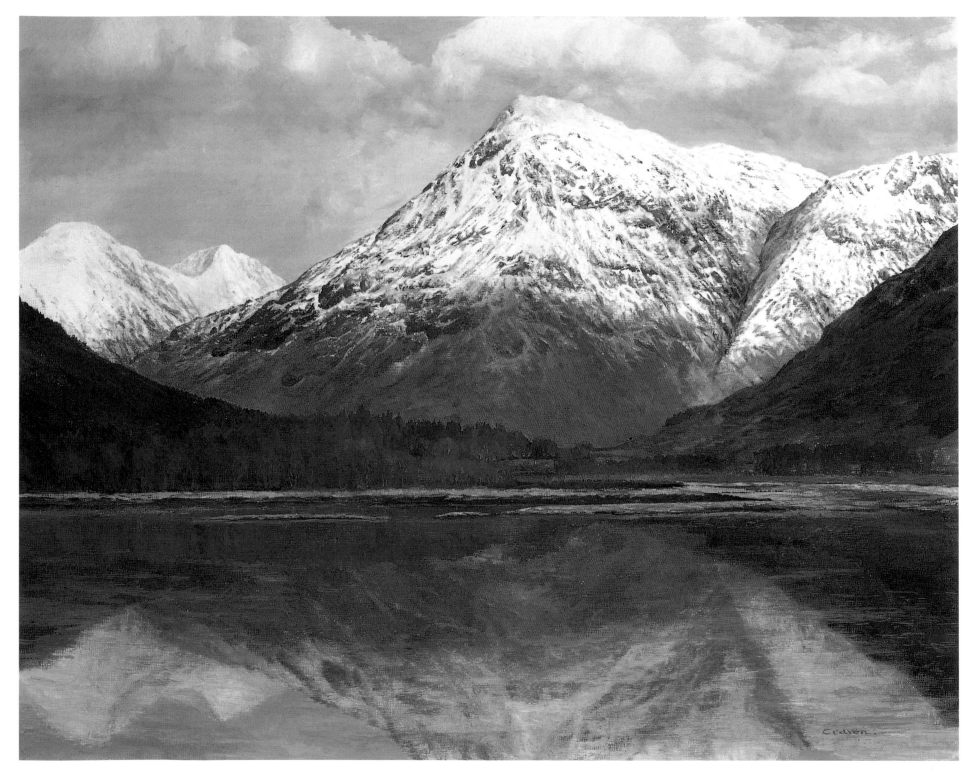

THE CENTRAL HIGHLANDS

LYING AT THE HEART OF SCOTLAND THE MAJORITY OF these peaks owns the same birthright, that of the denuded ice-carved plateau of the greater Grampians. Nippled by glum cairns, The Monadhliath's expanse of broad-backed summits looks south to the humped heathery hills at the heart of Scotland. Here many a loch adds a touch of colour to the view of those who venture into hill folds and the quieter reaches of the glens reaching up into these hills.

Left Stob Dubh, Beinn Ceitlein from Loch Etive (*Paul Craven*)

113

SGURR INNSE

2,654ft/809m

The peak of the meadow, or pasture

This is the more rugged twin of the two peaks guarding the pass of the Lairig Leacach. The similar usage of 'Innse' in the name confirms the link. If the spelling of 'innse' remains uncorrupted and is not, as is often assumed, 'innis' it speaks of 'intelligence or information'. Like its twin the peak occupies a similar position overlooking the narrow summit of a long-established hill crossing. As such the peaks offer a fine vantage which, in times of danger, could be used as a look-out to warn of the approach of hostile forces.

Right Sunrise over Sgurr Innse
(*Richard Gibbens*)

CRUACH INNSE

2,812ft/857m

The stack of the meadow, or pasture

'Cruach' signifies a heap similar to that of a haycock or peat stack and on approaches from the Spean by the old drovers' route through the Lairig Leacach the mountain has this appearance. Innse is usually thought to be from 'innis', an island or river-side meadow. In the days when the droving trade was at its height the crossing was one of the principle routes for the trafficking of cattle, and the small meadows beside the river at the mountain's foot would provide a suitable stance for the night.

Taken literally the name suggests 'island heap', and such it might appear for it lies off the great chain of the Grey Corries ridge and can, in imagination, be likened to a sea stack.

Above Cruach Innse from Sgurr Innse
(*Alan O'Brien*)

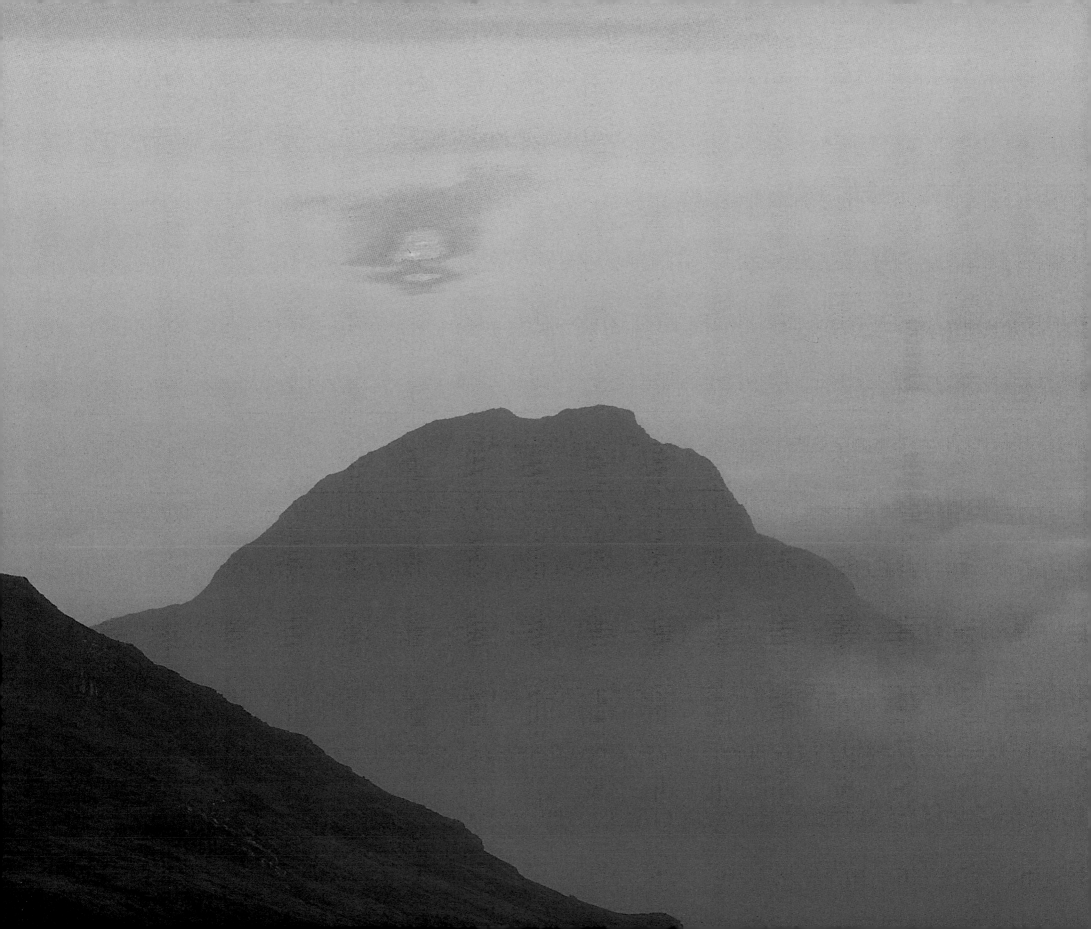

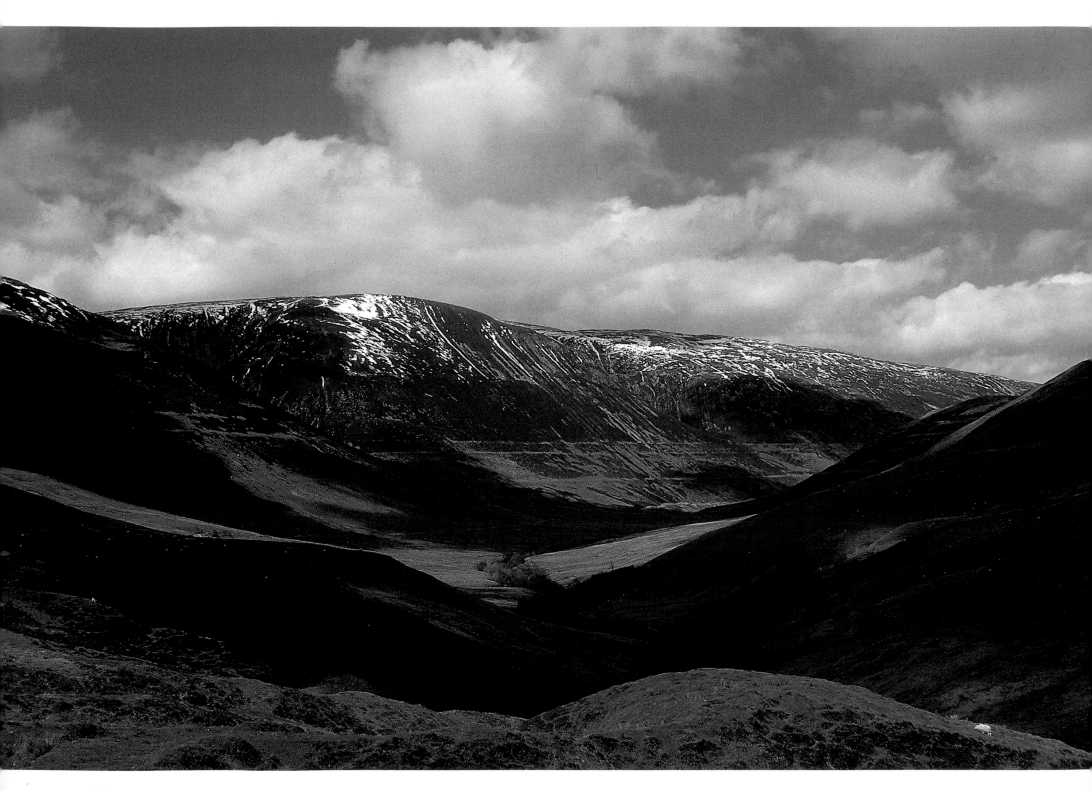

BEINN IARUINN

2,634ft/803m

Iron mountain

The reference to iron suggests the presence of a quantity of the mineral, but there is little evidence to suggest that there was any extensive mineral exploitation.

Some of the clearest examples of the 'Parallel Roads' are to be seen on the face of this hill. These terraces represent the successive shore lines of a lake impounded during the last ice age. The ice of the retreating glacier breached a series of outlets, each lowering the level of the lake until the final ice dam burst to drain the basin of the present Glen Roy.

Left Beinn Iaruinn from Glen Roy viewpoint (*Irvine Butterfield*)

CARN DEARG

(EAST OF GLEN ROY)

2,736ft/834m

Red peak, or cairn

This is one of three hills of the same name on the bounds of Glen Roy. There are over a hundred red hills scattered across Scotland, many often distanced at no great remove one from the other. The colour is usually that of rocky protrusions and such is the case here.

Right Carn Dearg from Glen Roy (*Martin Moar*)

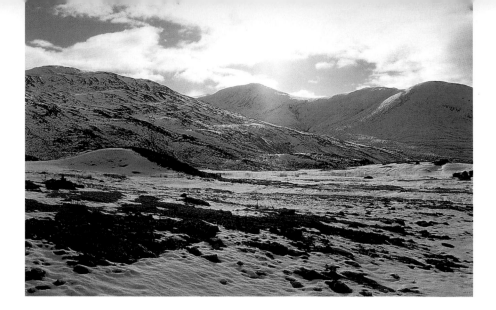

CARN DEARG

(SOUTH OF GLEANN EACHACH)

2,520ft/768m

Red peak, or cairn

The second of the red hills immediately above Glen Roy, and in configuration almost a mirror image of the peak of like name above the opposite bank of the brawling River Roy.

Left Carn Dearg from Turret Bridge (*Martin Moar*)

CARN DEARG

(NORTH OF GLEANN EACHACH)

2,674ft/815m

Red peak, or cairn

To distinguish this red hill from the two neighbouring peaks of the same name a suffix is provided to identify it to the side glen of a feeder stream which enters the broader glen of the River Roy.

Below Carn Dearg from Meall an t-Snaim (*Irvine Butterfield*)

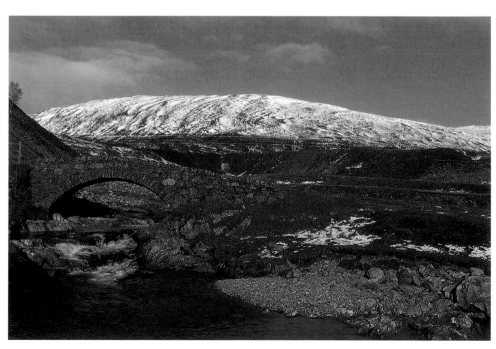

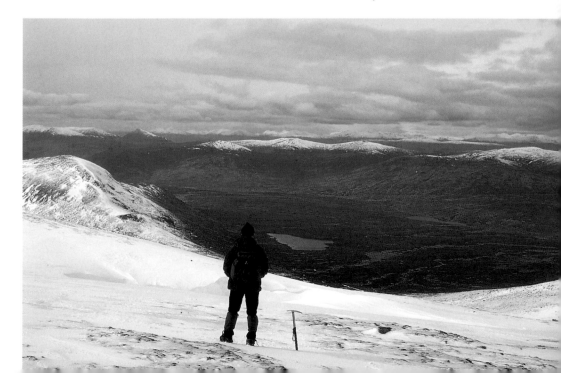

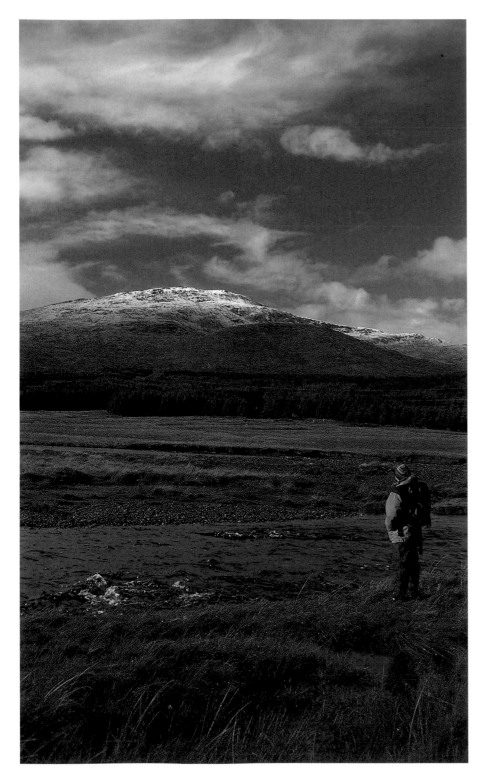

GAIRBHEINN

2,939ft/896m

Rough mountain

The name is most often considered to be a corrupted form of 'garbh-bheinn', hence the translation as rough mountain. Apart from some ruffles of crag on a steep eastern flank, and small outcrops below the summit, the mountain is little different to other peaks in the vicinity. However, roughness as a feature seems to have been well established in the minds of the local inhabitants as the house of Melgarve at the mountain's foot is also derived from 'meall garbh', rough hill.

Left Gairbheinn from the River Spey near Drimmin (*Irvine Butterfield*)

CARN A' CHUILINN

2,677ft/816m

Cairn of the holly

It is difficult to determine whether the hill takes it name from the presence of holly or whether the many small nipples of the mountain ridge are thought to resemble the spikes of the holly leaf. The dimpled ridge cossets many a small pool and the hill's eastern battlement, moated by a mosaic of lochans, hazards approaches from this quarter.

Right The ridge of Carn a' Chuilinn looking towards the Great Glen (*Richard Wood*)

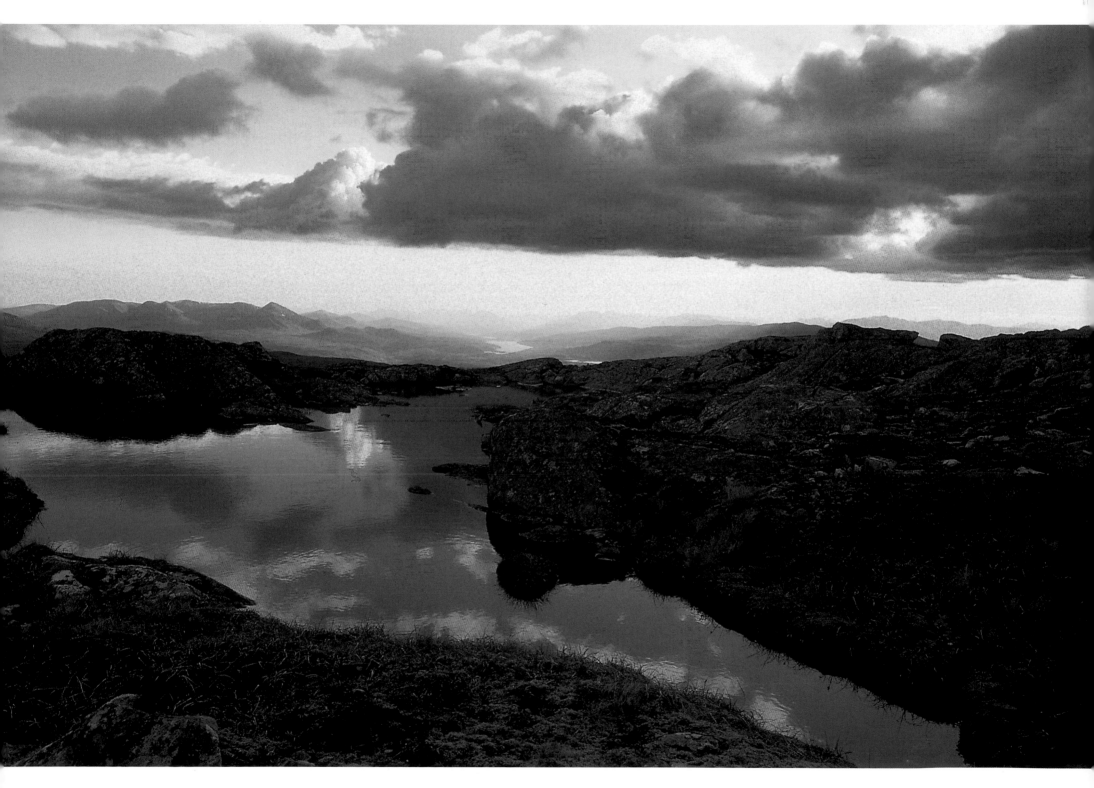

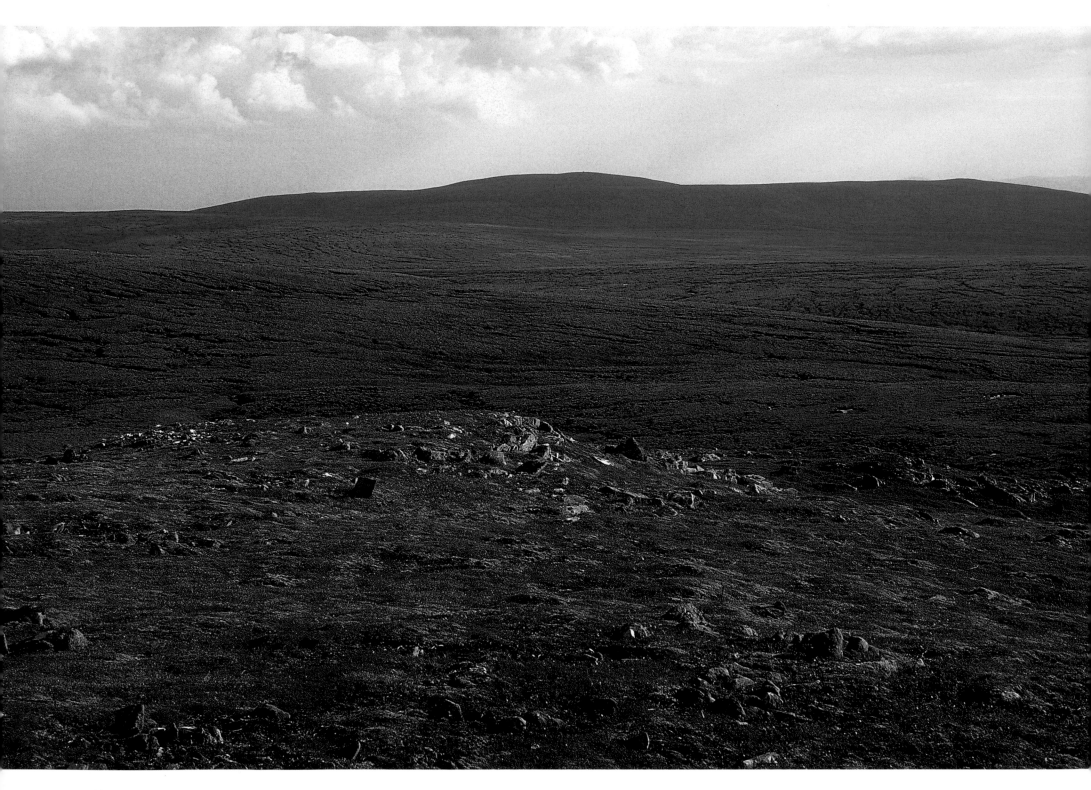

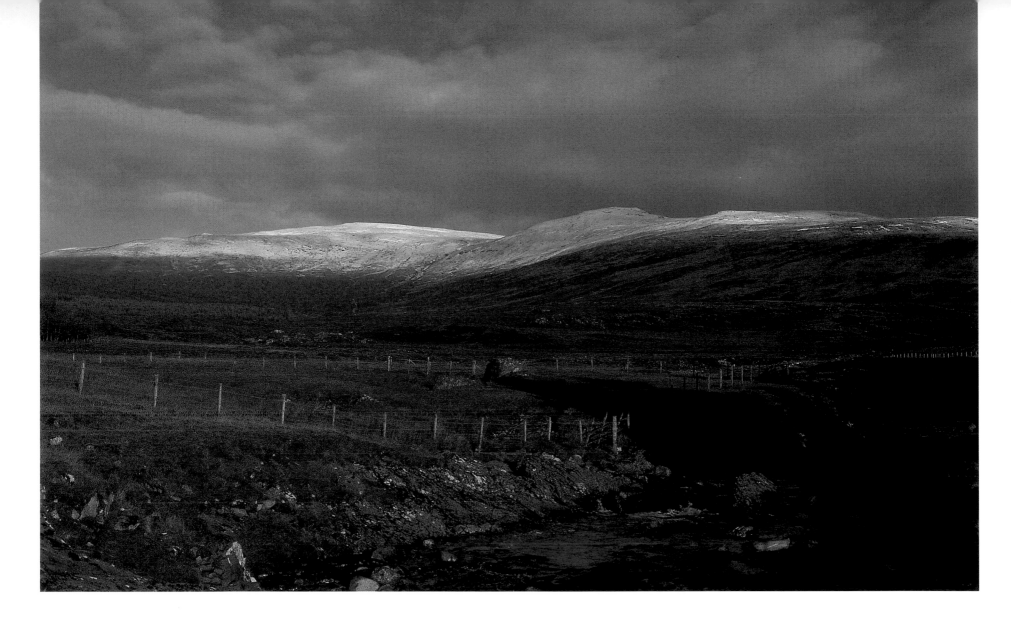

CARN NA SAOBHAIDHE

2,661ft/811m

Cairn of the fox's den

Foxes make their lair in tumbles of boulders and such are always to be found somewhere on any hill, even those as heathery as those in the heart of the plateau-land of the central Monadhliath. The fox which gave rise to the name for this particular heathery waste must have been a noteworthy member of his species to achieve such recognition.

The spread of this hill is so nondescript that even the actual summit has been in doubt. Metric mapping saw the elevation of the present-day cairn by the merest of margins, and there are few clues on the ascent as to its exact location. *Left* The broad flanks of Carn na Saobhaide (*Jim Teesdale*)

MEALL NA H-AISRE

2,828ft/862m

Hill of the defile

The defile here is that of the Allt Coire Iain Oig whose feeder streams drain the broad basin under the summit. The gathering force of the waters have gouged out a small gorge, with a similar small cut just above a confluence with the Spey near the attractive Garva Bridge.

Above Meall na h-Aisre from Garva Bridge (*Irvine Butterfield*)

GEAL-CHARN MOR

2,703ft/824m

Big white hill

The use of the Gaelic 'geal' appears to be a peculiarity of hill names around Strath Spey and Laggan. Though translated as white the colour is that of the pallid grasses which result from an overburden of snow which lies later than elsewhere. This prevents the growth of heather so that visitors to the hill-top will find that its cairn is approached across an easy carpet of short grass.

The ease of ascent should commend the hill to the most casual walker who will be rewarded with a fine panorama across Strath Spey to the high Cairngorms.

Below Geal-charn Mor from Strathspey (*Martin Moar*)

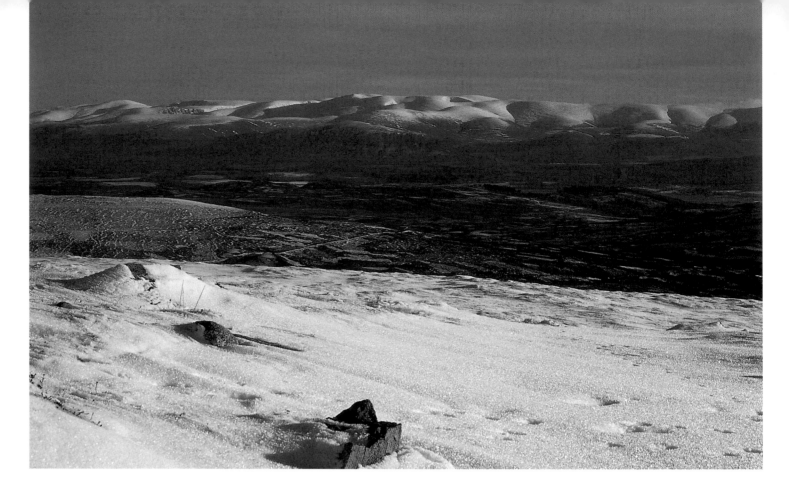

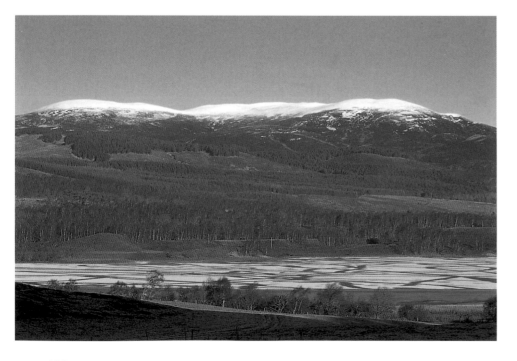

CARN AN FHREICEADAIN

2,880ft/878m

Cairn of the watcher, or look-out cairn

Roy's map of 1755 shows the route of a road crossing from Kingussie on the Spey to the Findhorn at Coignafearn. The route followed the Allt Mor to a breach in the hills between Carn a' Bhothain Mholaich and Carn an Fhreiceadain. Once across this watershed the route cut across the shoulder of the hill to reach a second gap leading across to the Elrick Burn, and thence downstream to its confluence with the River Findhorn. This was the gateway to a continuing route northwards to Inverness. In its time the road saw much traffic in cattle from the north and was a short cut which avoided the more circuitous corridor by way of Carrbridge and Aviemore.

This was one of the routes policed by the Watch companies charged with maintaining peace in the Highlands. The hill with its commanding position overlooking the Spey, and the alternative hill crossing from the Findhorn, provided an ideal look-out post for the sentinels.

Above Looking to the Cairngorms from Carn an Fhreiceadain (*Martin Moar*)

Right Looking west from Carn na Fhreiceadain (*Martin Moar*)

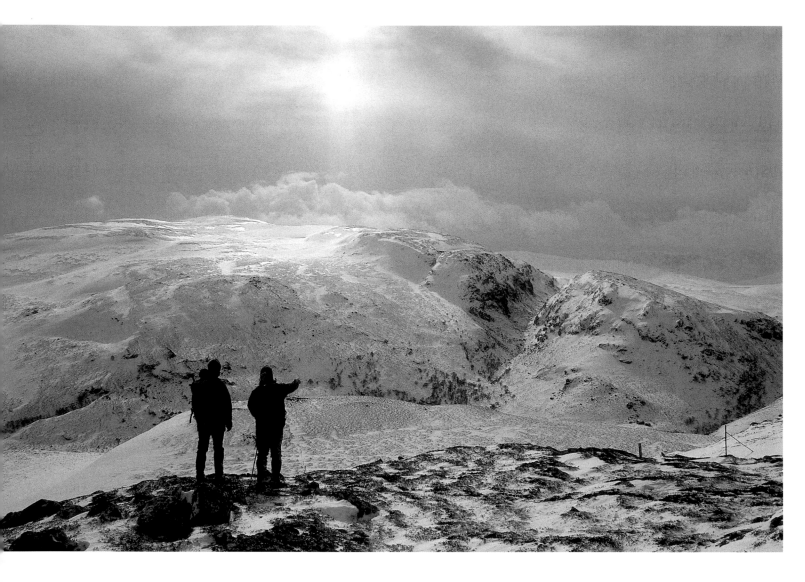

BEINN A' CHUALLAICH

2,923ft/891m

Mountain of herding

This hill lay beside one of the great drove roads to the south, and along its lower slopes there could well have been a collecting point for the drovers. It was certainly a hill thought worthy of identification on earlier maps, with Stobie noting the name 'Ben Chualach'. The later one-inch Victorian maps gave Beinn a' Chuallaich, the name which it retains.

A large summit cairn bears testament to the hill's popularity as it is a pleasant ascent from Kinloch Rannoch, affording views along Loch Rannoch and across to Schiehallion.

Right Schiehallion from Beinn a' Chullaich (*Irvine Butterfield*)

THE FARA

2,989ft/911m

The ladder, or the slope

The name may be from 'faradh', a ladder, which might be intended to convey the steepness of its sides presented to those who ascend from the shores of Loch Ericht. It has also been suggested that on approaches from the south the long hill crest rises gradually to the summit crown much as a ladder provides access to a chosen height. It is also possible that the distinctive slant of the broad slope above Loch Ericht being its most easily recognised feature might have been known simply as 'the slope'. This is in Gaelic 'leitir' and, as with many names, could now be a corrupted form of the original.

The rock climber will know of the climbs to be had on the walls of the deep cleft of Dirc Mhor, The Great Slash, a feature not normally seen by those taking the shorter route to the summit from the shores of Loch Ericht.

Above The Fara and Dirc Mhor from Meall nan Eagan (*Irvine Butterfield*)

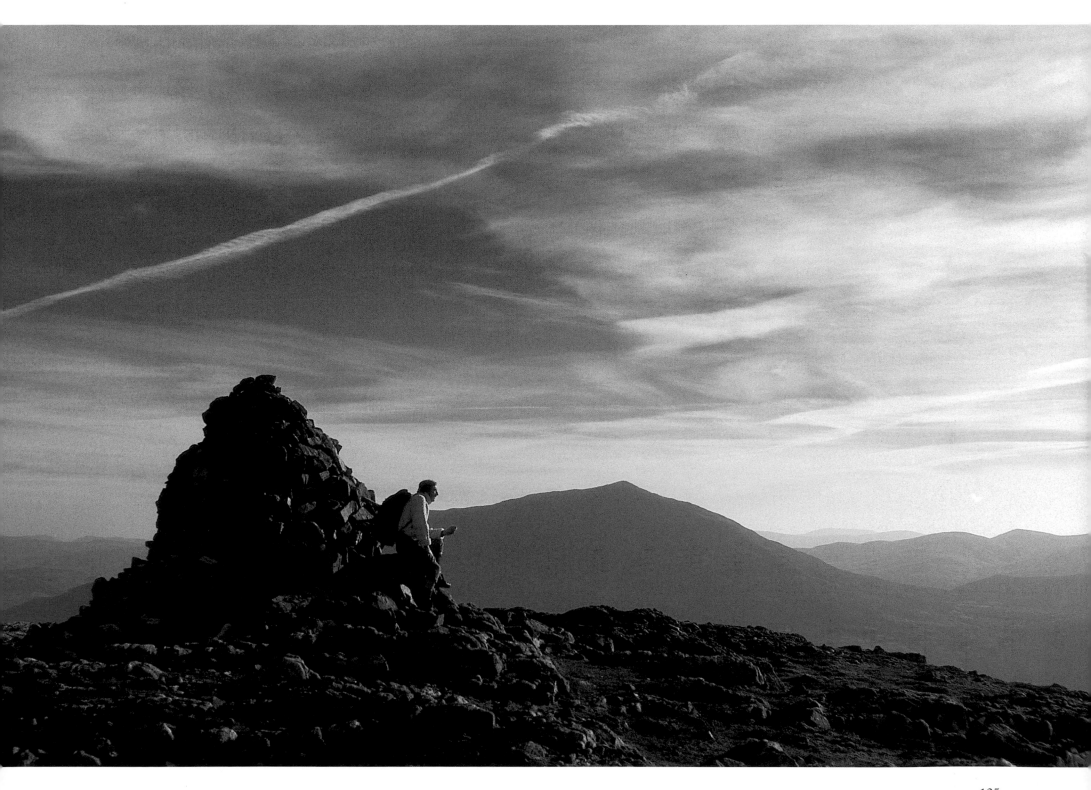

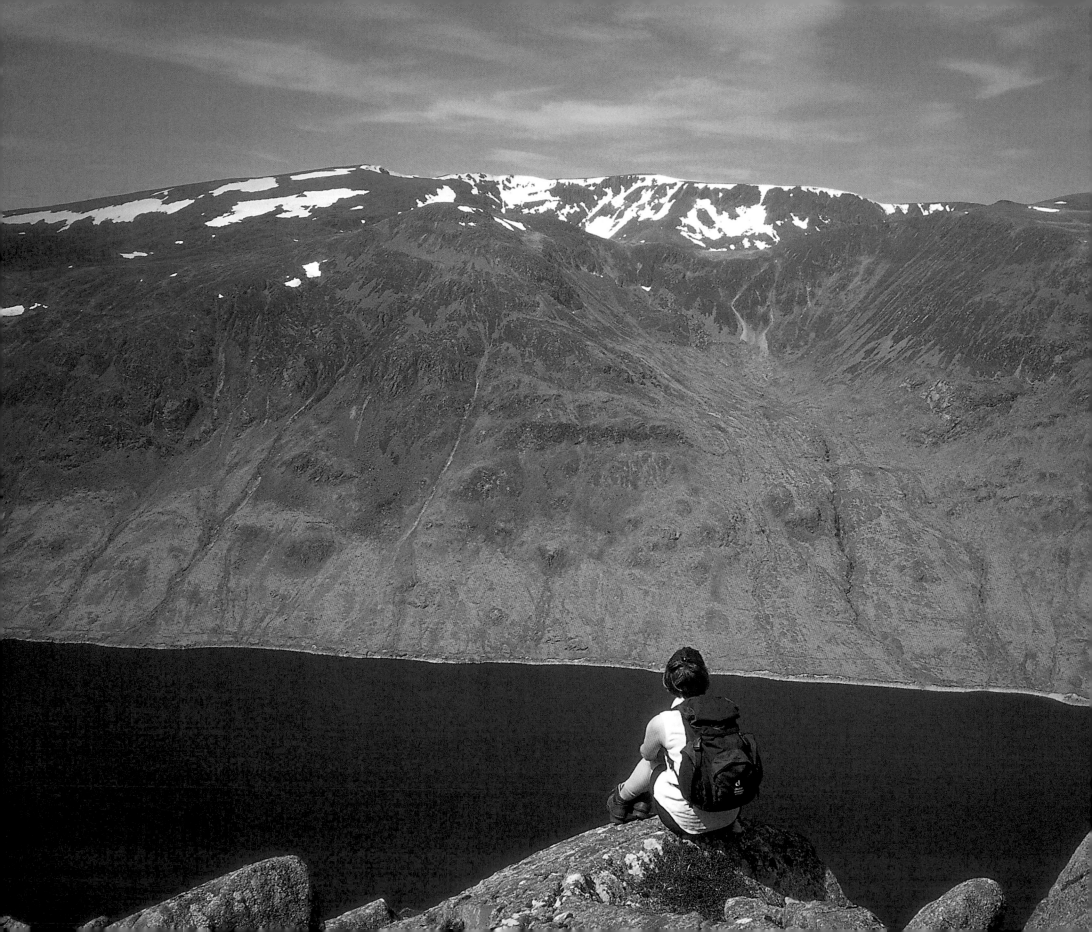

STOB AN AONAICH MHOIR

2,805ft/855m

Peak of the big ridge or crest

Stobie's map of 1783 marks that part of
the hill opposite the mouth of the Auld
Auler (Allt Alder) as the 'Place where C
S hid himself' and names that part of the
ridge 'Dunich-more'. The name is no
longer used and appears on current maps
as Creag na h-Iolaire.

'C S' is Charles Stuart, the Young
Pretender, who in the late summer of 1746
sought refuge with Cluny MacPherson.
The fugitive chief was holed up in a crude
habitation which appeared to be suspended
from the limb of a large tree which acted as
the main roof beam. It was this feature
which led to it being known as 'The Cage'.
It was said to situated on that part of Ben
Alder known as 'Letternilichk', which has
been identified as the spur lying above
Alder Bay. Though a detailed description of
the site is on record it has never been
located and proper authentication to date
has been denied. It is, therefore, possible
that the secretive Jacobites used the term
Ben Alder in its broadest sense to disguise
the actual location.

The hill's name is less of a mystery as
it is composed of Gaelic words in
common usage – 'stob', peak, 'an', of,
'aonaich', ridge and 'mhoir', big – for it is
literally the peak of the big ridge.

Left Ben Alder from Stob an Aonaich
Mhoir (*David May*)

BEINN MHOLACH

2,759ft/841m

Shaggy mountain

'Molach' is the Gaelic for rough or hairy
and here describes the appearance of the
mountain terrain which is a mix of coarse
heather and whispy grasses. This can also
mean shaggy and the unkempt
appearance of the hill would explain this
preference by some when giving the
Anglicised title.

Viewpoints from the low ground find
the mountain melts into a back-cloth of
similar rounded hills, the best viewpoint
being that from the southern end of
Meall na Leitreach.

Below Beinn Mholach from Sron nam
Faiceachan (*Richard Wood*)

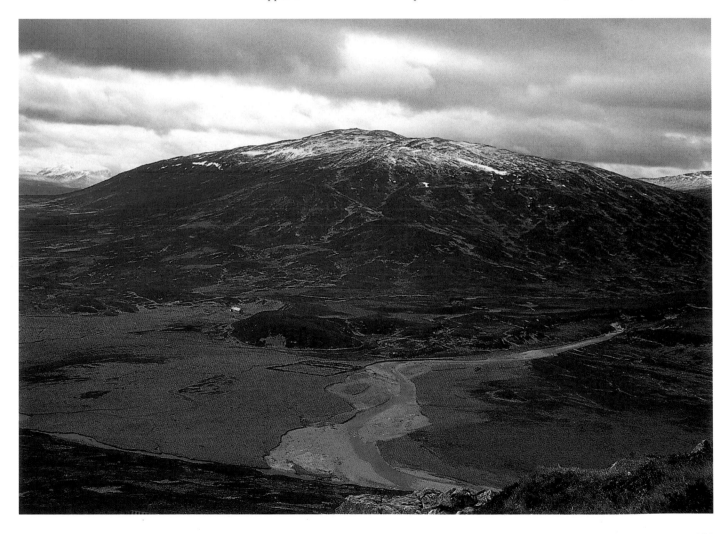

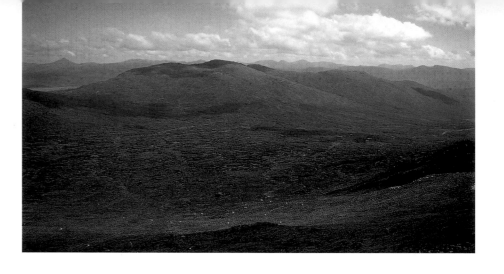

THE SOW OF ATHOLL
(MEALL NA DOBHRAICHEAN)

2,634ft/803m

Watercress hill

Although all maps are guilty of calling this hill The Sow of Atholl it should more properly be Meall na Dobhraichean, hill of watercress. The porcine terminology is a contrivance to match An Torc, the boar, on the opposite side of the ancient boundary between the lands of the Spey and the Garry; hence the association in the names now in current usage with the two districts of Badenoch and Atholl. The watercress would be found along the foot of the mountain in the marshier margins of the sluggish Allt Dubhaig. Much of this is now permanently underwater due to the installation of a cut-off dam near Dalnaspidal Lodge.

Below The Sow of Atholl, A'Mharconaich, and An Torc from Dalnaspidal Lodge (*Irvine Butterfield*)

MEALL NA MEOIG

2,848ft/868m

Hill of whey

This peak is the highest point of the larger mass known as Beinn Pharlagain. The name 'pharlagain' is obscure and perhaps refers to the grassy hollows around the small tarns on the hill's crest. These tiny hill pastures would have been valued as summer forage for cattle, and may have been particularly rich feeding for the milk cows, hence the association with whey. The small tarn of Lochan Meoigeach suggests that this water was whey-ish in colour, and it could be that the stump of the hill-top above was of like hue.

Above Meall na Meoig from Carn Dearg (*Iain A. Robertson*)

MEALL NA LEITREACH

2,543ft/775m

Hill of the slope, or hill of slopes

This hill is more broad ridge than peak, its one clear means of identification being the steep flank falling to Loch Garry. Thus the hill name derived from 'leitir', a slope, is descriptive rather than imaginative.

Right Meall na Leitreach from the old A9 Drumochter Pass (*Irvine Butterfield*)

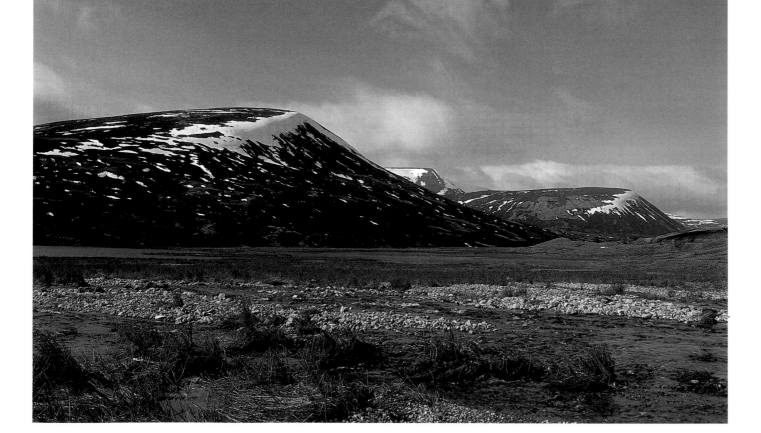

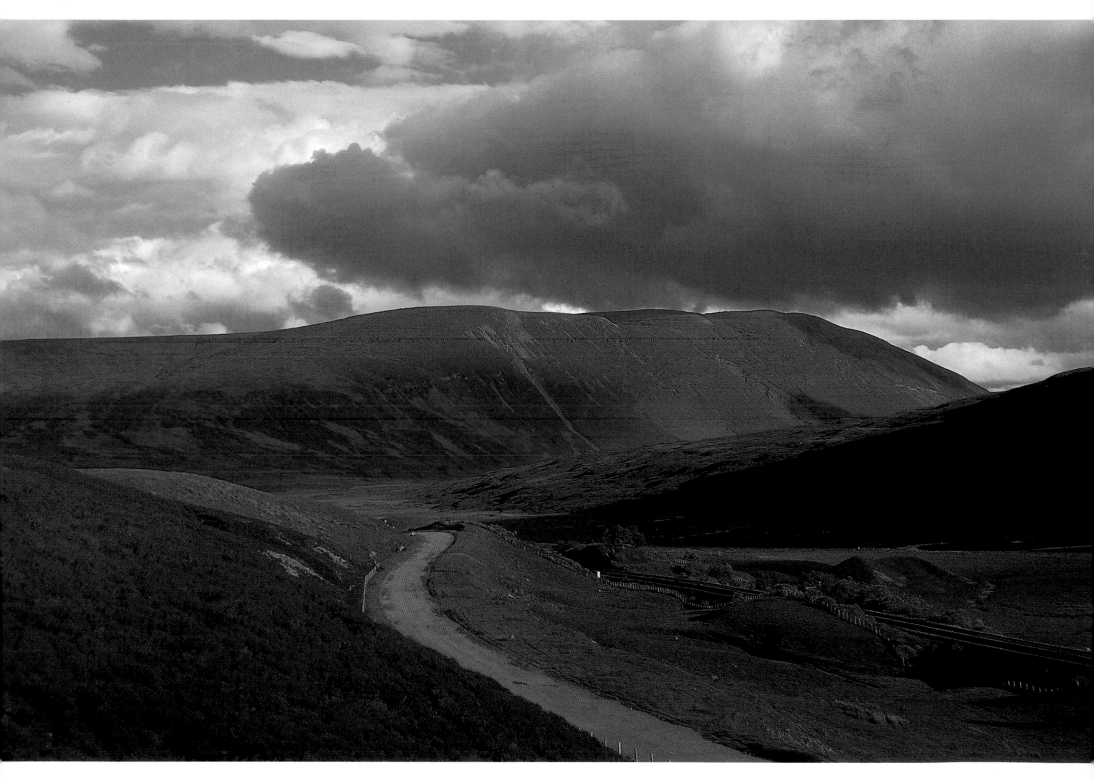

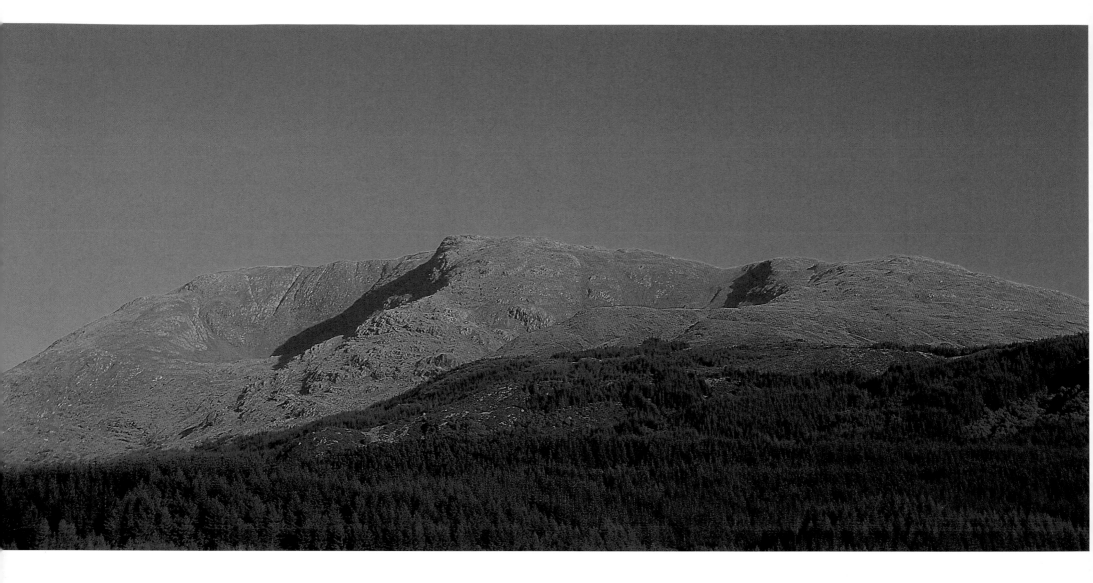

FRAOCHAIDH

2,884ft/879m

Heathery hill, or place of heather

The name of this hill is a good guide to the ground to be traversed to reach its cairn. Access to the hill is now a more complex proposition as the lower slopes are thick with the regimented stands of conifers, above which the mountain struggles to gain pre-eminence.

Above Fraochaidh from Duror (*Stuart Rae*)

MEALL LIGHICHE

2,533ft/772m

The doctor's hill

Hill names are more commonly linked to pastoral pursuits or ancient warriors. Kings may have a favoured viewpoint named in their honour, and Auld Nick himself is not averse to claiming a place or two for himself among the hills and glens. But there is a uniqueness about this relationship between a doctor and a hill here on the bounds of Glen Coe. Why were his ministrations of such note, and who was the man of medicine remembered?

Right Looking to Fraochaidh from Meall Lighiche (*Jim Teesdale*)

BEINN TRILLEACHAN

2,752ft/839m

Mountain of the sandpipers, or oystercatchers

The 'drilleachan', or sandpiper, prefers fresh water, whereas the 'trilleachan', or oystercatcher, seeks out the saltier coastal waters. Both might be content seeking a tasty morsel or two along the margins of Loch Etive as it contains both salt water and fresh. At the seaward entrance to the loch lie the Falls of Lora where a rock-shelf holds back the waters of the loch, depending upon the state of the tides. The flow of the saltier waters at high tide is less obvious as the impression is given of a constant level of loch and sea. The oystercatcher thus has the best of both worlds and it is this species' sharp trill which is most likely to be heard.

Below Ben Cruachan and Loch Etive from Beinn Trilleachan (*Irvine Butterfield*)

131

CREACH BHEINN

2,657ft/810m

Mountain of spoil or plunder, or
windswept hill

A 'creach' was the product of a cattle raid on a neighbouring clan and this is one of three such mountains in the west. This form of theft was a popular pastime and regarded as an honourable pursuit and the making of many a young clansman. Skirmishes between rivals could be bloody, and often led to swift retribution, and many a time led to long-standing

feuds between the opposing clans.

The proximity to a western shore swept by the prevailing winds scudding in from the Atlantic could also suggest that those who named the mountain were more conscious of this than any other feature. 'Creach' used in this sense indicates bareness, and the rough stone of the high top confirms this as a barren summit.

Above Loch Linnhe and Mull from Creach Bheinn (*Hugh Munro*)

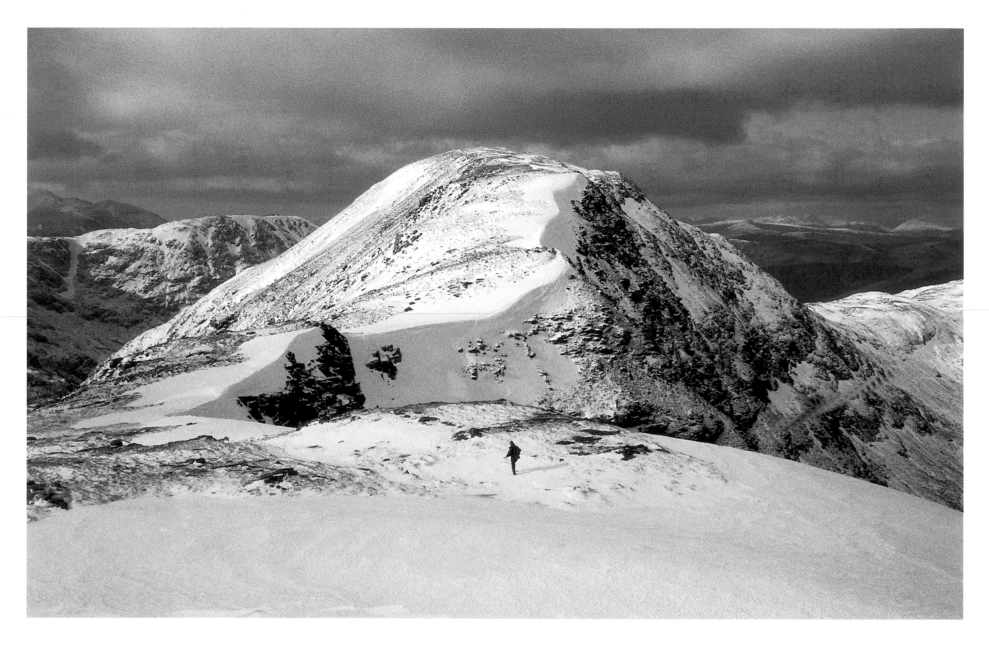

BEINN MAOL CHALUIM

2,976ft/907m

Callum's (Malcolm's) bare hill

There is a Munro, Beinn Challum, or Malcolm's mountain, in the forest of Mamlorn which has possible links with Columba. There is no record of a similar association here, and the Malcolm who gave his name to this hill and the deeds which led to his montane accolade are lost in the mists of time.

The hill lies much in the shadow of the mighty Bidean nam Bian, but judicious choice of a clear prospect of the hill proclaims its own prowess as very much a hill apart.

Left Beinn Maol Chaluim from Loch Leven (*Stuart Rae*)

Above Ridge to the summit of Beinn Maol Chaluim (*David McLeod*)

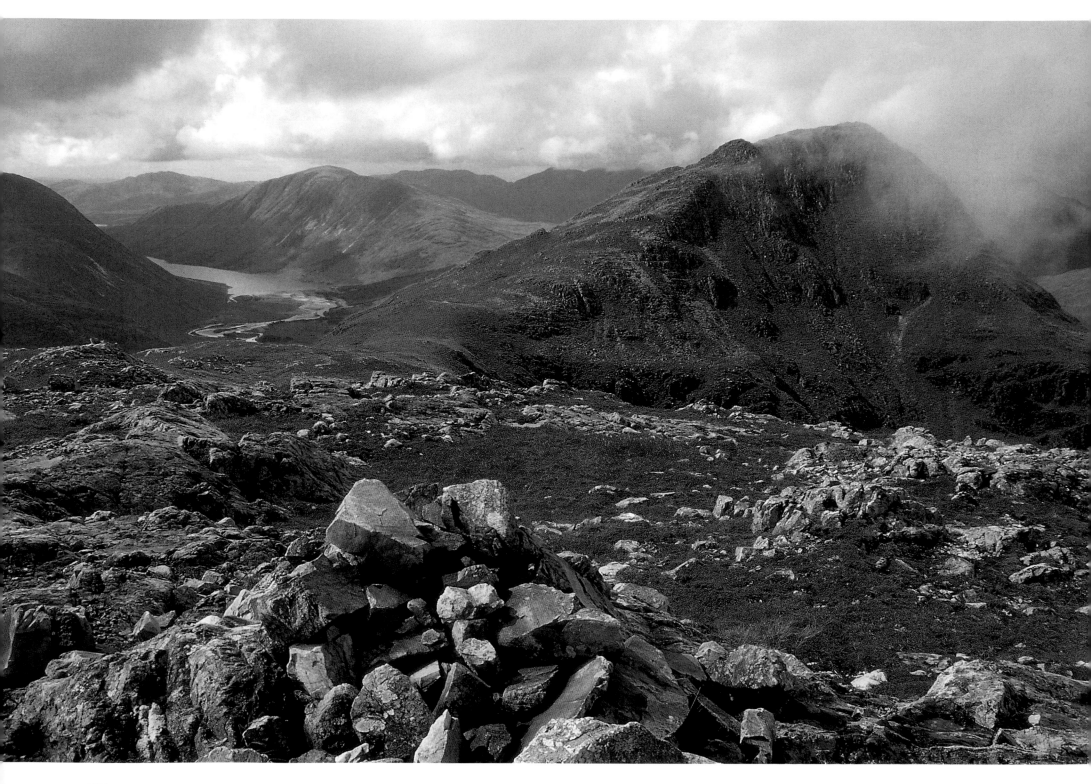

STOB DUBH, BEINN CEITLEIN

2,897ft/883m

Black point or peak, mountain of
concealment

The black element of the highest peak of this mountain is most probably that colour of the rocks or defending crags. On the majority of maps the main back of the mountain is given as Beinn Ceitlein, a name shared by a stream and glen of the same name cutting into the dark amphitheatre of the neighbouring hills. What was concealed, and by whom, is open to speculation, but a glen rich in grass with hidden corners would be ideally suited to the secretion of stolen cattle.

When seen from lower Glen Etive the mountain displays a deep gash in its side and its slopes appear precipitous and uncompromising. At its northern end it has a distinctive tower offset from the lower ridge. One of nature's architectural masterpieces, with fine views along Glen Etive to boot.

Left Stob Dubh and Glen Etive from Beinn Ceitlein (*Derek Sime*)

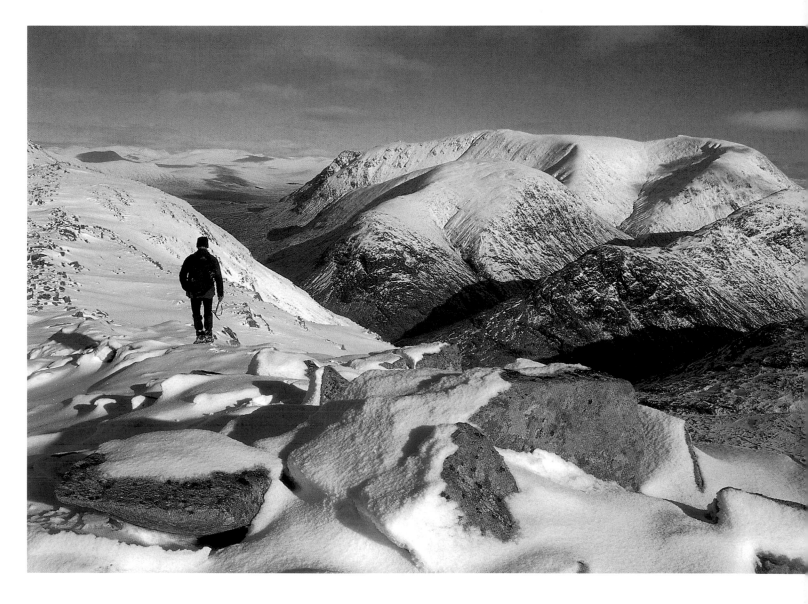

BEINN MHIC CHASGAIG

2,835ft/864m

MacCaskaig's hill

Another mountain bearing the name of an individual clansman but offering little other information as to his origins or fate.

Almost enveloped in the arms of the higher Black Mount ridges, the hill struggles to detatch itself from the massif of its grander neighbours, as can be seen from its adjacent fellow Corbett, Beinn Ceitlein.

Above Beinn Mhic Chasgaig and Black Mount from Beinn Ceitlein (*Martin Ross*)

135

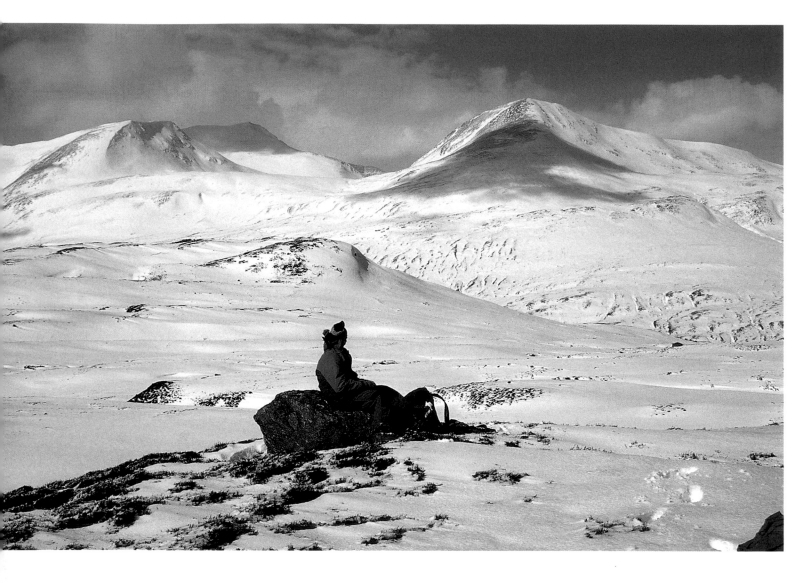

LEUM UILLEIM

2,972ft/906m

William's leap

An outlying point of this hill commemorates the legendary Cailleach Bheur whose well, Fuaran Cailleach Beinn a' Bhric, records her drinking fountain on the mountain slope. But what of William and his leap?

The singular position of this hill ensures unimpeded outlooks to the hills of the Ben Alder Forest, The Grey Corries, and The Mamores. But its roots lie in the Moor of Rannoch and on a good day beyond the great expanse of this desert tract the views encompass the hills of Glen Orchy, Glen Lyon, and Glen Coe. *Right* Glen Coe hills above temperature inversion from Leum Ulleim (*Derek Sime*)

GLAS BHEINN

2,588ft/789m

The green, or grey, mountain

Small exposed rocks on its crest, or screes on the lower slopes may account for any greyness, but those who visit the hill will find it rich in grass and very green in spring and early summer. Either colour may be appropriate, and as a compromise greyish-green is also an accepted hue for mountains bearing the word 'glas' in their title.

The mountain is an outlier of the Mamores, its isolated position and lengthy ridge offering amply opportunity to sample the views to the adjacent ranges. *Above* Binnein Mor and Sgurr Eilde Mor from Glas Bheinn (*Tom Rix*)

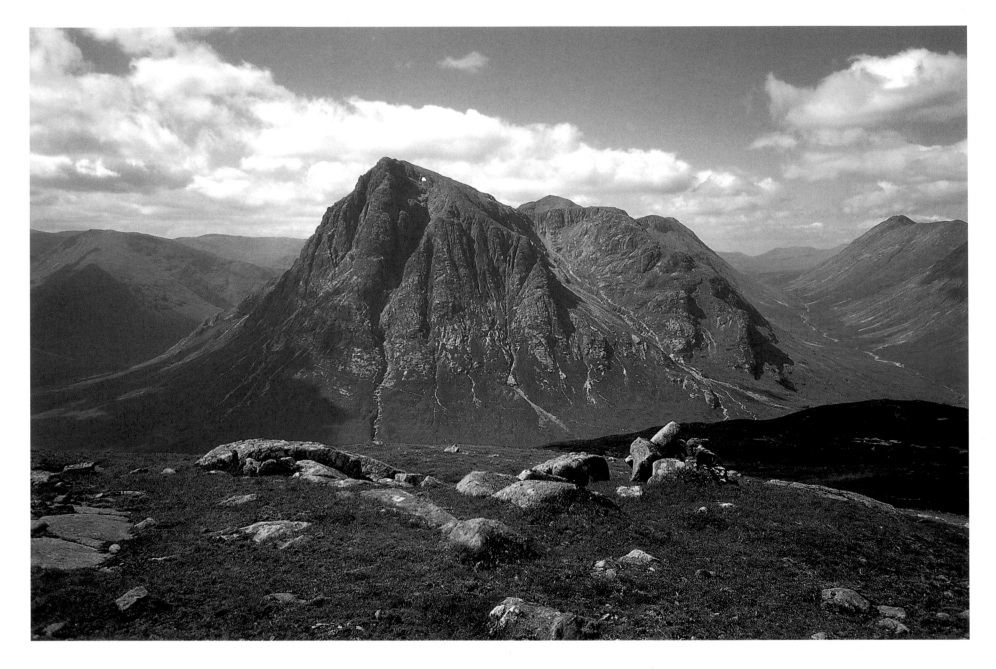

BEINN A' CHRULAISTE

2,812ft/857m

Rocky mountain

'Crulaist' is a name rarely found, and when applied to a hill means that it is rocky. Looking from Kingshouse and the lower ground thereabouts the hill presents a bland face. Towards its western edge there are broken crags, and once on the crest stones break through the heather of an uneven crest leading to the summit cairn. This hill is one which gives the best end-on view of the grander Buachaille Etive Mor with its rocky towers and fissured walls.

Above Buachaille Etive Mor from Beinn a' Chrulaiste (*John Allen*)

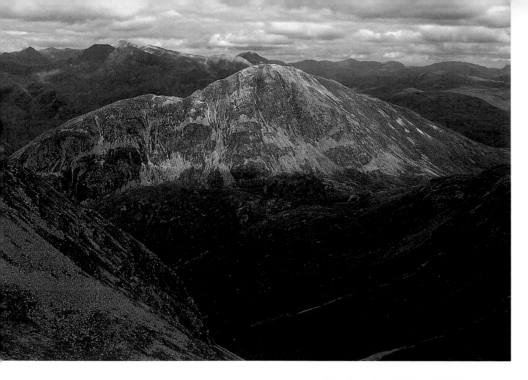

MAM NA GUALAINN

2,611ft/796m

Hill, or pass, of the shoulder

'Mam' is the term sometimes applied to a hill pass. The pass here is the Lairig Mor coursed by the old military road from Kinlochleven to Fort William, now recognised by walkers heading from the south along the West Highland Way as the last push through the mountains to their destination. 'Mam' is also a round steep hill shaped like a woman's breast, which suitably describes the summit point. The use of 'gualainn', a shoulder, draws the distinction between this lengthy hill mass and that of the greater ridge of the Mamores. and is intended to convey that this is a lower elevation of that main range and might be seen from some quarters as a shoulder of it.

As with Garbh Bheinn above the opposite shore of Loch Leven this hill enjoys the longtitudinal view along that loch towards the Glen Coe peaks.

Below Beinn a' Bheithir and Loch Leven from Mam na Gualainn (*John Allen*)

GARBH BHEINN

2,844ft/867m

The rough mountain

The knolly western ridge rises without interruption from the seashore, steepening on the approach to the broken rocks beneath the crowning hump. Guardian screes of red granite and broken crags bare the southern flank to confirm the impression that this hill is aptly titled. Its rough belvedere compensates those who attain it with views to the many hills ranged around the deep sea-lane of Loch Leven.

Above Garbh Bheinn from Aonach Eagach (*Tom Rix*)

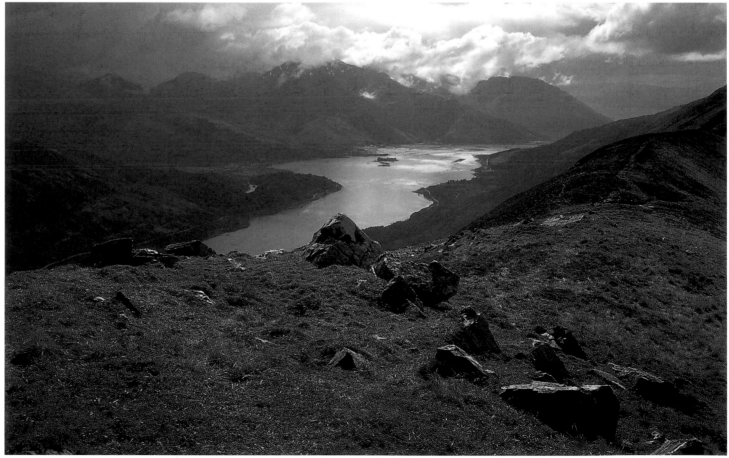

BEINN MHIC-MHONAIDH

2,611ft/796m

Hill of the son of the moor

The literal translation of the Gaelic is hill of the son of the moor. We are given no idea of who the son of the moor was, so are left to presume that it was someone once known for their association with the mountain.

Below Beinn Mhic-Mhonaidh from Creag nan Sean-chrodh, Glen Strae (*Irvine Butterfield*)

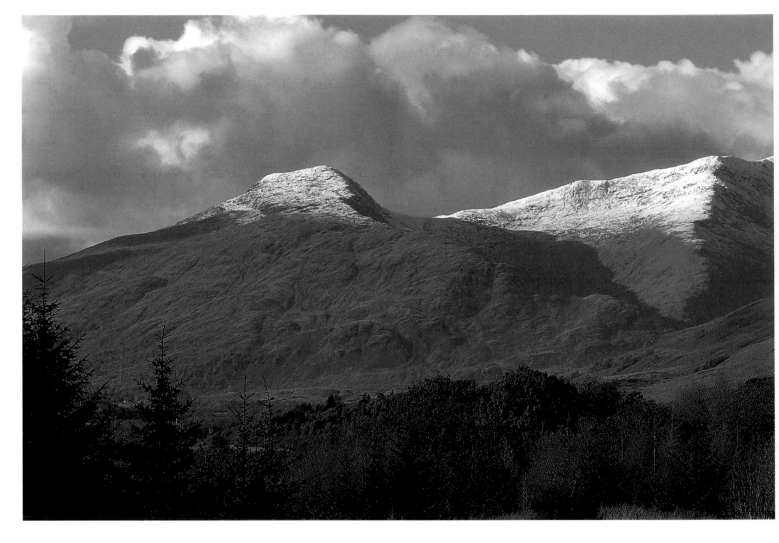

BEINN A' BHUIRIDH

2,943ft/897m

Hill of roaring

The roaring here is that of the stags, especially at the autumn rut. This is still a favourite haunt of the beasts as they find sanctuary in the corrie shadowed by the sweep of the mountain, and here are less subject to disturbance than on the great heights of Ben Cruachan of which this peak is an outlier.

Above Beinn a' Bhuiridh from Glen Lochy (*David May*)
Right Beinn a' Bhuiridh from Sron an Isean (*Malcolm Nash*)

140

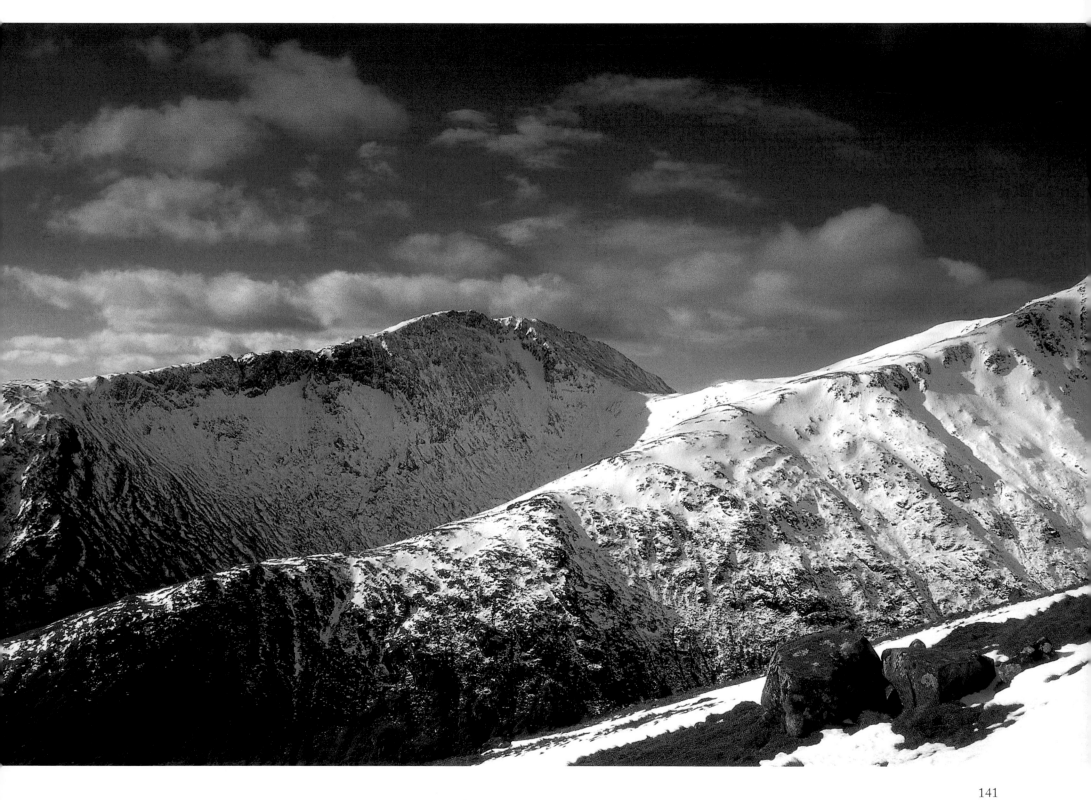

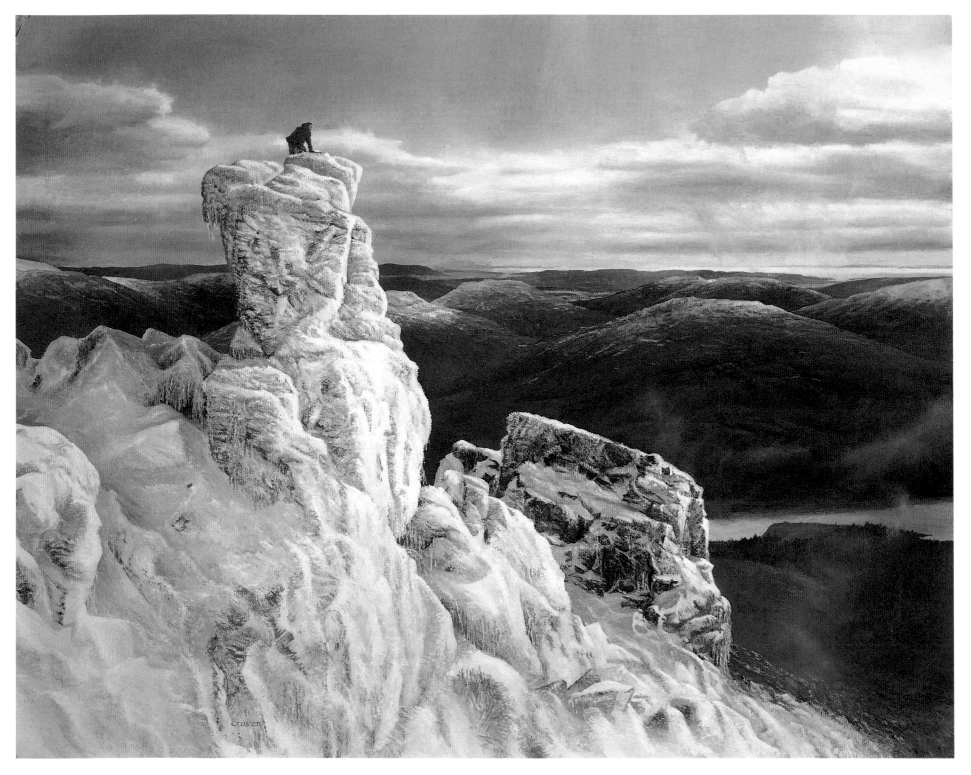

THE SOUTHERN HIGHLANDS

SOFTENED BY A GRASSIER COVERLET THAN THEIR NORTHERN neighbours, these hills provide a ready alternative to the more popular Munros ranged about. The hills around Arrochar and The Trossachs witnessed the earliest forays into the mountains and were deserved popular ascents for their views of the sea-lanes leading to the Clyde, and the panoramas of the lowlands. These peaks also provide many a superb outlook from which to view their higher neighbours, and in so doing a finer appreciation of the details of both are revealed.

Left The summit of The Cobbler (*Paul Craven*)

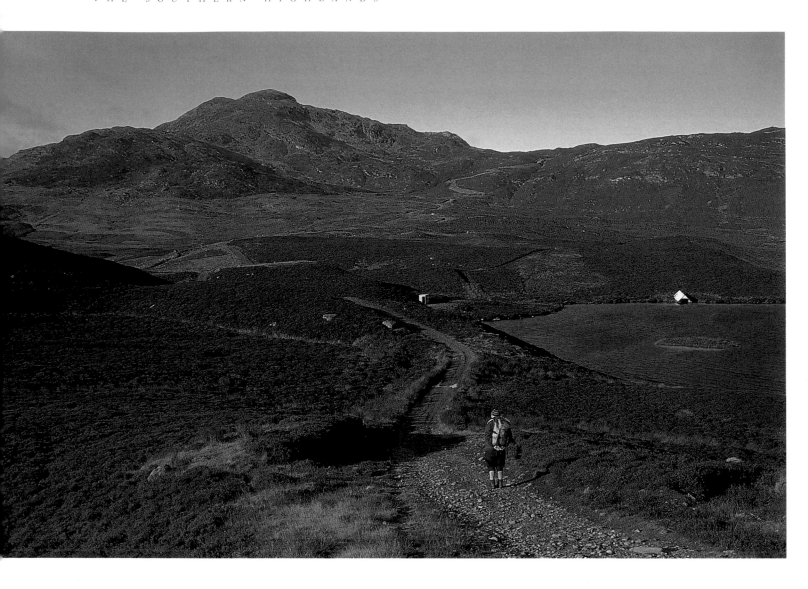

MEALL TAIRNEACHAN

2,582ft/787m

Hill of thunderclaps, or ptarmigan

Stobie's map of 1783 gives 'Hioch-more', which may be an attempt at the spelling of 'iochdmhor', meaning humane, merciful, or compassionate. This may relate to some unrecorded link with St Fergan's ministrations. Early one-inch maps name the hill as Meall Tarruin chon, suggesting a link with 'tarrunn', or 'tairnean', nails, an association still retained by the Allt Tarruinnchon, a stream rising on the northern slopes. In imagination the many small nipples of this mountain's crest might appear as nails. The current spelling of the hill's

FARRAGON HILL

2.569ft/783m

Warrior hill, or (Saint) Fergan's hill

Farragon may be a corruption of 'fear-feachd', literally translated as man of warfare, or 'feachdaire', a warrior. Those who postulate such a connection fail to explain who the warrior might have been and the link must, therefore, be considered very tenuous.

The distinctive shape of the hill's summit dome was an obvious one on which early cartographers could fix, and by which, in relation to it, less obvious heights could be identified. This is one hill whose name appears to have been in constant use since the maps of Stobie, published in 1783. The name 'Farragon' is derived from that of Feargain (Fergan), an Abbot of Iona who ministered in the district. This is one of the few mountains to have been named after a saint.

Above Farragon Hill and Loch Derculich
(*Tom Rix*)

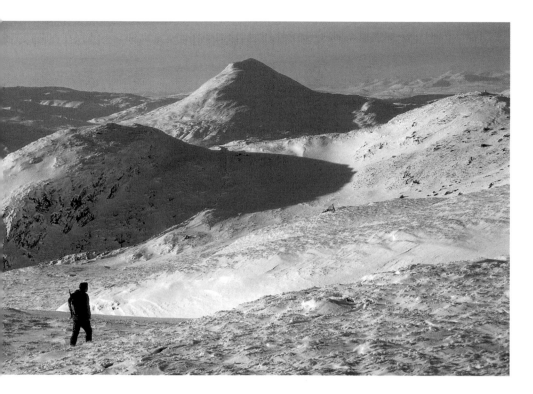

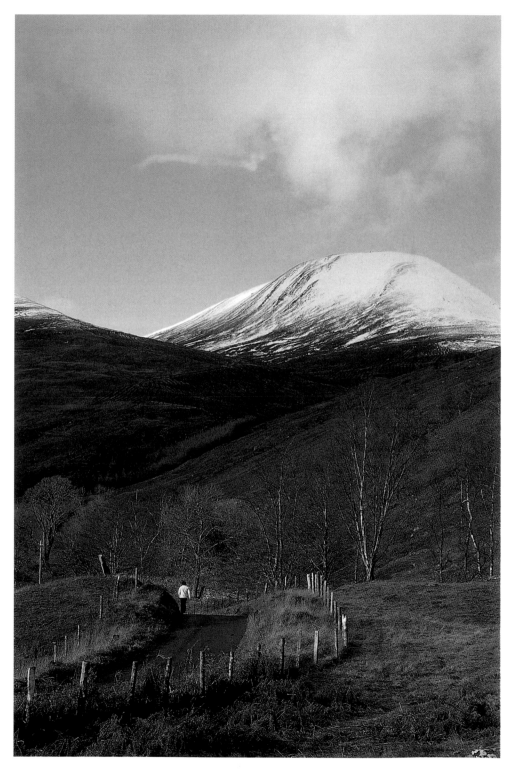

name is considered to be from 'tairneach', thunder, but why the hill should be singled out as one where thunderclaps are prevalent when other hills attract storm in equal measure remains a mystery. The alternative possibility offered is a corruption of 'tarmachan', the ptarmigan. The presence of the bird in great numbers would mark this hill as one ideally suited to their pursuit as game.

Now badly scarred by the access track and workings of a barytes mine the hill offers compensation with its unusual end-on view of Schiehallion.

Above Schiehallion from Meall Tairneachan (*Tom Rix*)

BEINN DEARG

2,723ft/830m

Red mountain

A not uncommon name for a Scottish hill and one most probably derived from the colour of the rock outcrops on the mountain's upper slopes. This colour manifests itself in a scree slope on the face of the hill, best seen from the proximity of Eonan's Cross beside the road between Slatich and Camusvrackan. This celebrates the saint who successfully prayed near this spot that the people of the glen might be saved from the scourge of the Gatar Mor, or Great Plague.

Right Beinn Dearg from Eonan's Cross, Glen Lyon (*Irvine Butterfield*)

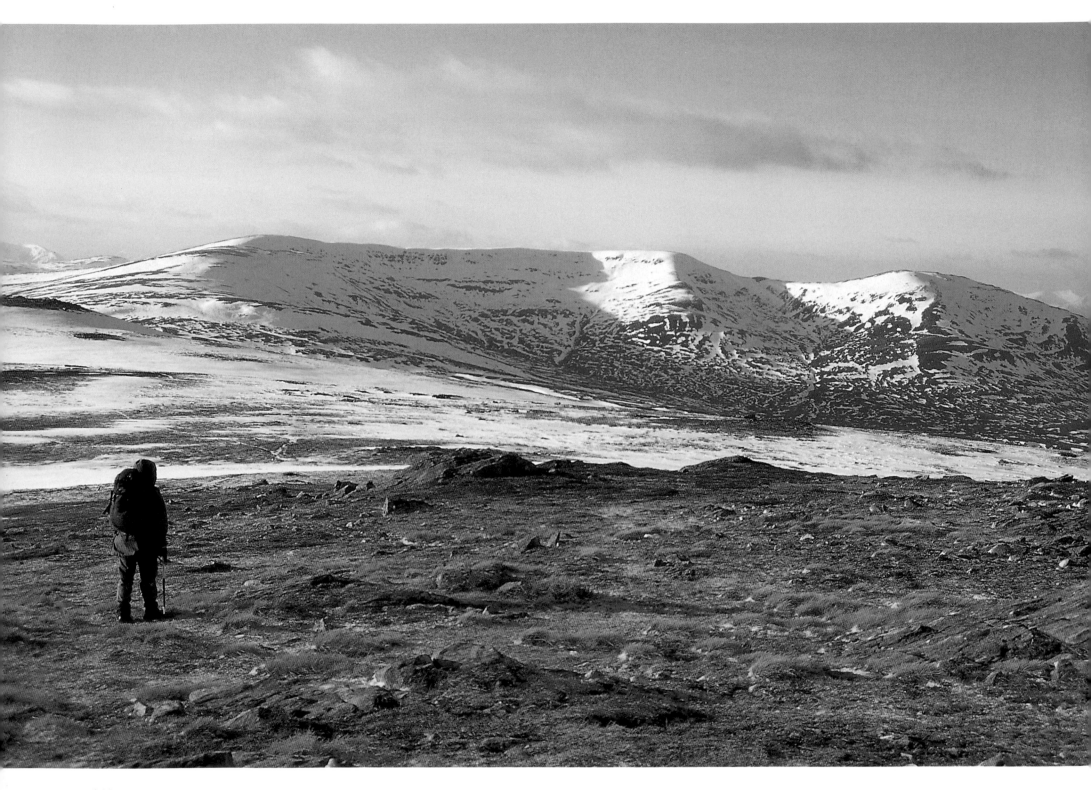

THE SOUTHERN HIGHLANDS

CAM CHREAG

2,821ft/860m

Crooked crag

Stobie's map of 1783 names the hill Ben Meggarnie, a name now retained by the point on the long eastern spur of the mountain. The crag from which the hill now takes its name lies at an eastern edge of the bare summit. Its projection prevents the perfect formation of a clear curve or angle where the lengthy northern and eastern ridges meet, hence the crookedness. This feature becomes clear on ascents by the long shank of ridge from Ben Meggernie.

Left Cam Chreag from Ben Meggernie approach (*John Allen*)

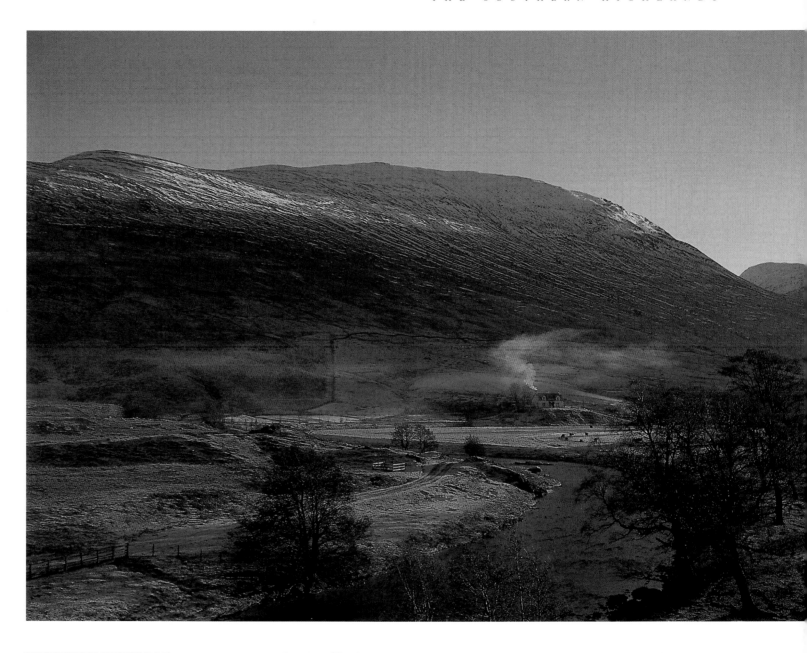

BEINN NAN OIGHREAG

2,982ft/909m

Mountain of cloudberries

Northern latitudes favour the production of fruit on the cloudberry which in Scandinavian countries is popular for making jam. This hill was obviously more productive than most and would be a source of the much sought-after berry.

The mountain was at one time considered as a potential 'Munro', and is also noted for a curious wind. This builds in intensity to die in an instant so that walkers leaning into it suddenly find themselves without support.

Above Beinn nan Oighreag from Moar (*Irvine Butterfield*)

147

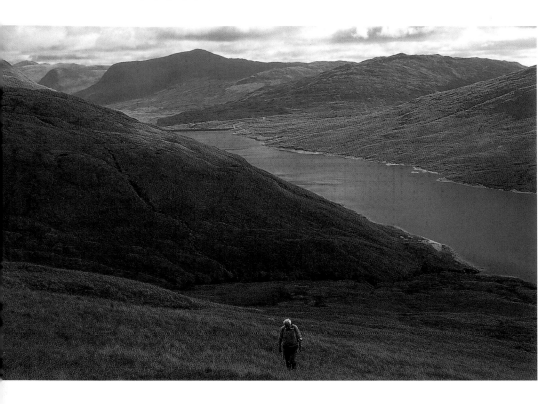

SRON A' CHOIRE CHNAPANICH
(CREAG DOIRE NAN NATHRACH)

2,746ft/837m

*The nose of the lumpy corrie – Crag of the
wood of the serpent, or adder*

Chnapanach, or lumpy, is an obvious
reference to the many small knolls and
grassed knots of the corrie under the flank
of the great neb of the mountain.
According to the Ordnance Survey map
the alternative name relates to a small
crag lying athwart the fence on the climb
from the south west. The wood or thicket
probably lay around the col below as
traces of bog wood remnants may still be
found in the peat hags thereabouts.

The one-inch maps gave the summit
in an elongated contour of 2,250ft so that
it never attracted attention as it failed to
attain the required height to be
considered a Corbett by a fair margin.
Upon remapping prior to its listing in
1984 it appeared to have grown in stature
by almost 500ft, surely the most
remarkable height gain ever experienced
at the hands of the Ordnance Survey!

Nonetheless, with so fine a summit
there must have been several people who
sought out the cairn on the short snout
high above Loch an Daimh for the view.
Right Sron a' Choire Chnapanich from
Stuchd an Lochain (*Hugh Munro*)
Below Loch an Daimh from Sron a'
Choire Chnapanich (*Lorraine Nicholson*)

MEALL BUIDHE

2,976ft/907m

Yellow-coloured mountain, or yellow dome

At a time when the upper reaches of Glen
Lyon were populated transhumance was
practised and ruined shielings are still to
be found on the hill's lower slopes. The
provision of good grass was an essential
element in this search for summer
grazing, and here the yellower grasses of
the poorer upland pastures would be
noted by the people in the glen.

As the name implies such is the
spread of this hill that any view along
the glens on either hand are best enjoyed
on the ascent rather than from the
summit cairn.

Above Loch Lyon from Meall Daill,
Meall Buidhe (*Tom Rix*)

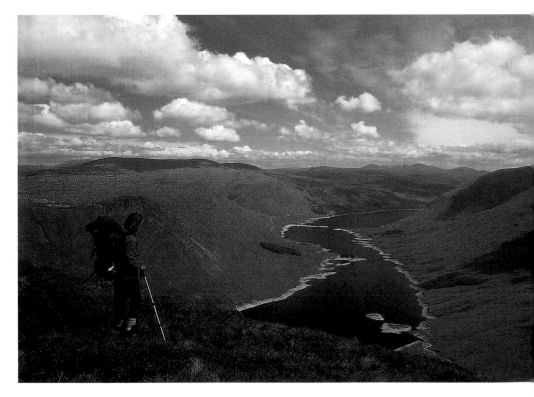

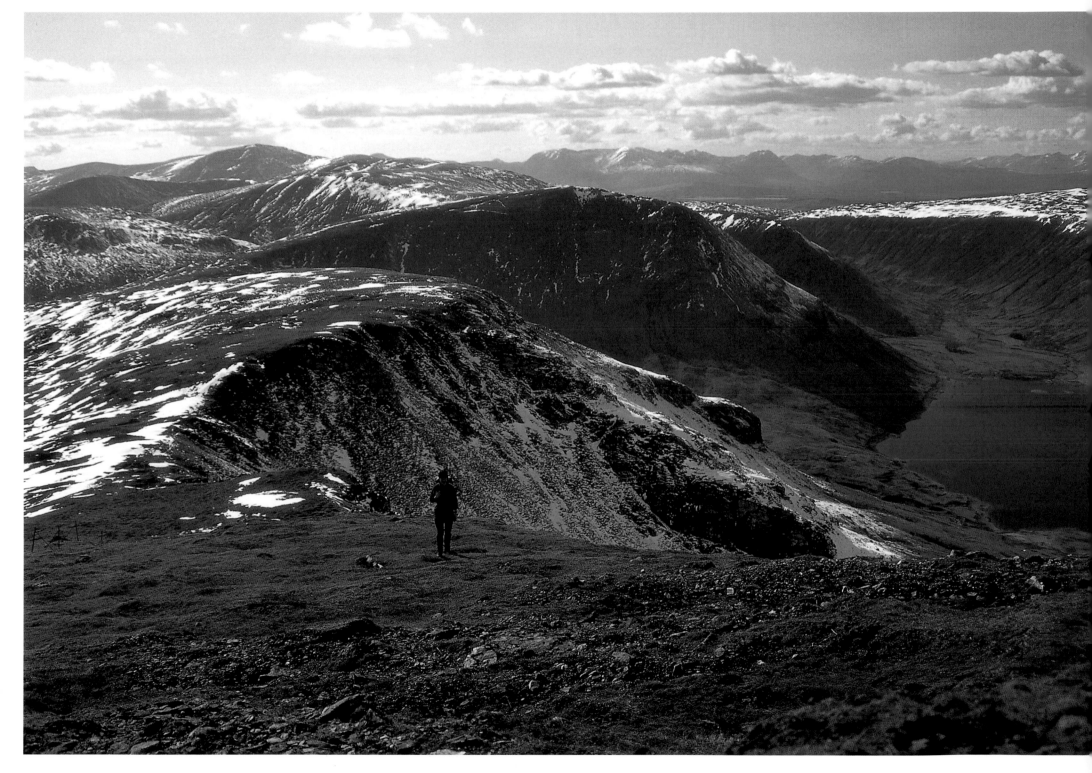

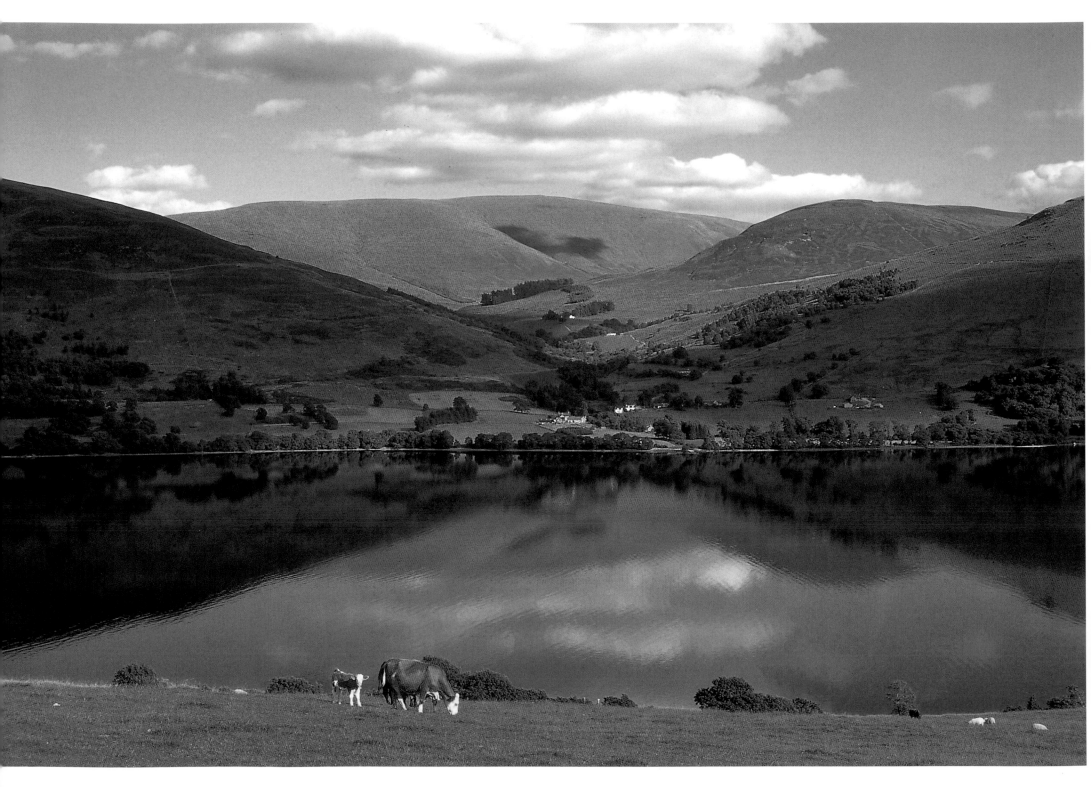

corner on the ancient crossing between Ardeonaig on Loch Tay and Comrie in Strath Earn. This provides the link with current translations of the name. Another possibility is that the name now given contains the Gaelic 'uchd', a bosom or breast, or may be derived from 'uchdan', a little knoll or eminence, interpretations which would be equally appropriate.

More romantically the Victorian name may be a derivation of 'uigean', a wanderer or fugitive, and though tenuous there might just be a link with the thief who hid out under Auchnafree Hill a few miles to the east.

Left Looking down Loch Lednock from Creag Uchdag (*Martin Ross*)

AUCHNAFREE HILL

2,588ft/789m

Hill of the field of the deer forest

The name is derived from 'achadh na frithe', field of the deer forest. Auchnafree may also mean heath-field so by liberal interpretation could serve as a warning to visitors that its summit is a vast expanse of peat hags and heather.

As with so many of these rounded heathery hills they are at their most colourful when the heather is in flower. The bloom is short-lived so that the presence of water is an added bonus when trying to capture such a hill at its best.

Below Auchnafree Hill and Loch Turret (*Irvine Butterfield*)

CREAGAN NA BEINNE

2,913ft/888m

Little rock, or cliff, of the mountain

Hill of the rocks or crags is another interpretation of the name and undoubtedly refers to the small outcrops of crags on the hill's upper slope above the deep cut of Gleann a' Chilleine, an ancient route from Loch Tay-side to the upper reaches of Glen Almond. Such landmarks would be known to the drovers and others who crossed the pass below, and as such a guide to progress on the climb to the watershed en route to the cattle markets and trysts further south.

Left Creagan na Beinne and Loch Tay from Lawers (*John Allen*)

CREAG UCHDAG

2,884ft/879m

Rock, or cliff, of panting, crag of the hollows, or steep crag

The present title of the hill is not the only one it has possessed. The Victorian one-inch map names the height Creag Uigeach, 'uig' here signifying a small conical steep rock. This accurately describes the summit point, with 'each' (horses), providing a translation as the conical steep rock of the horses. The root of the name may also lie in an alternative meaning of 'uig', a nook. If this is accepted the nook would be the small hollow at the watershed above the head of Loch Lednock, a recognised sheltering

MEALL NAM MAIGHEACH
(MEALL LUAIDHE)
2,559ft/780m

Hill of the hares, or hill, or dome, of lead

Several of the hills in the Southern Highlands are noted for their hare populations. As a source of sport and food the hare provided a welcome change of diet for a people with a livelihood dependent on what they could wrest from a land affording limited resources. The alternative name should more properly be applied to the westerly summit where small grassed spoil heaps on the slopes mark the site where once lead was gleaned from shallow trenches, cut to access the veins of ore.

Below Meall nam Maigheach from Lochan na Lairige (*David May*)

MEALL NAN SUBH
2,638ft/804m

Hill of berries, or raspberries

The name given identifies this hill in a similar fashion to the cloudberry-bearing hill further down Glen Lyon. The close proximity of the two hills yielding natural fruits is unique to Glen Lyon, and evidences a time when its people were more numerous and very much aware of what the land could provide. 'Subh' comes from 'suibheag', a berry, or more particularly a raspberry. Curiously 'suibheag' can also mean a tooth, which here finds expression in the small tops whose molar-like stumps sit astride the summit ridge, providing ideal resting places from which to admire the view.

Above Looking to Beinn Achaladair from Meall nan Subh (*Mark Gear*)

BEINN NAN IMIREAN
2,779ft/847m

Mountain of the ridges of land, or hill of the ridge

Stobie's map gave the name Ben animmeren, so that as long ago as the late sixteenth century this mountain was known by a title little changed over the years. The ridge of the mountain crest is well defined, and there are furrows traced across the slope when seen from the ruins of old shielings still visible at the mountain's northern foot. This lends credence to the suggestion that the hill was accorded distinction by the people of Glen Lochay.

Right Beinn nan Imirean from Ben Challum (*Mark Gear*)

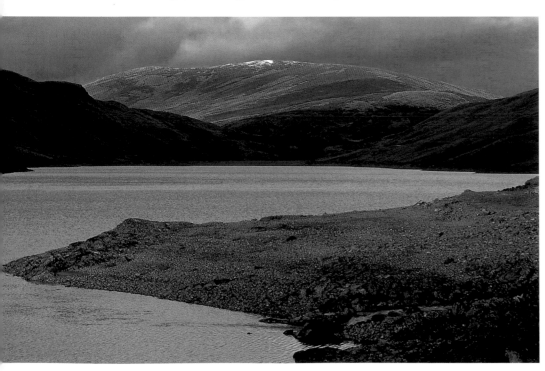

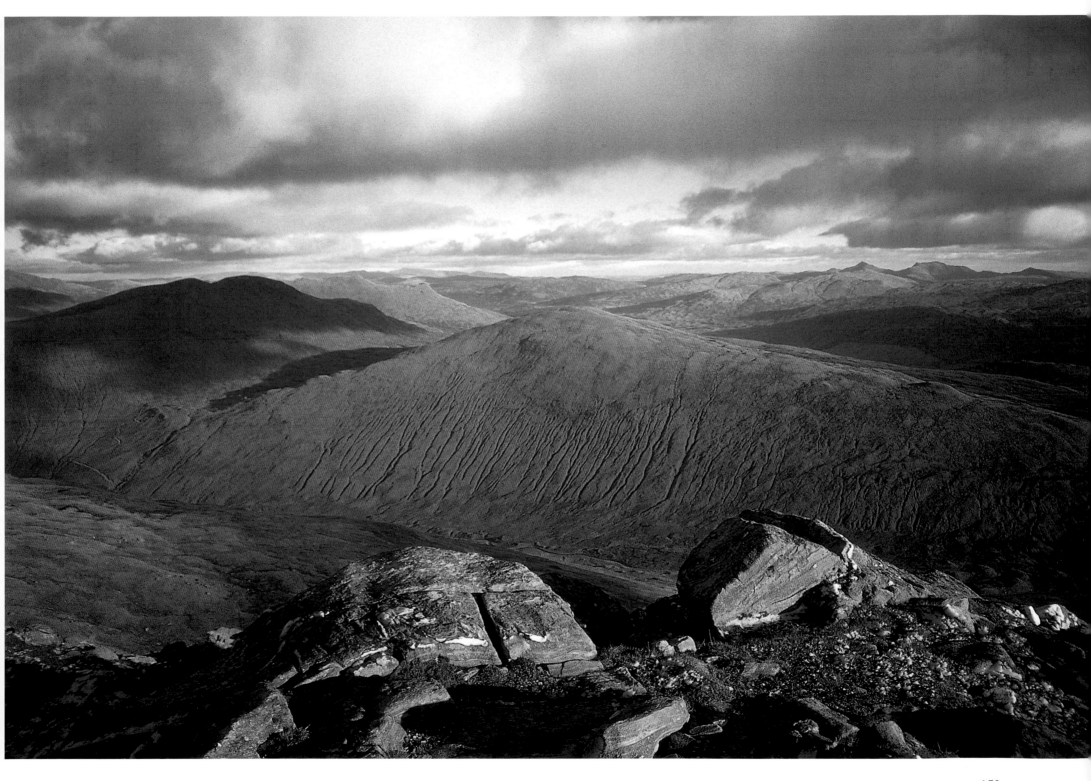

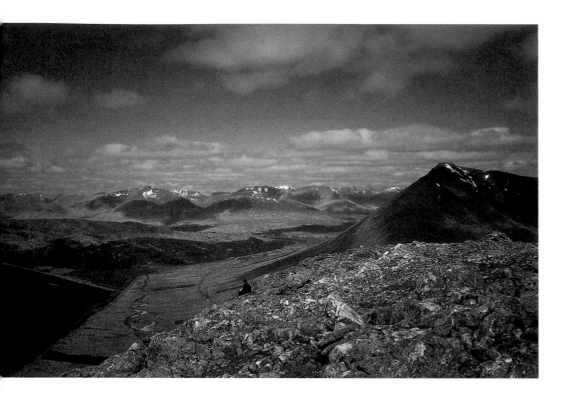

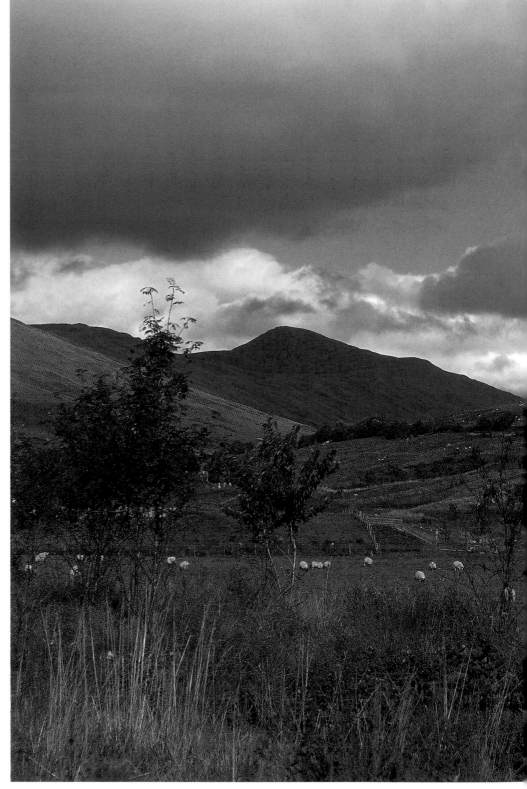

BEINN ODHAR

2,956ft/901m

The dun-coloured mountain

Colour here played a role in the naming
of this hill which might seem a little tame
given the steepness of its ascent and the
hill's distinctive shape. The dullness
alluded to comes from a mix of heather
and yellow-brown grass.

The steep walls of this mountain
really set it apart from its neighbours and
it is well suited to one of those short,
sharp winter ascents when on a clear day
the mountaineer is rewarded with
extensive views westwards toward the
Black Mount and on the opposite hand to
the cluster of Crianlarich peaks.

Above Looking north to the Black Mount
from Beinn Odhar (*Tom Noon*)

BEINN CHAORACH

2,684ft/818m

Mountain of the sheep run, or sheep hill

This hill name is one of few which
specifically mentions sheep. This suggests
that the mountain either lost its original
name or was not named before the hills
were parcelled into sheep runs around the
mid to late eighteenth century.

Right Beinn Chaorach from Kirkton
Farm (*Irvine Butterfield*)

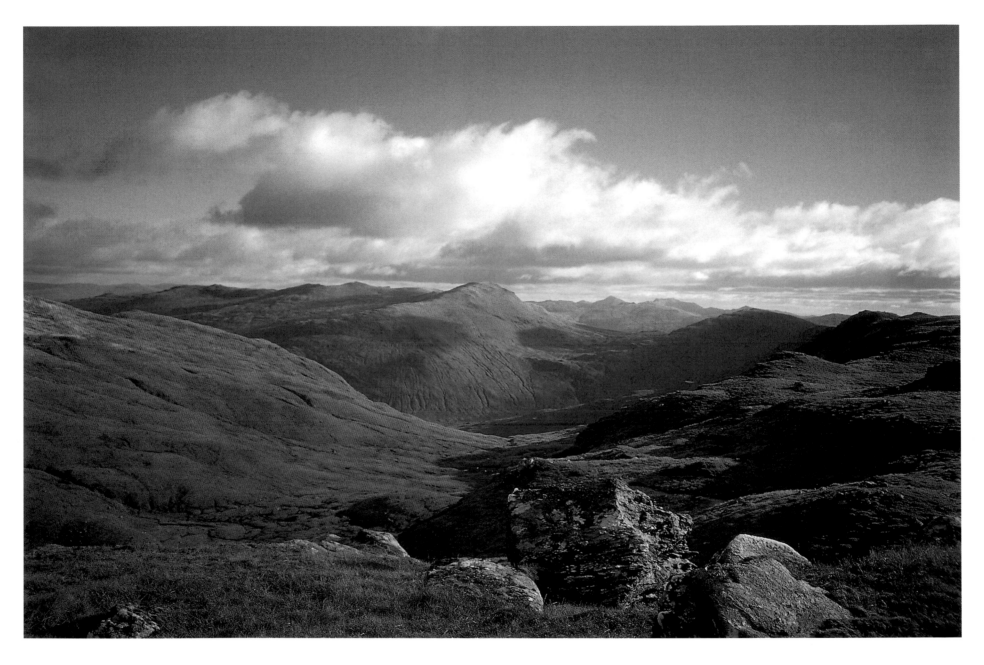

CAM CHREAG

2,900ft/884m

Crooked crag

In 1783 Stobie recorded the name Camachreag so that the mountain is known by a title long established. This is another hill which relies on its topography to differentiate it from other hills of like stature round about. The crags twist around an end of the summit ridge and, in mist, invite a cautious descent to the streams draining to a lonely corner at the head of Loch Lyon. At the centre of an eastern flank the crags are more broken with gullies opening a way to the summit crest.

Above Meall Glas from Cam Chreag (*Mark Gear*)

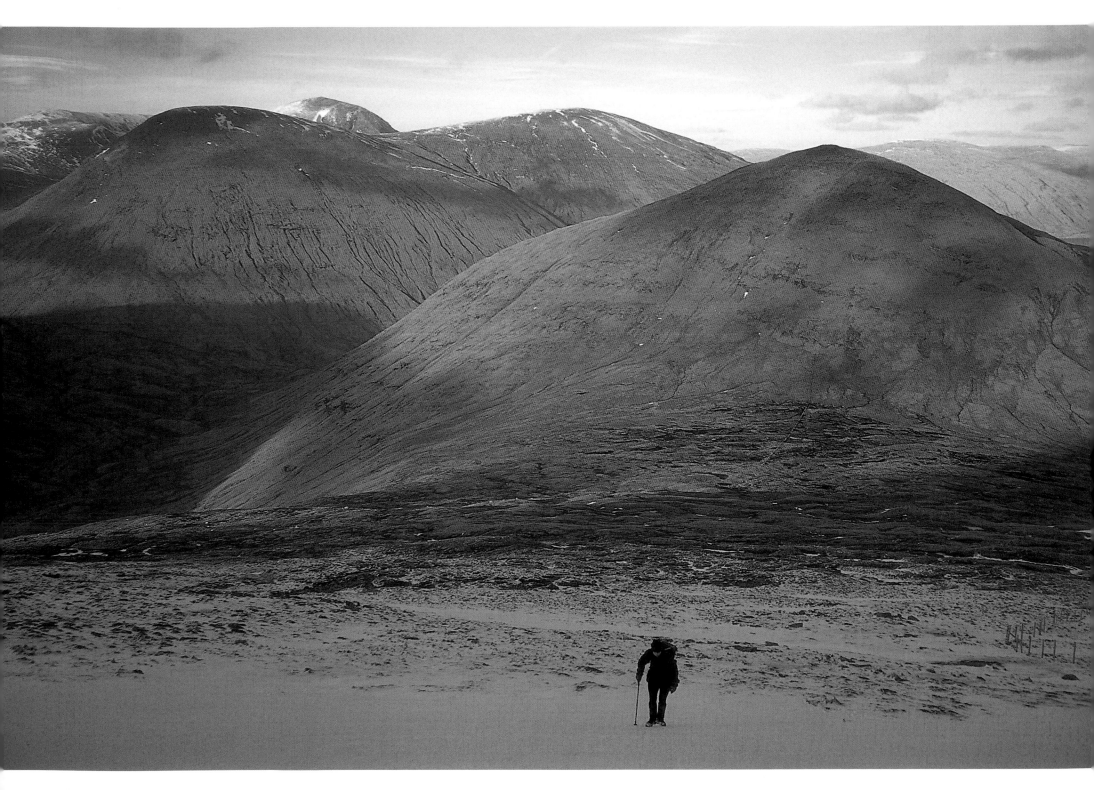

BEINN NAM FUARAN

2,644ft/806m

Mountain of the springs, or hill of the well

The presence of Coire Glas, the green corrie, hints at green grasses nurtured by infant streams so that there is no difficulty in accepting the normal translation of 'fuaran' as meaning well, or spring. Stobie's map of the area gave the name Ben vurlan, and as there is no letter 'v' in Gaelic it is an obvious attempt at phonetic spelling. A corruption of 'urlann', the butt of a spear, might be explained by accepting that the long ridge, of which the mountain forms a part, ends in a point, here the spike of Beinn a' Chaisteil. The word 'murlan' is more in keeping with hill names in the district as it translates as ugly head of hair, or dirty, matted hair and could well refer to the predominance of rough tangled grasses on the major part of the hill.

Left Beinn nam Fuaran from Beinn a' Chaisteil (*Hugh Munro*)

BEINN A' CHAISTEIL

2,907ft/886m

Mountain of the castle

An old spelling Ben achastle confirms a name of long standing. When seen from the west it is well defended by steep ramparts and walls of crag, outflanked to gain a summit battlement which needs little imagination to be thought a castle.

Above right Beinn a' Chaisteil from Coille Bhreac-liath (*Irvine Butterfield*)

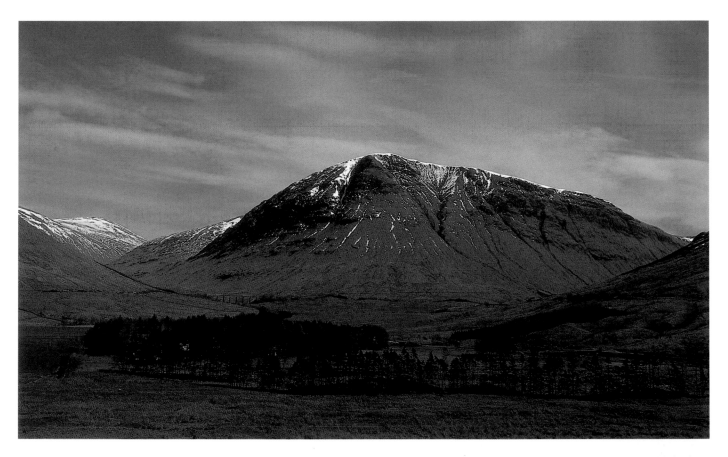

BEINN BHREAC-LIATH

2,631ft/802m

Speckled grey hill

Grey rock with hints of white specks readily explain the descriptive title of this hill. The best examples are to be seen in the broken terraces of crag on a western flank, or the scoured stream gullies of the Coire Chailein to the south west of the summit.

The hill appears from most quarters as one long ridge-back, and this is no more apparent than when seen from Glen Orchy.

Right Beinn Bhreac-liath from Glen Orchy (*Stuart Rae*)

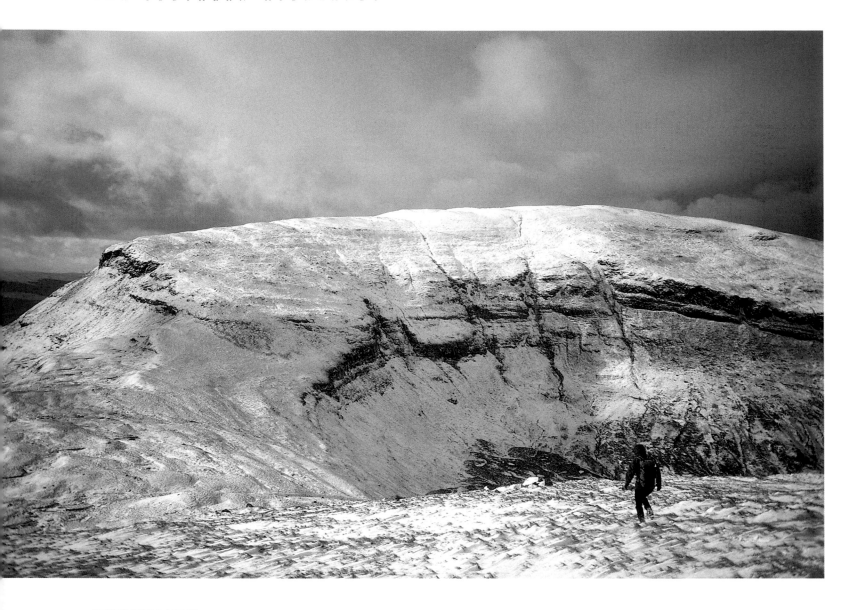

BEINN CHUIRN

2,887ft/880m

Cairn mountain

This mountain sits on the ancient boundary of Druim Alban, which separated the old Scottish kingdom of Dalriada from that of the Picts. Watson's *Celtic place names in Scotland* provides a clue to the name which he says has links to an ancient boundary line. On the old county march above Tyndrum lies Carn Droma, cairn of the ridge, an ancient landmark. This is not marked on the Ordnance Survey maps, and neither are two cairns to the west. On the south side of Glen Orchy lie Sron nan Colan and Beinn a' Chuirn, a part of Druim Alban which might be styled 'hill of the cairns'. Beinn Chuirn is the highest of these points. Another translation gives mountain of the rocky heap and although the hill has been exploited for its minerals, the term rocky heap has no connection with spoil tips and clearly is a substitute for cairns.

Right Beinn Chuirn from Glen Cononish (*Irvine Butterfield*)

BEINN UDLAIDH

2,756ft/840m

Dark, or gloomy, hill

The black crags of an eastern flank, shadowed by the protective curve of a southern wall, seldom catch the sun and for that reason often impart to the mountain a rather forbidding appearance. The only relief in a brown coverlet of heath is the sparkle of some quartzite outcrops on the hill's northern nose.

Above Beinn Udlaidh from Beinn Bhreac-liath (*Mark Gear*)

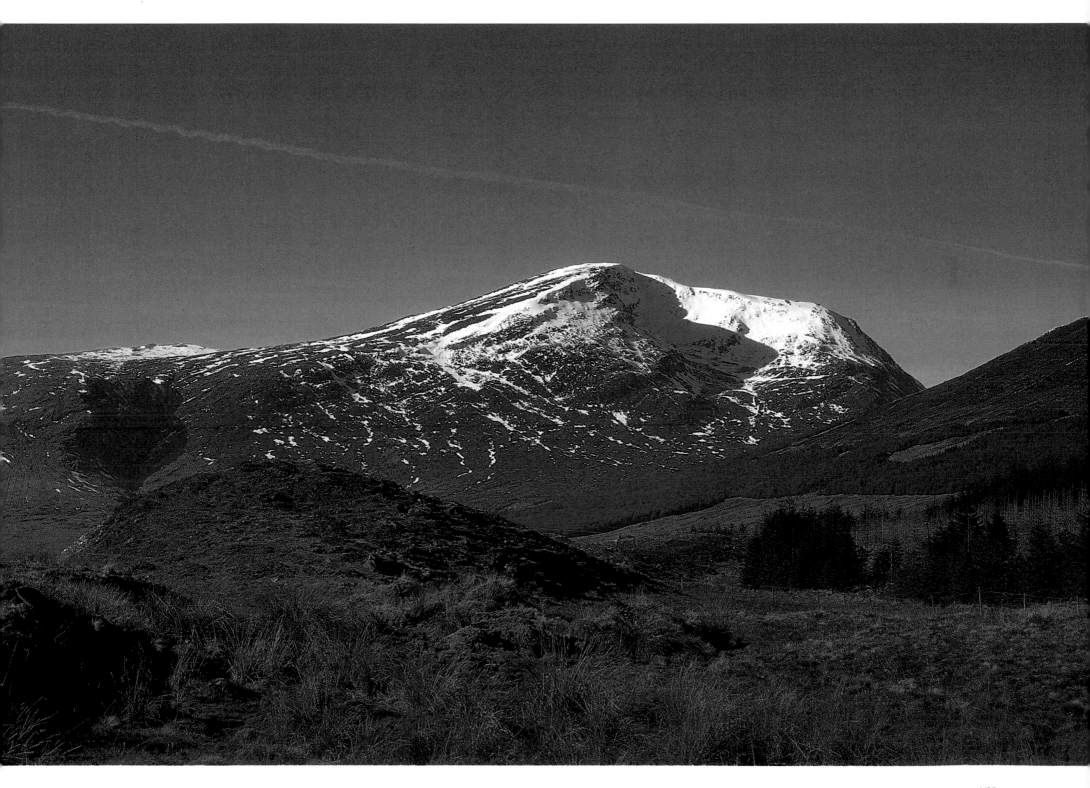

BEN ARTHUR (THE COBBLER)

2,900ft/884m

Arthur's mountain – The crooked shoemaker,
or cobbler

This is one of several Scottish hills named after the legendary King Arthur who is also commemorated elsewhere, the Arthur's Seat in Edinburgh being the most well known. A southern top of this triple-summited mountain is another Arthur's Seat, and not too far distant is Aghaidh Artair, Arthur's face, a rock on the west side of Glen Kinglas. The hill's more popular title, The Cobbler, is an English translation from the old Gaelic name and should strictly speaking be given to the summit, the central of the three heights. Writing in his book *Local Scenery and Manners* in Scotland in 1800, John Stoddard recorded, 'This terrific rock forms the bare summit of a huge mountain, and its nodding top so far overhangs the base as to assume the appearance of a cobbler sitting at work,

from whence the country people call it "an greasaiche crom", the crooked shoemaker.'

The new chief of the Clan Campbell, the Duke of Argyll, had to prove himself by climbing to the top of the 'Cobbler's Cowl'. This, the summit, is reached through a hole in the supporting rock known as Argyll's Eyeglass, and thence by a narrow sloping ledge to a final scramble up onto the exposed block.

Above Looking to the summit block and Argyll's Eyeglass from the North Top, The Cobbler (*Gordon Hadley*)
Left The Cobbler from Allt a' Bhalachain (*David May*)

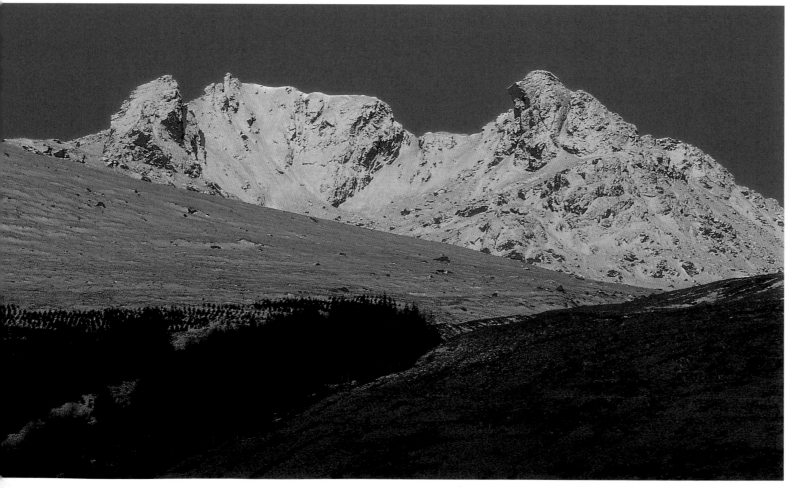

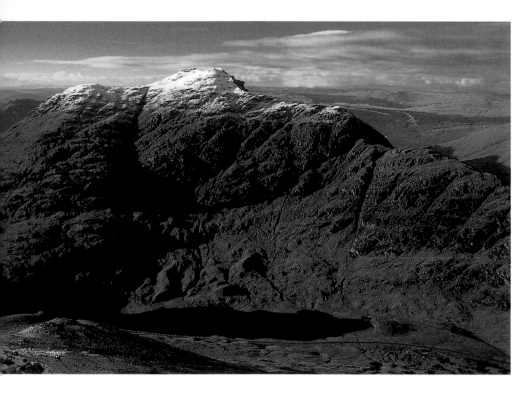

Left Beinn an Lochain from Beinn Luibhean (*Hugh Munro*)

BEINN LUIBHEAN

2,912ft/857m

Hill of the little plant

The Gaelic 'luibheanachd' is botany, and this close connection to the hill's name suggests a peak rich in plantlife. The tormentil is a favourite, and in season its bright yellow flowers lie scattered like droplets of sunshine on the greensward of the mountain. In winter's grip the peak, like many others, assumes a more forbidding mantle.

Below Beinn Luibhean from Binnein an Fhidhleir (*Derek Sime*)

BEINN AN LOCHAIN

2,956ft/901m

Hill of the little loch, or small lochs

Loch Restil, cupped between two peaks at the head of the Rest and be Thankful (the top of the climb on the road crossing between Lochs Long and Fyne), is obviously the little loch referred to here. If small lochs is the interpretation the lesser tarn to the north may also have some claim to recognition, though this is by no means certain. For sure the mountain is associated with Loch Restil which provides a moat to the mountain's bastion walls. Due to over-zealous calculation of its height it was for many years listed as a 'Munro', but loss of such status is of little account to so rugged and grand a mountain – climb it and see for yourself!

STOB COIRE CREAGACH
(BINNEIN AN FHIDHLEIR)

2,680ft/817m

Peak of the craggy corrie – Peak of the fiddler

Until 1990 the lists of the Scottish 2,500ft peaks bore the name of the point at the western end of the mountain alone. In that year a name to identify the actual point of the summit was introduced. This followed a practice of the late Sir Hugh T. Munro who used the prefix 'stob' to denote a top whose name was unrecorded, or unknown. The name was completed by associating the peak with a hill feature in close proximity. Thus the small corrie tucked under the northern edge leading from the summit was used to produce the

name Stob Coire Creagach.

Above Looking across Coire Creagach from Stob Coire Creagach (*Irvine Butterfield*)

THE BRACK

2,582ft/787m

The dappled, or speckled (mountain)

The name is derived from the Gaelic 'breac', dappled or speckled. This is a name usually given to mountains whose slopes are a patchwork of heather, grass and scree, which provide a natural palette of browns, greens and greys. Gaelic legends tell of a hag-like creature, Cailleach Beinn a' Bhric, 'the spirit of the speckled mountains', and this may be one

of several speckled mountains so named to win her favour.

Below The Brack from the head of Glen Croe (*Martin Ross*)

BEN DONICH

2,779ft/847m

Donnan's mountain

Most interpretations of the hill name link it with 'donn', brown. Although there are patches of brown heather on its slopes the mountains hereabouts are very green and suggest that the origin of the name has little to do with its colour. There are some suggestions that the name comes from 'dona', evil or vile, though why no one knows. As the neighbouring hill has possible links to Cailleach Beinn a' Bhric could it be that this was a hill where she most practised

her nastier influences on passers-by?

For so pleasant a hill it is more pleasing to record that it is more truly associated with St Donnan, a disciple of St Columba who accompanied him to Iona. St Donnan later established a monastery on the island of Eigg, which was burned by sea raiders one Sunday after mass. Like many of his brethren he travelled to spread the gospel and must at some time have visted this area of Argyll to minister to its people.

The views down to and along the long sea arms of Loch Goil, Loch Long, and Gare Loch stretching away to the Clyde estuary are a reminder that these missionaries came from across the waters on the distant horizons.

Right Looking to Loch Long from Ben Donich (*Gordon Hadley*)

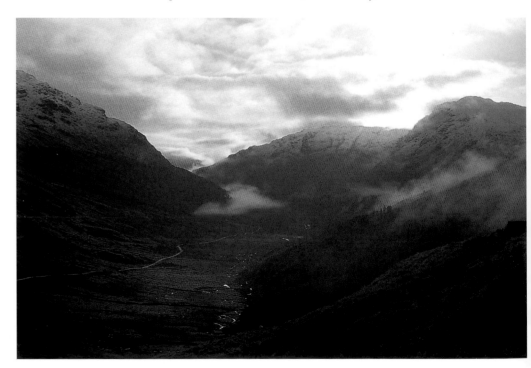

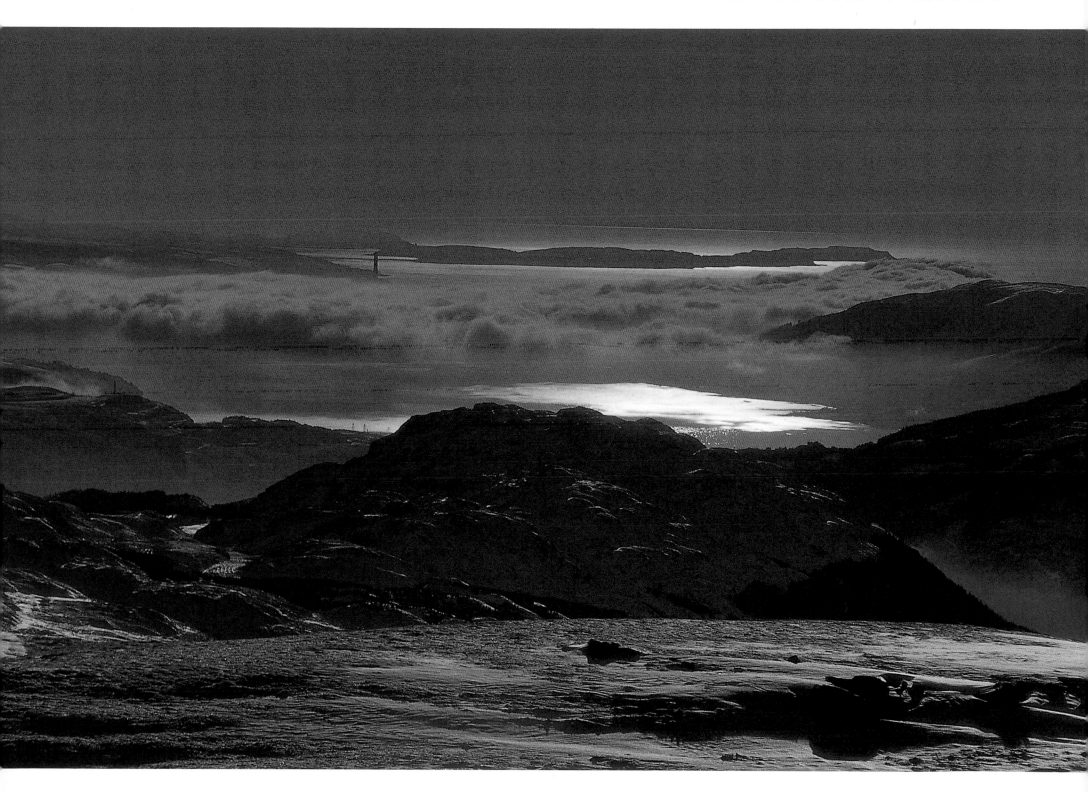

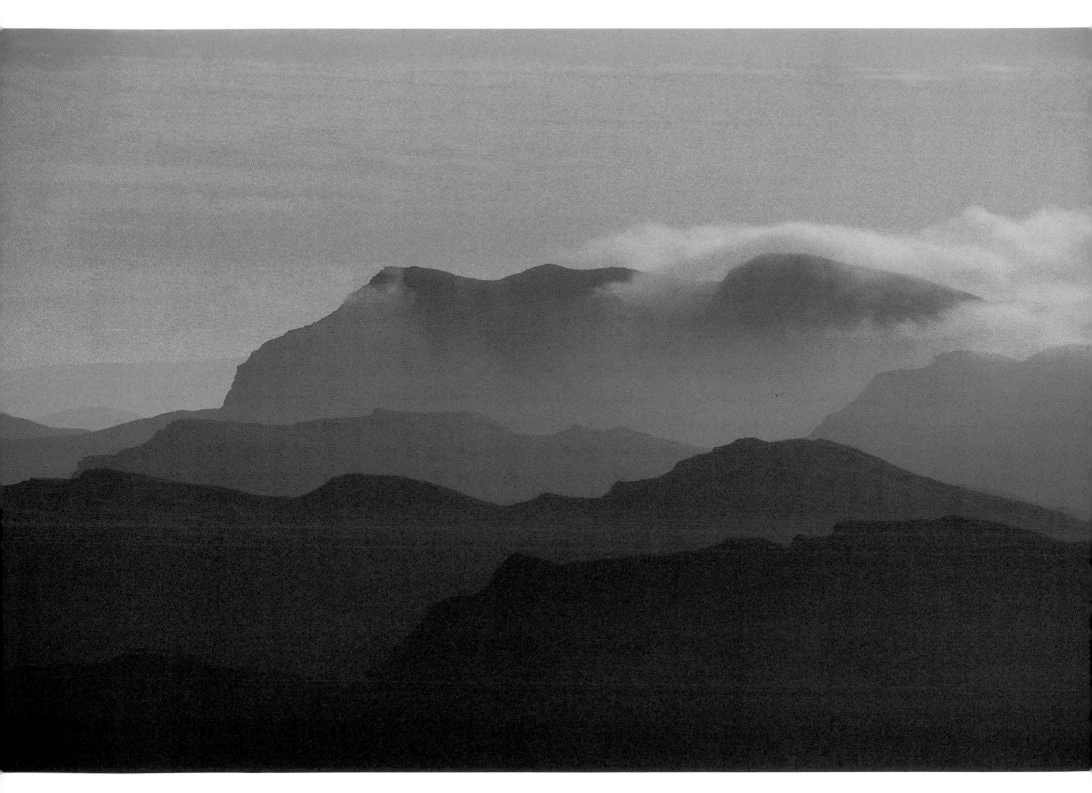

BEINN BHEULA

2,556ft/779m

Mountain of the ford, or mountain of the mouth, or lying place for cattle

Bheula comes from the Gaelic 'beul', a mouth. This became a word to mean a common pasturage, or lying place for cattle, and it is understandable how a protected scoop in the hills might invite comparison with the shelter provided by the mouth. Such protected folds lie under the escarped edge of this particular mountain where lush grass would have provided hill grazing for cattle.

Left Beinn Bheula from Stob an Eas (*Martin Ross*)

MEALL AN FHUDAIR

2,506ft/764m

Gunpowder hill

Stobie's map of 1783 names the hill Meal-breck, with Meall Fraskich given for the eastern end of its ridge. This would be an appropriate name as the ridge is a mix of heather, grass and outcrops which give the dappled or speckled effect that the name would imply.

In Gaelic 'fudar' is powder, or gunpowder. In this case the latter has been used suggesting some event when gunpowder played a significant part in the history of the hill or its immediate neighbourhood. To its visitors the mountain gives prospects of the higher peaks ranged about.

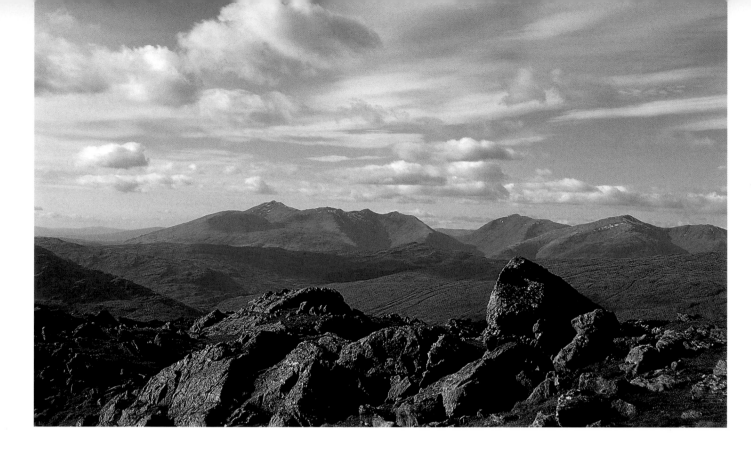

Above Ben Cruachan from Meall an Fhudair (*Irvine Butterfield*)

CREAG MAC RANAICH

2,600ft/809m

MacRanaich's crag, or hill

The use of the word 'creag' in the title is obvious enough as the upper crest is well buttressed by large blocks of broken crag. 'Ranaich' is drawling, or crying, hence some literal translations give rock of the son of the roarer. The name Mac Ranaich is less obvious and apparently records an association with an otherwise long-forgotten robber.

The ascent and the enjoyment of the northern prospect to Ben Lawers and the hills of central Perthshire will be less easily forgotten should you choose a fine day for the ascent.

Below Looking north from the cairn, Creag Mac Ranaich (*Martin Ross*)

MEALL AN T-SEALLAIDH

2,795ft/852m

Hill of the sight

An ideal look-out point from which to observe the hills and glens round about, the name of the summit is better translated as mountain of the prospect, or view. This would be apparent to those who climbed its slopes in days gone by, and it was perhaps a favoured belvedere of those tending their beasts in the corrie below.
Above Creag Mac Ranaich from Meall an t-Seallaidh (*David McLeod*)

STOB A' CHOIN

2,851ft/869m

Peak, or point, of the dogs

This is one of two hills associated with dogs, situated in the tract of country to the north and west of Loch Katrine. This suggests a connection and it could be that the respective hills were points of vantage used by the keepers of hounds at a time when the hills lay in a hunting forest.

Right Stob a' Choin from Balquhidder (*Malcolm Nash*)

CEANN NA BAINTIGHEARNA
(STOB FEAR-TOMHAIS)
2,529ft/771m
Her ladyship's head – Surveyor's peak
Stobie's map identified the hill by the
name 'Meal aonach', which literally
means round hill of the ridge mountain –
a perfect description for the long,
rounded barrow of ridge set on a
north–south axis. For reasons

unexplained this name disappeared.

In compiling his lists Corbett used
the name Ceann na Baintighearna, her
ladyship's head, which actually refers to a
point on the nose to the north of the
actual summit. As the mountain was
known locally as the Surveyor's Peak the
Scottish Mountaineering Club adopted
this as the name, embellishing the title
with a touch of Gaelic.

Above Ben Vorlich and Stuc a' Chroin
from Stob Fear-thomais (*Martin Ross*)

BENVANE

2,690ft/820m

Middle hill, or white hill

Some translations take the name to be an Anglicised pronunciation of 'beinn mheadhoin' which means the middle or central of two other hills, here Ben Ledi and Beinn an t-Sithein. Older maps such as Stobie's give the name Ben bane which suggests a spelling of Ben Ban, white hill. The colour could come from the light grasses and rocks but this does not hold true as the cliffs appear very dark, so middle mountain it is.

Below Ben Ledi from the slopes of Ben Vane (*Mark Gear*)

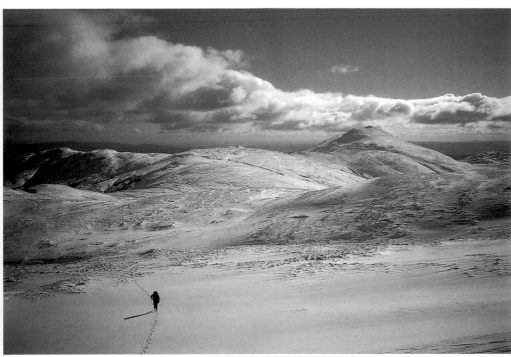

BEN LEDI

2,884ft/879m

The mountain of the gentle slope, or God's hill

In the days of the Druidical priesthood the people of the country round about assembled on the summit about the time of the summer solstice to worship the Deity. This explains a popularly held assumption that the interpretation of 'ledi' should be 'le dia', hence God's hill.

Local pronunciation as recorded by Dwelly in the nineteenth century was Lidi or Lididh, which places stress on the first syllable and thereby contradicts those who argue for 'beinn le dia', the mountain with, or in the company of, God, which lays emphasis on the last syllable. The latter is a curious use of the language and suggests the origin of the name lies elsewhere.

The most probable explanation lies in a derivation from 'leitir' or 'leathad', a slope. There is a long gentle slope rising from the glen to the south which was a well-known approach to the southern ridge, and the preferred route of ascent in the last century. Moreover this slope has a breadth to it which is what the word 'leathad' is intended to convey.

Above Looking towards Ben Vane from the northern ridge Ben Ledi (*Richard Gibbens*)

169

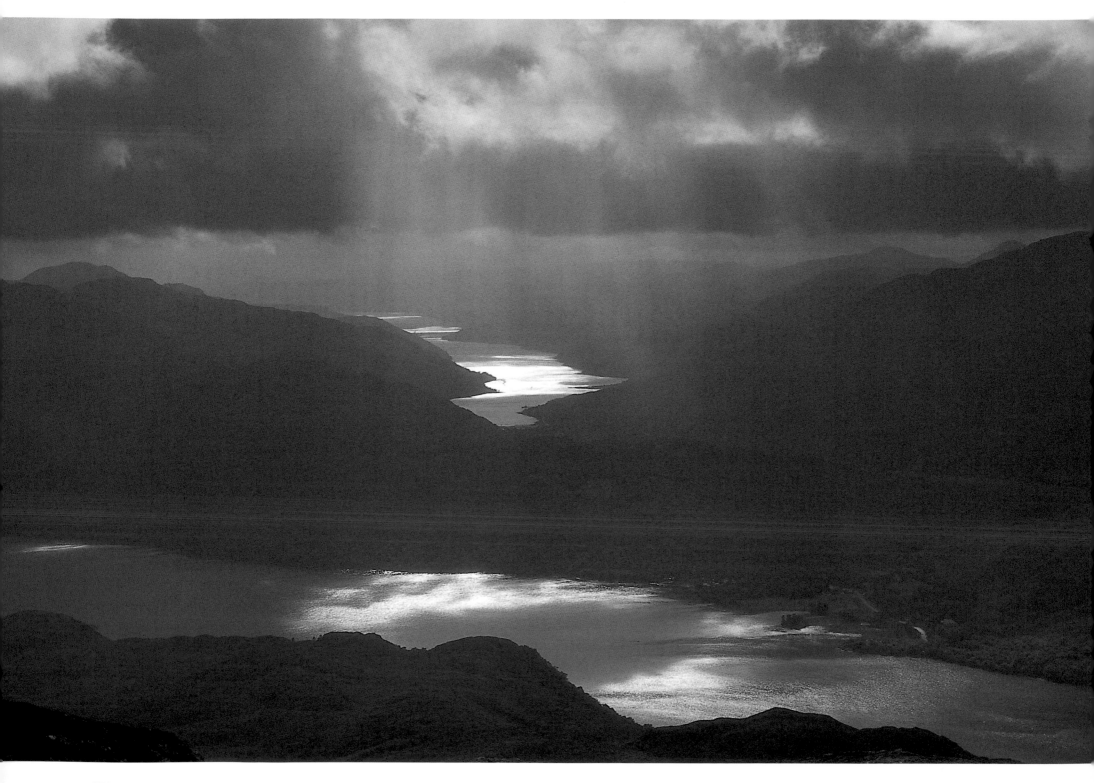

BEINN A' CHOIN

2,526ft/770m

Hill of the dogs

This is the second of two hills in the area around Loch Katrine which has some link to the use or presence of dogs. The interest in this hill is similar to that of its counterpart to the east in that it is an excellent viewpoint, with extensive views of the surrounding hills, and more especially across the isthmus between Loch Lomond and Loch Long.

Left Across Loch Lomond to Loch Long from Beinn a' Choin (*Irvine Butterfield*)

BEINN EACH

2,661ft/811m

Horses' hill or mountain

In the days when this area was less accessible horses roamed free and were of some importance to the economy of those who lived in the remote glens among the hills. This would be such a hill and probably one selected by the horses as a feeding ground.

Above right Meall na Caora and Beinn Each from Arivurichardich (*Irvine Butterfield*)

MEALL NA FEARNA

2,654ft/809m

Hill of the alder

Alder trees are no longer much in evidence and such as may have resisted the depredations of grazing deer and

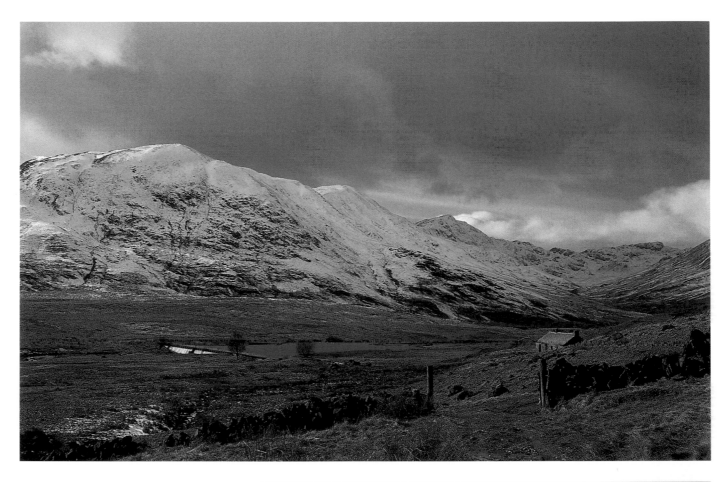

sheep owe their existence to their inaccessibility. The few which manage to survive may be found clinging to moist ledges above the mountain's draining streams.

The best view lies on the western slopes where, climbing from the divide which separates the hill from the higher Ben Vorlich, this neighbour assumes a more dramatic profile than that presented towards Loch Earn.

Right Ben Vorlich from Meall na Fearna (*Hugh Munro*)

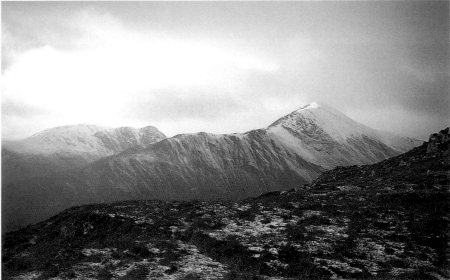

171

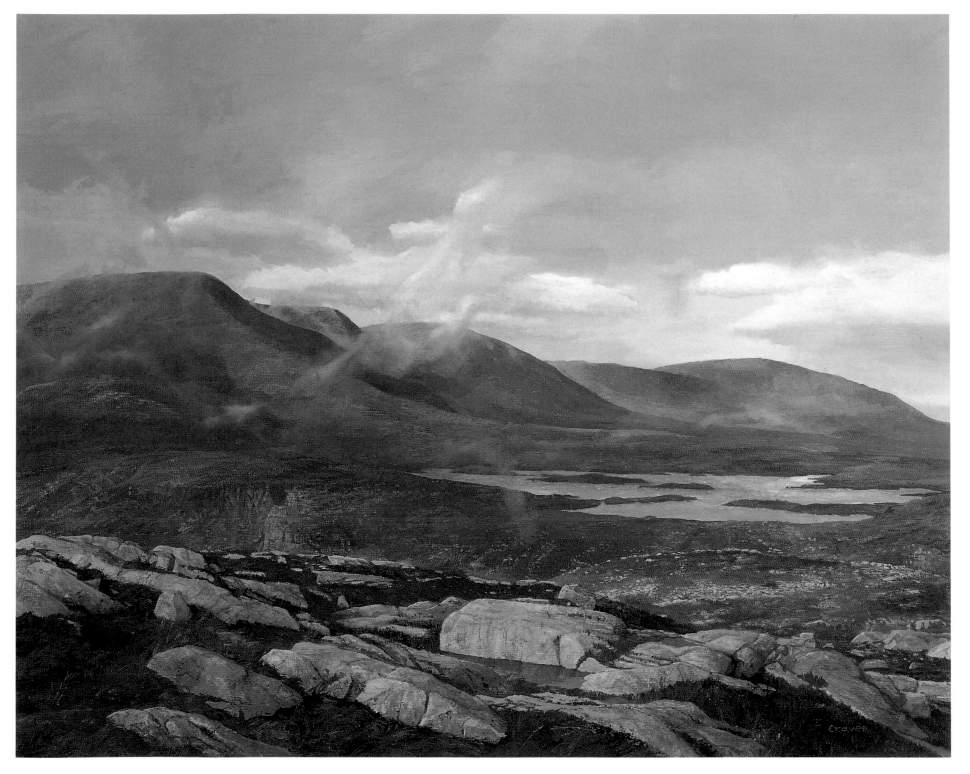

THE SOUTHERN UPLANDS

THESE HILLS MARK THE SOUTHERN LIMITS OF THE SCOTTISH mountain ranges, here divided into two distinct groups which identify with Galloway and the Borders. Crests of cropped grass and heather are causeways to long, carefree tramps across broad rolling ridges which seem to go on forever. On days of sun and high riding cumulus this is the land of the big skies.

Left Merrick and Loch Enoch from Craignaw (*Paul Craven*)

MERRICK

2,766ft/843m

The branched finger

This area was settled by the early Scots from Ireland and therefore has many Gaelic names. The name is of such origin, and comes from 'meurach', a pronged or branching place, a word which has its root in 'meur', a finger, branch, or prong. The mountain's title is long established and was one of those recorded by the earliest cartographers, and was shown as Maerack Hill in Pont's seventeenth-century map. In later years the resemblance to a gigantic hand led to the range centred on the mountain being accorded the colloquial title of 'The Awful Hand'.
Left Merrick from Kirrieoch Hill (*Richard Wood*)

SHALLOCH ON MINNOCH

2,526ft/770m

The heel of the ridge over the Minnoch, hunt of the Minnoch, or middle hill of the place of willows

Shalloch is unlikely to be derived from the Gaelic 'sail', a heel, as there is also a top to the north west called Shalloch, with an extending spur, Rig of the Shalloch. Given its pronunciation as 'shellag', a possible derivation from 'sealg', a hunt, seems more probable. This is supported by other references to hunting in the naming of hills close by. Eldrick Hill beyond Shalloch takes its name from

'iolairig', a deer trap, and Mullwhachar, to the south east, comes from 'Meall an h-adhairce', hill of the huntsman's horn, or from 'adharcach', horn shaped. Minnoch could come from either 'mheadhonach', middle, or, given its spread, from 'monadh', the old Gaelic word for a hill mass. Shalloch may also be a corruption

of 'seileachan', related to 'saileachaidh', a place of willows. Pronunciation may also suggest shalloch was a poor phonetic rendering of 'teallach', a forge or hearth. The connection here is with the Minnigaff Hills to the south, which are thought to be 'monadh a' gobhainn', hills of the smith.

The mix of old names and dialects in the area may confuse, as may the hill itself when seeking the summit. Take heed of the map and its contours – triangulation pillars do not always mark the summit!

Above Ailsa Craig from Shalloch on Minnoch (*Derek Sime*)

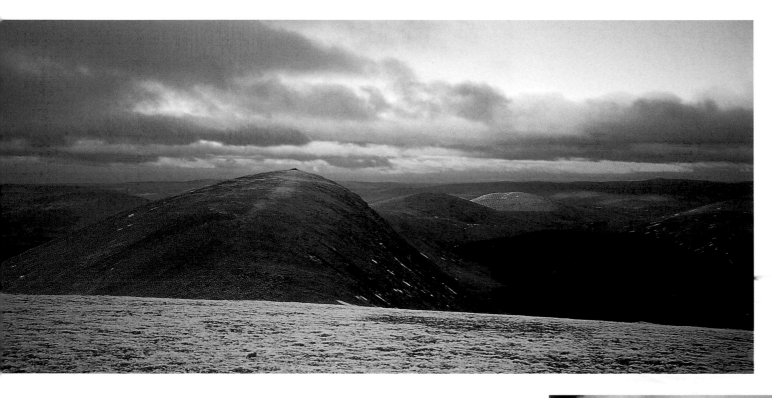

CAIRNSMORE OF CARSPHAIRN

2,615ft/797m

Big hill above the valley of the alder trees

The name comes from a combination of 'carn moor', big hill, 'carse', valley, and 'fearn(a)', alder trees. Bedecked in its lower slopes with regimented conifers the easiest approach to its isolated summit is by the track from Green Well of Scotland in the valley of the alder trees.

Below Cairnsmore of Carsphairn from Dunool ridge (*Irvine Butterfield*)

RHINNS OF KELLS

The headland of Kells (a local parish)

The name is derived from the old Irish 'rind' meaning a headland, and the name carries a link with the Irish who settled in the south west and west of the country.

Left Rhinns of Kells from Black Shoulder, Cairnsmore of Carsphairn

(*Irvine Butterfield*)

CORSERINE

2,670ft/814m

The crossing of the ridges

'Corse' is a common version in Scots for cross, and 'rinn' an old Gaelic word for a ridge. The name thus means crossing of the ridges. A massive cairn on the point northwards along the ridge gives title to this summit of the range and is reputed to have been built by an old lady to honour Robert the Bruce, who was actively engaged in this part of Scotland during his campaign to win Scottish independence.

Above Carlin's Cairn from Corserine (*Hugh Munro*)

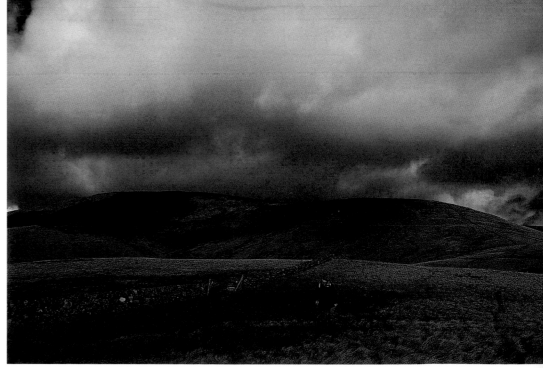

177

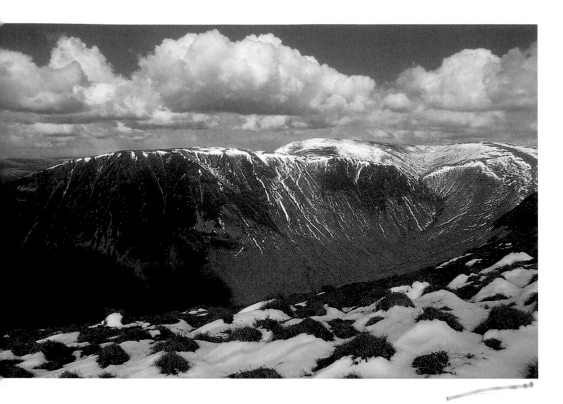

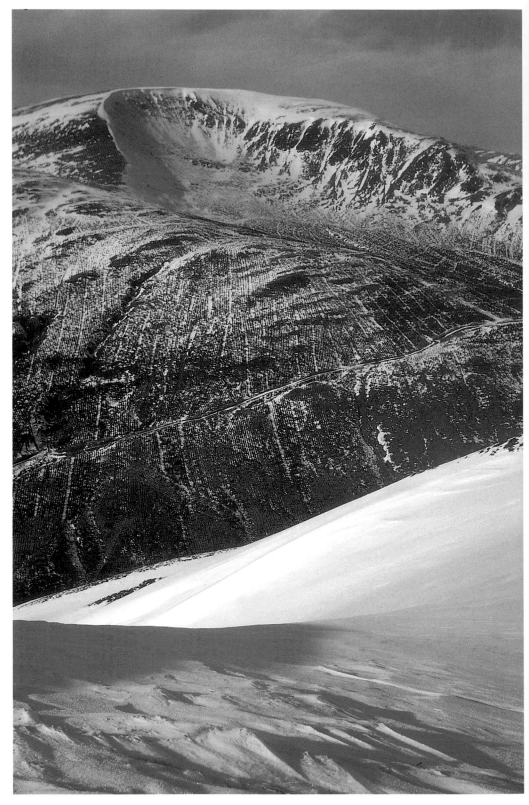

HART FELL

2,651ft/808m

Hart (deer) mountain

According to author Nikolai Tolstoy in *A Quest for Merlin* this hill was the site of the Arthurian figure Fergus' 'Black Mountain' and at one point the home of Merlin the magician. The hart, noble beast and prince of the animal kingdom, was the creature into which Merlin could magic himself on occasion – hence the hill's name. Today the most obvious association with this legendary wizardry lies in the name of the hill's south-west shoulder – Arthur's Seat.

Above Hart Fell from Under Saddle Yoke *(John Pringle)*

WHITE COOMB

2,697ft/822m

White valley, corrie, or bosom of the hill

The name may be derived more anciently from the Gaelic Carn a' Choire Ban, hill of the white hollow. 'Coomb' is Scots terminology, similar in meaning to that of the Gaelic corrie, intended to convey an interpretation more akin to 'a bosom of the hill'. The whiteness is that of the snow which holds fast in the hollow of the south-east facing corrie unto late spring, and it is this lingering cirque of snow which helps identify the hill when seen from a distance.

Right White Coomb from Bell Craig *(Richard Gibbens)*

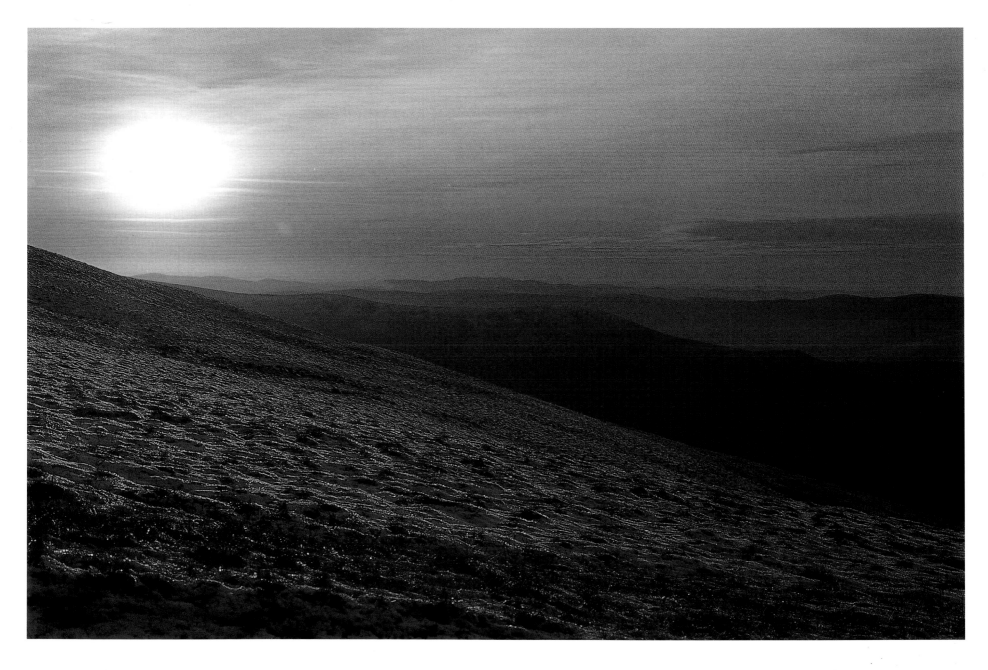

BROAD LAW

2,756ft/840m

Broad burial mound, or wide hillside

Law is a Scots name for a hill and here broad is intended to convey an expansive hill. As the second highest hill in the Borders its broad ridges of gentle gradient have proved its downfall. A wide track scars the slopes above Hearthstone on the climb to an expansive summit housing an ugly radio beacon.

Due to its central position, views from the mountain range across the many groups of rolling hills of the greater part of the Borders.

Above North-east slopes of Broad Law looking north (*Martin Moar*)

179

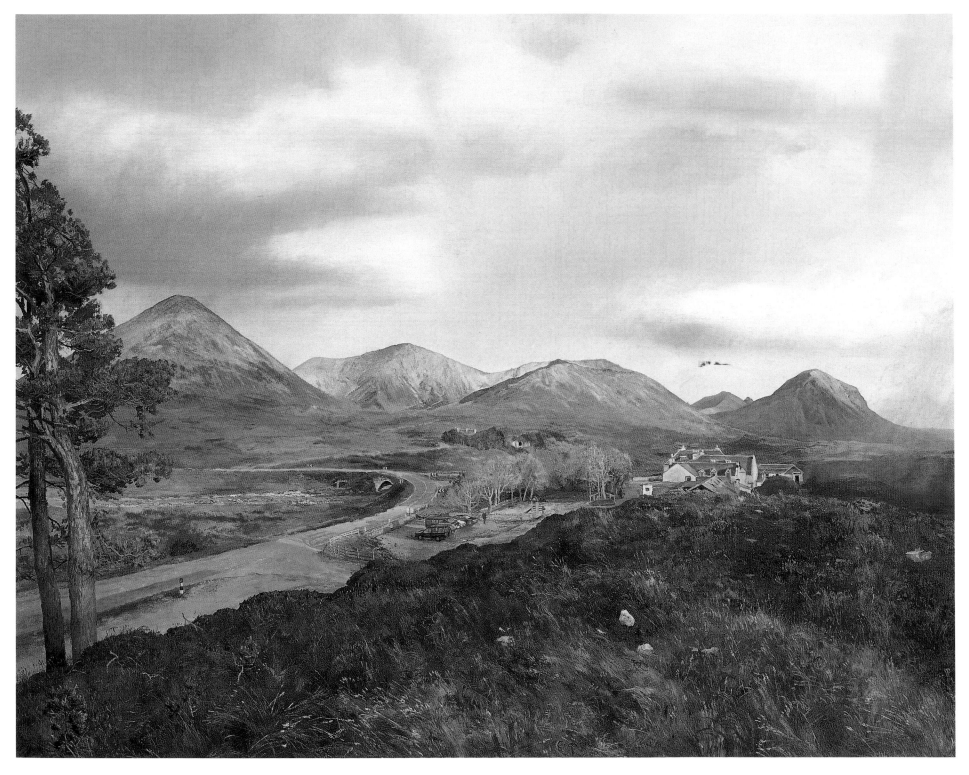

THE ISLANDS

ISLANDS HOLD A PARTICULAR FASCINATION, ESPECIALLY when mountainous, as the peaks provide superb belvederes from which to gaze across the mystic vastness of the sea. The six islands represented in Corbett's list provide a variety of such panoramas. These range from Clisham in the Outer Hebrides from which, on a clear day, there are glimpses of the remote outpost of St Kilda, to the clustered hills of Arran with their spires and tors overlooking the estuary of the Clyde. Betwixt the two, the Skye and Rum Cuillin boast peaks looking out to the smaller islands dotted on the sea: Mull offers an ascent to a view along the inner sounds, and Jura enchants with the sea crossings to reach its premier peak.

Left Glamaig and the Red Cuillin from Sligachan (*Paul Craven*)

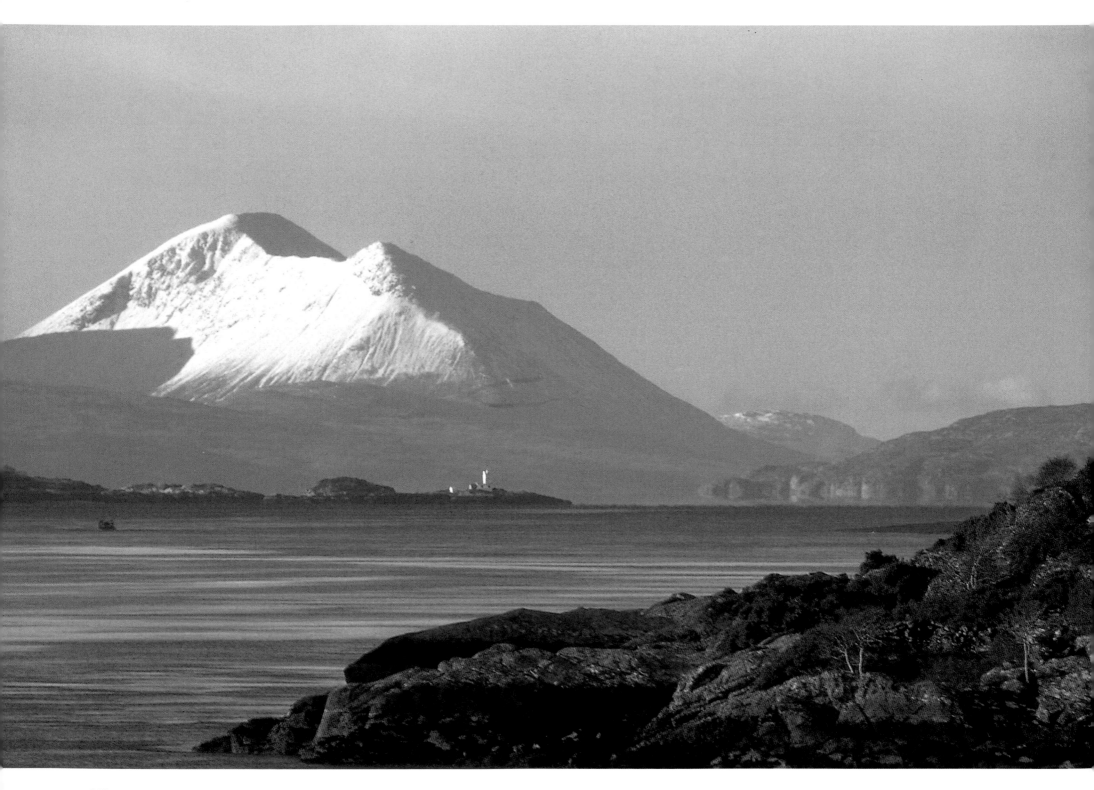

GLAMAIG *SKYE*
(SGURR MHAIRI)

2,543ft/775m

Deep gorge mountain, or greedy woman –
Mary's peak

'Glamhaich', a gorge, would seem to be
the most likely origin of this mountain's
name, and links it to the dark chasm of
the Allt Daraich found at the mountain's
foot. Others more romantically inclined
say the name may be from Old Norse
'glam-r', a poetic name for the moon.
Another Norse word 'glam', meaning
noise, or din, may maintain the
association with the thunder of the
waters in the gorge. Arguments for a link
to a greedy woman which would come
from 'glaimseach', pronounced glym-
chuch, do not appear to be borne out by
local pronunciation. The one lady we
know of, if only fleetingly, is one by name
of Mary, who is remembered in the
summit, Sgurr Mhairi. This recalls a herd
girl who died here while on pastoral duty,
seeking a lost beast.

Left Glamaig from Strome
(*Clarrie Pashley*)

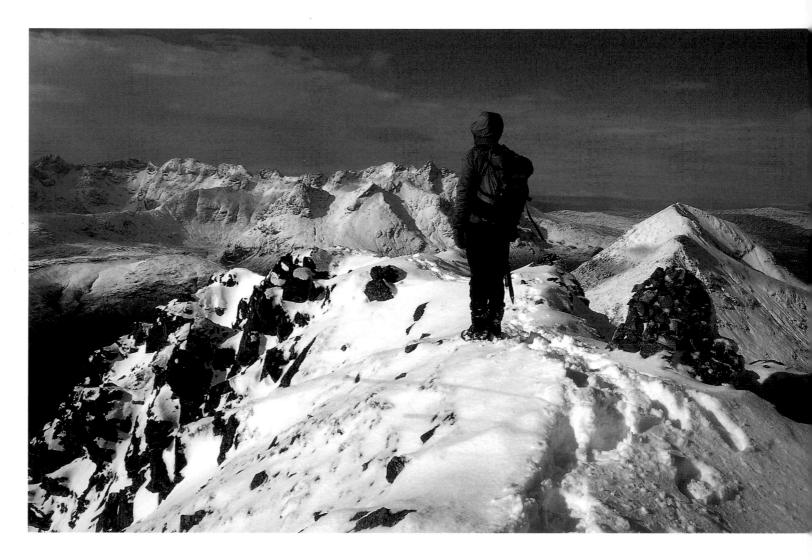

GARBH-BHEINN *SKYE*

2,644ft/806m

The rough mountain
As with many peaks of the Black Cuillin
this hill is a jumbled mass of weathered
rocks, with a finely honed ridge. It may be
no rougher than other hills in The Cuillin,
but compared to the neighbouring hills
around the head of Loch Ainort it appears
to be the most rugged.

The hill marks the divide between the
Red and Black Cuillin, and from its
summit there are panoramas of the sweep
of both these mountain ranges.

Above Looking to the Black Cuillin from
the summit of Garbh-bheinn
(*Jim Teesdale*)

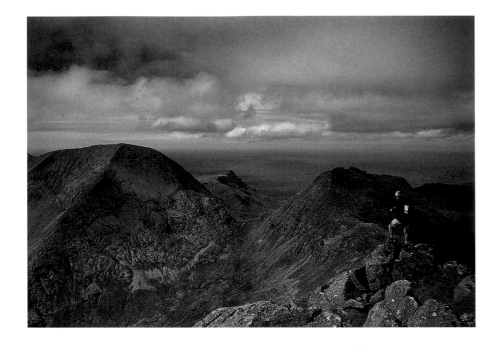

Left Ainshval and Trollval from Askival
(*Malcolm Nash*)
Below Hallival from Askival
(*Tom Rix*)

Right Askival and Ainshval from the
Singing Sands on Eigg (*Hugh Munro*)

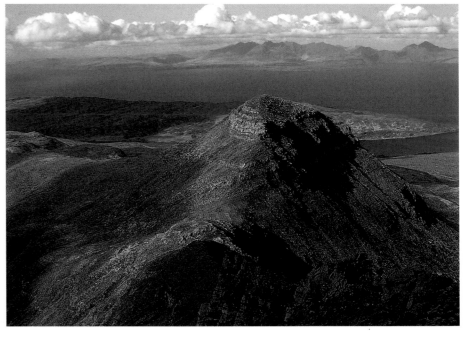

RUM CUILLIN

The collective name for the Rum peaks are the Cuillin, though this is not given on the maps of the Ordnance Survey. It derives from the hill walker's deference to the magnificence of the mountains in their island setting.

ASKIVAL *RUM*

2,664ft/812m

Hill of ash trees, or spear hill

Older spellings of Haskeval suggest the origin of the name is Old Norse 'haska fjall', dangerous hill. This seems most appropriate given the northern approach is by way of a narrow ridge from Hallival to a rocky summit guarded by the famous 'gendarme' of the Askival Pinnacle. The initial 'ask' could also be derived from the

Norse 'askr' meaning ashwood. This also conveys a meaning suggestive of a spear which given the mountain's pointed summit is an apt figurative description.

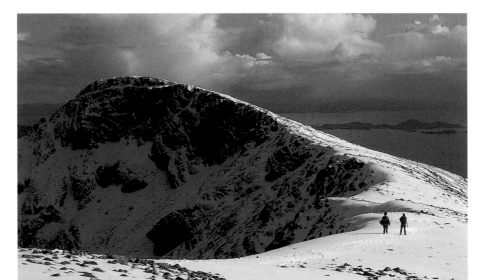

AINSHVAL *RUM*

2,562ft/781m

Hill of strongholds, or rocky ridged hill

The Norse 'ass', a rocky ridge, with an ending corruption of 'fjall', a mountain, portrays the mountain to perfection. Hill of strongholds may exercise a little more poetic licence in the translation but holds good given the hill's rough ramparts and rocky battlement.

Left Sgurr nan Gillean from Ainshval
(*John Allen*)

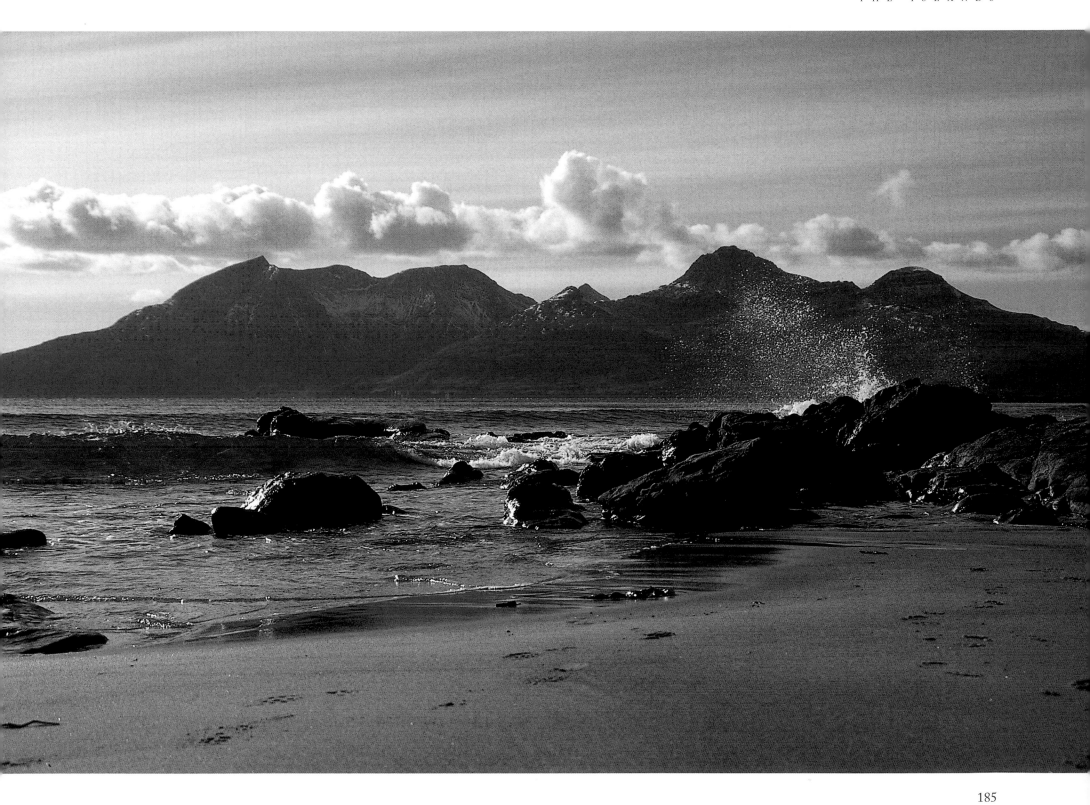

GOAT FELL *ARRAN*
(GAOTH BHEINN)

2,867ft/874m

Goat hill, or the hill of the wind

Probably Old Norse in origin from 'geitar-fjall', meaning nanny-goat fell. The link with goats is maintained by Timothy Pont's map of 1650 which records Keadefell hil, following a similar reference by an earlier writer, who in 1628 mentions Goatfieldhill.

A Gaelic version of the name 'gaoda-bheinn' suggests they copied the Norse, replacing the word 'fjall' by 'bheinn', a not uncommon practice in other parts of the land previously settled by the Norsemen. Corruption of goat as 'gaoth', wind, appears to be an over-enthusiastic attempt to give the hill a purely Gaelic name. This would not be entirely inappropriate given the summit's exposure to the south-westerlies sweeping in from the Atlantic.

Right Cir Mhor and Caisteal Abhaill from Goat Fell (*John Gillham*)

CLISHAM *HARRIS*

2,621ft/799m

Rocky cliff

The name is most probably from the Norse 'klif', pronounced 'klee', with an end syllable 'hamarr', a rocky outcrop or hillside. The name could simply mean rocky hillside as there is ample evidence of rocks and outcrops on this hill's slopes. The Gaelic 'cliath', a slope, lacks conviction.

Above The summit of Clisham (*Jim Teesdale*)

DUN DA GAOITHE *MULL*

2,513ft/766m

Castle, or fort, of the two winds

The summit lies some distance above the recognised site of its dun, or fort, but is without doubt exposed enough to catch the wind from whatever quarter it blows. Easily ascended from the pier at Craignure, the views which unfold often tempt the walker to explore the other high tops of Mull seen to the west.

Right Beinn Talaidh and Ben More from Dun da Gaoithe (*Don Green*)

BEINN TARSUINN *ARRAN*

2,707ft/825m

The transverse, or crosswise, mountain

The name is a simple reference to the mountain's formation in relation to the main axis of the ridge to the west of Glen Rosa. It is the first hill encountered above the foot of Glen Rosa, and its ascent often the precursor to a round of peaks. The curious will search out the rock formation known as the Old Man.

Left A'Chir and Beinn Tarsuinn from Cir Mhor well (*Irvine Butterfield*)

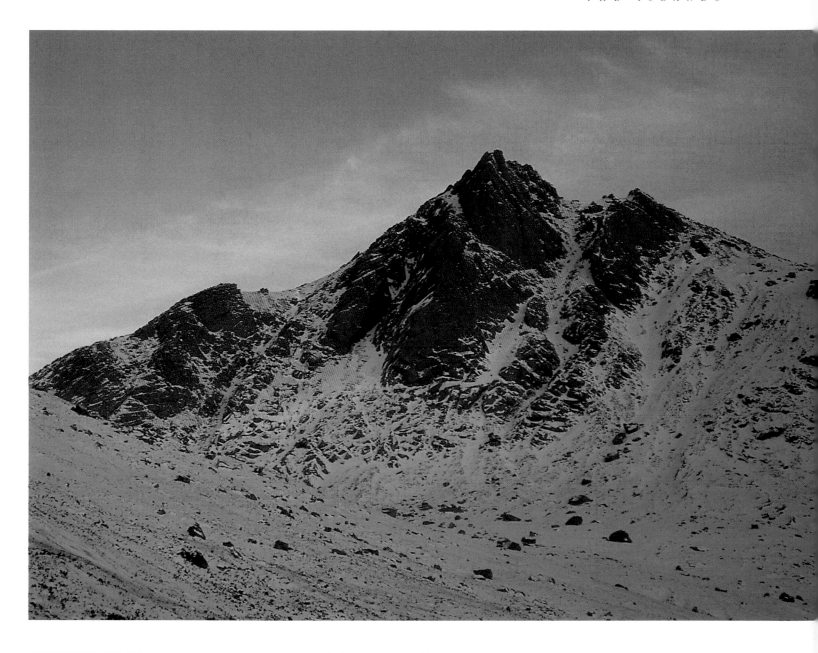

CIR MHOR *ARRAN*

2,618ft/798m

The great comb, or crest

To the Gael the serrations of the summit ridge must have appeared like the teeth of a comb, and it is this feature which gives the mountain its association with a prized domestic instrument. If the term crest be the interpretation this could refer to the erect crest, or comb, of the cockerel.

Above Cir Mhor from Coire Daingean (*Ruaridh Pringle*)

BEINN AN OIR *JURA*

2,575ft/785m

The boundary hill, or hill of gold

The name of this hill is well established and on Blaeu's seventeenth-century map was named Bin na Noir. As far as is known there are no legends connecting the hill with hidden treasure, and is more likely to point to the presence of the mineral iron pyrites, or fool's gold.

Below Beinn an Oir from Beinn Shiantaidh (*Alan O'Brien*)

THE PAPS OF JURA

The paps, or breasts, of Jura

The collective name for various peaks in the centre of the island of Jura is another example of conical hills appearing to the Gael to be the firm shape of a maiden's breasts.

Right Paps of Jura from the Port Askaig ferry (*David May*)

CAISTEAL ABHAIL *ARRAN*

2,818ft/859m

Castle of the fork, or death

The name most probably comes from 'casteal a' ghabhail', castle of the fork, from the outline of its granite battlement. The nearby presence of Suidhe Fergus, the seat of Fergus, might provide a romantic link as he was the ruler of Arran, Bute and Kintyre, and this would be a fine viewpoint from which to survey his dominion. More dramatically 'abhail', death could signify a warning of the difficult, and potentially fatal, traverse of the ridge out to Ceum na Cailleach, The Witch's Step.

Above Caisteal Abhail from Cir Mhor (*Mark Gear*)

190

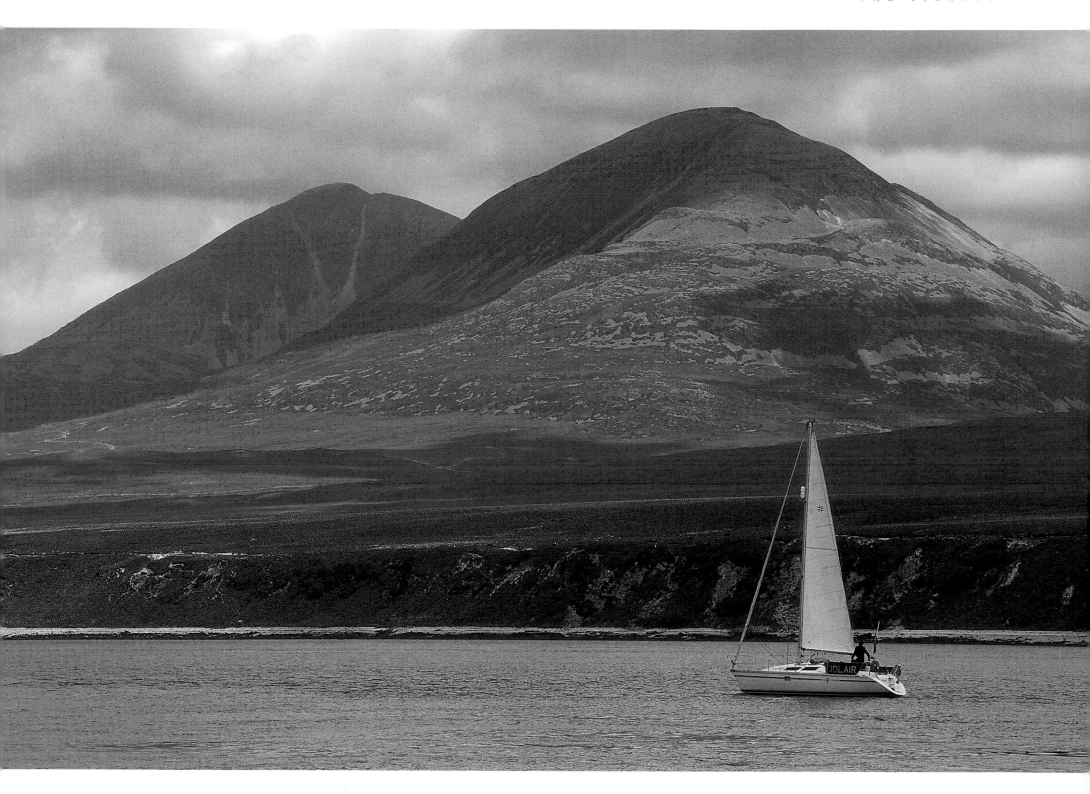